THE
Calligrapher's
BIBLE

THE
Calligrapher's
BIBLE

**100 COMPLETE ALPHABETS
AND HOW TO DRAW THEM**

David Harris

Contributing authors:
Mary Noble *(Preparation)*
Janet Mehigan *(Illumination)*

B L O O M S B U R Y
LONDON · NEW DELHI · NEW YORK · SYDNEY

A QUARTO BOOK

First published 2003
Bloomsbury Visual Arts
an imprint of Bloomsbury Publishing plc
50 Bedford Square
London WC1B 3DP
www.bloomsbury.com

Reprinted 2004 (twice), 2005, 2006, 2008,
2010 (twice), 2012, 2013 (twice), 2014

ISBN: 978-0-7136-6504-8

QUAR.TCBI
Conceived, designed and produced by
Quarto Publishing plc
The Old Brewery
6 Blundell Street
London N7 9BH

Project Editor **Vicky Weber, Paula McMahon**
Art Editor **Karla Jennings**
Copy Editor **Petra Kopp**
Designers **Paul Wood, Karin Skånberg**
Assistant Art Director **Penny Cobb**
Photographers **Paul Forrester, Colin Bowling**
Proof reader **Anna Bennett**
Indexer **Pamela Ellis**

Art Director **Moira Clinch**
Publisher **Piers Spence**

Manufactured by Universal Graphics, Singapore
Printed by Midas Printing International Limited, China

Contents

Introduction

The unprecedented growth of information technology in the late twentieth and early twenty-first centuries are the culmination of a process that began over a century earlier with the invention of the typewriter. There is ever less need to write in a clear and legible hand, and keyboard skills have become more important than handwriting.

It is perhaps because of this reliance on technology and the mechanistic perfections it creates that, paradoxically, many people now appreciate and practise the tactile art(s) of calligraphy.

Modern-day calligraphers have a rich inteheritance of Latin scripts developed over 2,000 years. Most of these are readily intelligible, and even scripts that have fallen out of use have many characteristics that can be incorporated and adapted for modern calligraphy.

The alphabet we use today was aquired by the Romans from the Etruscans. The Romans added the Greek letters Y and Z, bringing the total count to 23. "J", "U" and "W" were medieval additions to accommodate further phonetic values.

The greatest calligraphic debt that we owe to the Romans is unquestionably that of their capital letters, above all the inscribed capitals that appear in the late first century B.C. Inscriptions had been used in many civilizations before, but the extreme subtlety, beauty and elegance of the character of these Roman letterforms, the *capitalis monumentalis*, was different. Directly or indirectly, these letters provided the model for almost all of our text typeface capitals, as well as many of our display and calligraphic capitals.

In calligraphic terms there is one other Roman script of use to us: the Rustic capital. This gives us a different ductus but, unlike the *capitalis monumentalis*, also served as a manuscript hand.

As the Western Roman Empire fell into decline and became fragmented, most of the writing hands became increasingly regionalized. The Uncial, however, retained much of its integrity during this Late Roman period. This script can be viewed as a Latin interpretation of the Greek Uncial. Most of the Christian texts were written in Greek and as such were regarded almost reverentially. All of the known early Christian Latin texts were written in this hand.

By the sixth century A.D., the Uncial was developing different characteristics, particularly in relation to the features we now define as ascenders and descenders. We now define this letter as a Half-Uncial. Two significant developments had an

Inscription from the base of Trajan's Column in Rome. These letters, described in a stroke-by-stroke sequence on pages 42-43, are regarded by many authorities as among the finest examples of the Roman letter.

impact on this script. The first took place in northern Britain and Ireland, where the Half-Uncial attained a magnificence, as seen in the Book of Kells and the Lindisfarne Gospels, which arguably has never been surpassed. These books were written to the glory of God and as such were the very best that could be made in respect of writing, decoration, and binding.

The Half-Uncial was also an important script in continental Europe, where it was used for both secular and non-secular work, although it was written more speedily and consequently had a more cursive character. By the late eighth century Charlemagne had established the first post-Roman empire, stretching from the Baltic to northern Italy. Charlemagne saw himself as the inheritor of Imperial Rome, with literacy and the spread of knowledge key elements in his civilizing mission.

Inherent in this process were the establishment of scriptoria and the training of scribes. Also needed was an easily penned, legible, and universally acceptable script. By cutting his pen at right angles to the shaft instead of the oblique angle required for the Half-Uncial, the scribe produced a true minuscule.

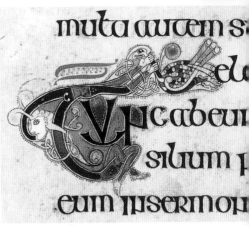

This magnificent insular script dates from between the late eighth and early ninth centuries.

This gave less contrast between strokes, was more cursive in character and quicker in execution. Thus the reformed Half-Uncial became the Caroline minuscule.

The Roman capital and the Caroline minuscule are the two defining scripts for modern letters. The Caroline hand eventually became the model for the Renaissance Humanist hand. With the invention of printing with moveable type, it also became the model for many typefaces, and we can trace back much of our modern text type design to this period.

By the twelfth century the Caroline minuscule had grown increasingly cursive for secular work, and more compressed and upright for religious works. At the beginning of the thirteenth century this division was complete: the stately Gothic

Modern expressive calligraphy but with clearly defined letterforms.

This is the Caroline minuscule, which dates from the late eighth century.

scripts date from this point.

The Humanist minuscule, a child of the Renaissance, spawned other scripts: the earliest was the Italic, a cursive form of the Humanist minuscule. This letter, with a forward slope, could be written at speed. By the mid sixteenth century this script again became more formal and known as the Chancery Script through its use in the Papal Chancery in the Vatican.

The next innovation again related to the cutting of the nib. By the mid seventeenth century, scribes discovered that by cutting their nibs to fine points, dramatically increasing the angle of slope and by joining their letters they could often write a part, or even a whole word, without lifting their pens and at a considerable speed. This Roundhand or Copperplate letter found particular favour

in England, and with the rise of a trading empire it was quickly disseminated throughout the world, including the United States.

Knowledge of how the earlier scripts had been written was all but lost. The resurgence of modern calligraphy is due to the skill and painstaking research of a few individuals, including Edward Johnston in Britain. Taking the Ramsey Psalter, an English Caroline minuscule, as his model, he developed a simple and unambiguous writing hand that he taught to students. The Foundational hand remains the favourite teaching hand for almost everyone who has learned calligraphy.

The following directory contains step-by-step instructions for virtually all the major scripts from the last two millennia. In addition there are examples of many modern interpretations and re-workings. Also included is a whole range of modern scripts, drawn with pen and brush and with a variety of writing implements, both conventional and otherwise.

By 1400 the Humanist minuscule was the established writing hand of the educated person in northern Italy. The Canselleresca Formata developed from the Italic hand and dates from the mid sixteenth century.

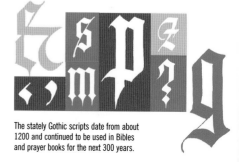

The stately Gothic scripts date from about 1200 and continued to be used in Bibles and prayer books for the next 300 years.

How to use this book

There are one hundred different hands shown in this book. They are organized into chronological groups. Each hand is treated in a similar way. You will find that as you become familiar with a script you may wish subtly to alter it to suit your own hand.

For scripts drawn with a broad-edged, chisel-shaped brush, angles and letter heights apply, but because of the flexibility that a brush gives these rules are more loosely applied. For Italic hands, the angle indicated is the angle at which the letter slopes from the vertical. For hands drawn with either a pointed nib, a ruling pen, or a pointed brush, measuring the height of the letter in relation to the pen or brush width is no longer applicable, although in a few instances the relationship of stem width to stem height has been indicated within the text.

Many of the scripts have been written with a broad-edged pen. When doing this, it is helpful to show the height of the letter measured in pen widths (see page 23).

The angle at which the pen is held determines the letter shape. The predominant pen angle is shown here. However, these angles are not absolutes: the angle will alter, sometimes within a single stroke and sometimes between adjacent strokes.

A "skeleton" letter shown at the beginning of the step-by-step sequence clearly shows the shape of the letter.

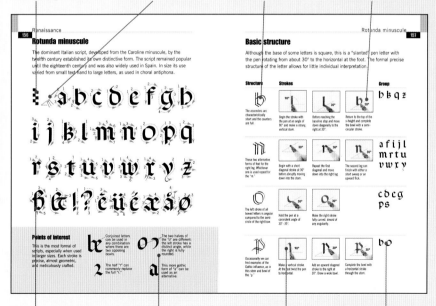

Numbered arrows indicate the order of individual strokes needed to create the letter. A handful of hands can be created in any sequence the calligrapher wishes and these do not have arrows.

This panel calls out characteristics of the script and sometimes offers alternative letterforms.

Step-by-step sequences demonstrate a selection of letters. Practise will give you a good grasp of the entire script.

Letters are organized into general groups. Not all letters are included and some letters may fall into several groups. They are, however, a useful indication of the way letters relate to each other.

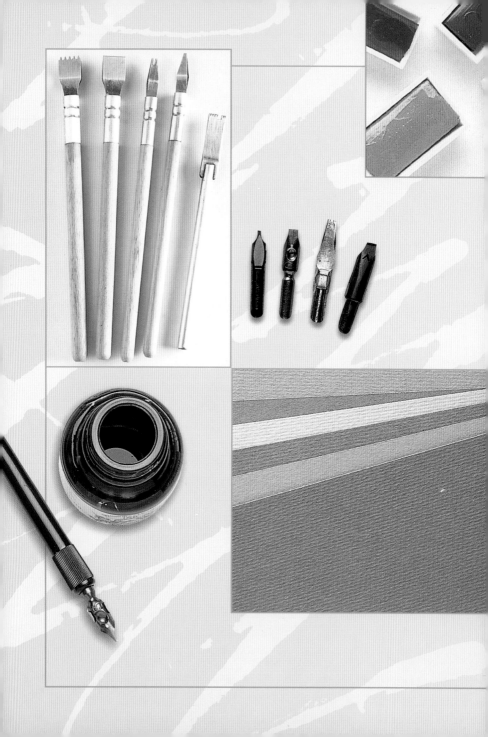

Preparation

Full enjoyment of calligraphy begins with getting to know your tools and equipment. The following pages offer guidance on what you might need, and shows you how to use what you choose. There are detailed instructions for developing writing skills, from getting your pen working to ruling lines ready for studying an alphabet. The simple suggestions for laying out your text will help you to produce visually effective designs.

Tools and materials

The writing instrument is one of the most significant factors in the appearance of a calligraphic letter. Edged or pointed, soft, rigid or flexible – these factors affect the speed and rhythm of writing, and everyone develops favourites. Exploration of the many kinds of pens, papers and inks is part of the fascination of calligraphy.

To find the right tools to suit your level of expertise, look through the following descriptions. Availability may be the final deciding factor. Although office and stationery suppliers will have the more standard items, artists' suppliers will be the major source. More specialized items will only be available through groups such as calligraphy societies. Find the nearest society through your local library or check the Internet for national societies.

Felt-tipped pens

Pens
Felt-tipped pens

Dip pens

Economical and convenient disposable felt-tipped pens are useful tools for practice, and for items that will not be on display for very long: the inks are generally not lightfast, so their colors fade over time. They should be replaced when the tips start to lose their sharp edge.

Fountain pens

Fountain pens are popular for beginners, as they have convenient ink cartridges, which can be purchased in a variety of colours. However, these inks will also fade in time, so fountain pens, too, are excellent tools for practice and temporary documents. Once black ink has been used, it is difficult to wash out sufficiently well to change to a bright colour. Several nib sizes are available in a pen set.

Fountain pen sets include a wide range of nib sizes.

Dip pens

All dip pens will be useful for writing with coloured inks and paints, as they wash out easily.

Quills: These are the best-known traditional dip pen. People who use them constantly insist that there is no finer tool. Some skill is needed to cut the nib sufficiently well for consistently sharp writing, as it softens and wears with use, necessitating re-cutting after a short time. Practising on reed pens, if you can obtain suitable Norfolk reed, is a good introduction. It is sometimes possible to purchase ready-cut quills.

Reed pens and quills need careful cutting for a sharp writing edge.

Steel nibs: These became popular as a convenient ready-cut tool manufactured in up to ten widths. They are square-cut "roundhand" nibs, which attach to a pen holder (handle). A separate reservoir attaches to the underneath of the nib to help retain more ink. (This reservoir is not a precision instrument and often needs its grip adjusted by squeezing or opening out the sides.)

Steel nibs have a straight writing edge, but it is possible to obtain left oblique nibs for left-handers, which help to compensate slightly for the wrist-twisting that a left-hander has to do to achieve the same angle of writing (see Preparing to Write, page 20). Sometimes these nibs need "breaking in" when new: Hold each side for two to three seconds (don't overdo it!) over a match flame to burn off the varnish at the first 1cm of the tip. Test it by dipping in the ink; if the nib stays coated, it is ready for use.

Some dip nibs come with a reservoir built into the top, which is very convenient, as it never slips off and does not

Steel nibs come in many shapes. Many have reservoirs attached.

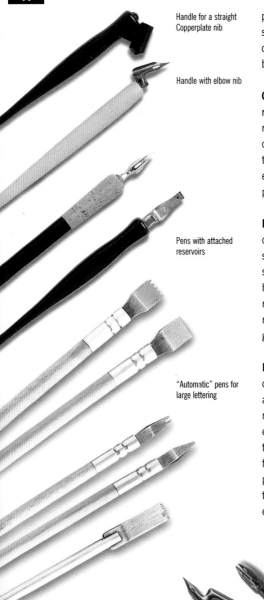

Handle for a straight
Copperplate nib

Handle with elbow nib

Pens with attached
reservoirs

"Automatic" pens for
large lettering

"Elbow"
copperplate nib

Brause, Mitchell, and Speedball nibs

pinch the nib. Many of these nibs are slightly right oblique, designed for the comfort of right-handers – so left-handers beware.

Copperplate nibs: Copperplate work requires a flexible, pointed nib without a reservoir. Copperplate nibs wear out more quickly than square-edged pens because they are worked by pressure, thus causing eventual metal fatigue. It is worth purchasing several at a time.

Poster pens: Larger pens for poster work come in many varieties from specialized suppliers. "Automatic" pens and multi-stroke pens are the most popular. They have very wide nibs in various sizes and retain the ink with some form of integral reservoir. They are simple to wash out and generally come with an integral handle.

Ruling pens: These were once the domain of technical draughtspeople but have been adopted by calligraphers for two roles: for ruling straight lines and for freeform experimental writing. For the latter purpose they are held flatter to encourage the ink to flow out freely. Several specialized ruling pens have been designed by calligraphers to make bolder marks for greater expression.

Brushes

Brushes are important for mixing paints to feed the pens, for painting decorative features in their own right, and they are also very good for writing.

Choose cheap brushes for mixing, as the paint clogs up the ferrule (metal grip) and adversely affects the profile of the tip. Springy nylon brushes are ideal as a writing tool. They come in many widths, both pointed and chisel-edged, allowing plenty of scope for writing size and style. Chisel-edged brushes should be checked edge-on: if the shop will allow it, dip in water and squeeze it out between the fingers. Reject the brush if it divides into two layers, or if the edge is blunt rather than sharp. Pointed brushes should come to a single fine point; check there are no stray hairs.

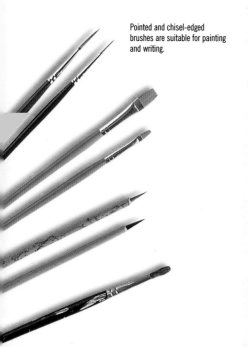

Pointed and chisel-edged brushes are suitable for painting and writing.

Illuminator's tools

You will need:
- Patent gold (attached)
- Transfer gold (unattached)
- Brushes for applying ammoniac size or gesso
- Agate burnishers – medium (size 24) and small dog tooth (size 34)

In addition:
- Vellum or good-quality paper
- Pestle and mortar to grind the materials for gesso
- Dip pen for drawing fine lines or writing in gum
- Large soft brush for dusting away gold particles
- Craft knife with rounded blade for removing unwanted gesso and gold
- Piece of silk for polishing the gold
- Glassine paper or crystal parchment to lay on your work to protect it when burnishing gold
- Eraser
- Gums or adhesives to fix the gild to the paper or vellum.
- Pounce (pumice powder and cuttlefish) to prepare the surface of vellum

Other tools

Rulers

For measuring and for accurate ruling of lines, choose a clear plastic ruler with clear markings. Some plastic rulers have a metal strip to allow for cutting. Alternatively, choose a steel ruler; cutting against a plastic or wooden ruler will soon destroy the smooth edge that is needed for ruling straight lines.

Setsquare and protractor

A plastic triangle is useful for measuring 60° angles, and for making parallel lines by holding carefully against a steady ruler. Alternatively invest in a T-square, which does the job of parallel lines on a larger scale and needs to hook over the edge of a writing board. A protractor (plastic semicircle with degrees marked on it) can be used for measuring angles.

Pencils

HB is the standard grade for pencils in calligraphy. Harder pencils (2H, 3H, 4H) stay sharp for longer, thus aiding accuracy, but the very hard ones can be difficult to erase. 2H is good for ruling lines, HB for sketching ideas. Soft pencils (2B, 3B) are not usually necessary for calligraphy, except for ruling lines on delicate paper; they erase easily but blunt quickly. Keep pencils constantly sharp with a pencil sharpener or a craft knife. Soft erasers are best; try a plastic one.

Scissors

Scissors are frequently needed for cutting paper, as is a craft knife. Keep a set of spare blades, as blunt knives are dangerous to use: you press harder and they can slip.

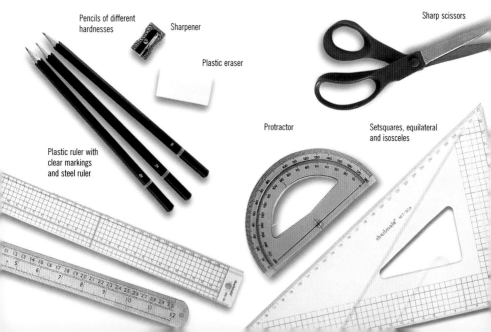

Pencils of different hardnesses

Sharpener

Plastic eraser

Sharp scissors

Protractor

Setsquares, equilateral and isosceles

Plastic ruler with clear markings and steel ruler

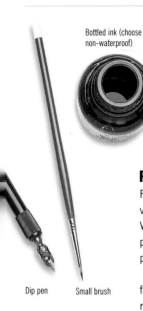

Bottled ink (choose non-waterproof)

Chinese inks

Chinese stick ink with inkstone

Dip pen Small brush

Paints and inks

For bottled inks, choose a non-waterproof variety, whether black or coloured. Waterproof inks are thicker and clog the pen. Never use waterproof ink in a fountain pen. Check the label for lightfastness.

Chinese stick ink is a traditional favourite, requiring an inkstone on which to reconstitute it.

Gouache and watercolour paints are much used by calligraphers, for writing and for background washes. In good-quality products lightfastness is excellent and is usually indicated on the label. Watercolour paints are transparent and are perfect for background washes, or for writing on white paper where the colour will show true. However, the opacity of gouaches makes these the best choice when writing in colour on top of a background colour. Transparent watercolours would interact with the background and lose vibrancy.

Watercolour pans

Tubes of gouache paint

Tubes of watercolour paint

Palette for mixing

①

②

⑧

⑦

Papers

Practise paper must be plain white, with a smooth but not shiny surface. If it is thin enough to see ruled lines through it, this will save the trouble of ruling guidelines for every page. Layout paper, which comes in a pad, is a popular choice, as is good-quality photocopy paper. Some inks bleed on some papers, so it is advisable to try to check this before purchasing large amounts.

For finished work a thicker paper is needed because thin paper creases easily and wrinkles when you write on it. An economical paper for beginners is a good-quality, heavy-duty cartridge paper – but check it has a smooth surface. Avoid children's drawing paper as this may cause inks to bleed.

Beware of papers advertised as "calligraphy papers" and often sold in pads: these frequently have a mottled parchment effect that is an unsatisfactory surface for sharp writing.

Watercolour paper is the ultimate choice: select one with a very smooth surface, called hot-pressed (HP). The more textured surfaces present a challenge for fine writing but can be very effective for large textural letters.

Use 190gsm/90lb thickness/weight, or 300gsm/140lb, which will not wrinkle. Coloured papers save the trouble of making a wash background and come in many subtle finishes. Check the surface for good writing quality. Ingres papers work well.

Handmade papers may seem an extravagance, but some are perfect for calligraphy, providing subtle colour which needs no other embellishment. Indian Khadi papers generally make very successful writing surfaces.

Across these two pages you will find an assortment of papers. Clockwise:

1. Watercolour paper
2. White cartridge paper
3. Natural handmade paper
4. White handmade paper
5. Coloured cartridge papers
6. Layout pad
7. Vellum and parchment papers
8. Pastel and Ingres papers

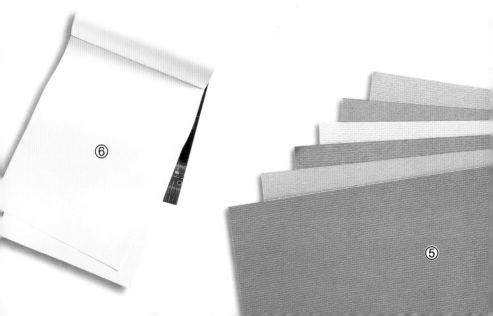

Preparing to write

To allow yourself to enjoy calligraphy to the full, it is worth spending some time setting up a comfortable place to work, as you will be sitting there for long periods of time.

The workstation

You may be more used to writing on a flat surface, but a sloped writing surface will help you avoid back strain. The slope can also help prevent blots from the dip pen: an angle of about 45° is best for this, but experiment to see what suits you.

Many manufactured boards are available, some with special hinges that allow an infinite variation of slope, others with slots like deckchairs. To make your own use a piece of thin plywood cut to size, about 45 x 60cm, sandpaper the edges to avoid splinters, and prop it up with books.

A new board needs to be padded in order to improve the writing surface. Cover it with several sheets of newspaper (ironed) or scrap paper with a sheet of white paper on top, secured with masking tape. Leave a smooth, straight edge on the board if you plan to use a T-square to rule your lines.

Finally, always use a guard sheet. This is a

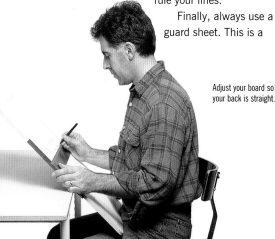

Adjust your board so your back is straight.

Padding the board

1 Place several layers of scrap paper on the board, and cover with white paper.

2 Secure with masking tape all around, avoiding going over the edge.

3 Fix a narrower sheet loosely across the board at writing level, as a guard sheet.

strip of protective paper to cover the part of the board where your hand rests as you write. The natural oils in your hand can make the paper less receptive to your ink.

If working in daylight, position your table near a window; it is worth investing in a desk lamp for working at other times or in poor light conditions. Check that your hand does not cast a shadow over the work. It is possible to buy "daylight" bulbs if you intend to work a lot with colour. They cast a bluer light, but this can make people feel chilly!

Using the pen

Place the ink on the side of your writing hand, so that you don't have to reach across the paper to refill, and secure the bottle to the table with masking tape to prevent spillage.

If you are using a new or different pen, spend some time getting used to the "bite" of the nib on the paper, as all makes of pen differ in this feel. A

Work with your ink on the same side as your writing hand.

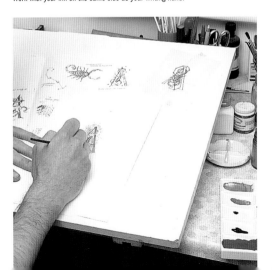

Left-handers

Sit with your board a little to your left to minimize the need to bend your left wrist to hold the pen at the same angle that is comfortable to a right-hander. Left-handers who write in the "hook" position can achieve success by writing the letters from the bottom up, which would mean re-interpreting the stroke order shown in the alphabet exemplars.

Hold the pen with your wrist inclined to the left, so that you can make these thick and thin zigzags.

For the "hook" method, try writing from bottom to top, reversing the stroke order shown in the exemplars.

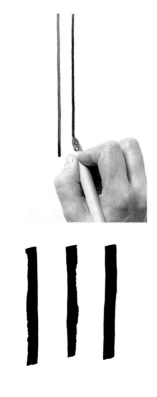

See how much ink the reservoir can hold by making these long strokes. If one side of a stroke is ragged, press more evenly with the nib. Make zigzag patterns to practise keeping a constant pen angle.

broad nib of about 2mm is recommended if you are new to calligraphy, as this will allow you to see what is happening with the strokes you make. Make a tiny sideways movement at the start of a stroke to spread the ink from the slit across the nib and to encourage the pen to discharge it more evenly. This creates a "serif", the small hooked starting stroke.

Make straight, long marks, beginning with the tiniest "serif" to start the ink flow. If your stroke has ragged edges, the whole of the nib is not sufficiently pressed against the paper as you write – try again.

If you are starting a new dip pen, dip it into the ink and then look closely at both sides. If the ink is not spreading evenly across the metal surface, it may need treating with detergent or a match flame to take off the varnish or machine oil. You need only treat the forward 1cm of the nib, both sides. Take care not to overheat the nib if using a match flame: count two to three seconds each side, then dip the nib quickly into water to cool. Test the nib for ink spread.

When you are happy with the pen's "bite" on the paper, rule some lines or fix a sheet of guidelines underneath. Begin by practising regular thick and thin marks: hold the pen at a constant angle while you make zigzag patterns across the page. Start with a constant angle of 45°, as this is relatively simple to estimate: it's exactly halfway between vertical and horizontal. Travel between your guidelines to make neat patterns. It is important to grasp the concept of pen angle, as it influences the look of each alphabet.

Still at 45°, make vertical and horizontal strokes. The strokes can make a pattern, but they are also a good test of whether you are maintaining the 45° angle: horizontal and vertical strokes should be the same thickness. Keep trying until they are.

Now try 30° and note the differences. You may wish to use a protractor to work out the angle, or trace from the diagram on this page. Make more

CA un sa fa

zigzags, which will have longer thins and shorter thicks, then notice what happens when you compare vertical with horizontal lines. These should be of different thicknesses: the upright strokes should be thicker than the horizontal ones.

Now try writing other letters and various doodles with the pen at that angle. The upright strokes should come out thicker than the horizontal ones – you could think of it as shelves needing to be fixed to strong walls.

Some general rules about writing apply to all the different alphabets in this book. They all have their specific rules for pen angle, which we have just tried, and "nib widths", which we haven't.

These letterforms are all written at a 30° pen angle.

Try the first two lines of these doodles to get used to 30° pen angle — the vertical strokes should be thicker than the horizontals. The bottom two lines use a 45° pen angle; see if you can get used to the difference.

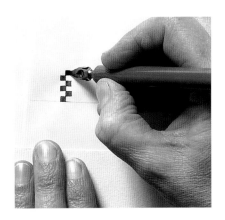

Make sure that you hold the pen at this unnatural, absolutely vertical angle, to make these squares for gauging the height of your writing.

Nib widths

"Nib widths" means the number of times the thickness of the nib goes into the height of the letter. Writing a word at a height of four nib widths will create a different effect than writing the same word at a height of seven nib widths. Check

Make squares with your pen, one above the other, either as a vertical "ladder" or as a diagonal "staircase," whichever is the most accurate for you.

"Thicks" and "thins"

For calligraphy to look its best, it must be crisp. That means clear differences in the thickness of strokes as they move around the letterform. A letter "O" should have thick and thin parts, clearly defined, and letters with entry and exit strokes should have "hairline" strokes at each end, rather than blobs. The blobs are an integral part

when you start learning an alphabet from the exemplar, and make sure you rule your lines to fit the pen you plan to use. When you are beginning, it is best to use a large pen, perhaps 2mm wide.

Hold your pen completely vertically to make the nib width squares, and try to be as accurate as possible, avoiding overlapping or gaps. Try a few times; if the result varies, take an average.

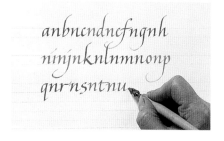

This red Italic alphabet clearly demonstrates "thicks" and "thins".

How to rule lines

It is important to rule accurate lines if your writing is to look consistent in weight and height. Learn good habits with large writing and it will serve you well for smaller work, when a hare's whisker becomes a significant proportion.

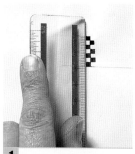

1 Use a freshly sharpened pencil and a ruler with clear markings. Check from your alphabet exemplar how many "nib widths" are needed; make these with the pen you plan to use. Measure very accurately the height of your "nib widths", and then use one of the following methods.

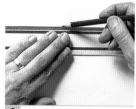

2 Transfer the measurements with your ruler all along one side of the paper, repeat them along the other side and join them up with your ruler.

of the letter. This is achieved by taking care with your pen angle, and by developing a sensitivity in your fingers for holding your pen steadily on the paper.

For the lower-case, or small, letters we measure the main body of the letter, not counting the ascenders and descenders. Capitals don't have these features, but for lower-case writing we have to allow more space between the lines of writing to prevent any ascenders and descenders colliding.

Ruling lines

Check each alphabet exemplar for how many nib widths you need for ruling the lines; this gives you the "body" height or x-height. Then work out what is needed to avoid ascenders and descenders colliding between the lines. If you are unsure, the

safest measurement is as shown here: twice the body height. Follow the instructions for each alphabet carefully, as differences are sometimes quite subtle. It is a good idea to stay with one script until you are confident with its rules before attempting another.

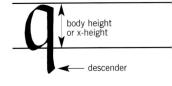

body height or x-height

descender

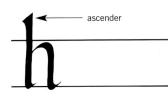

ascender

Always allow sufficient gap between lines of writing to avoid the ascenders and descenders colliding.

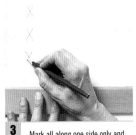

3 Mark all along one side only and use a T-square to rule parallel lines. You must fix your paper to the board in two places to prevent it moving while you do this.

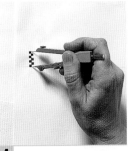

4 Use dividers (an instrument like a compass but with two points) and set them accurately to the nib-width height.

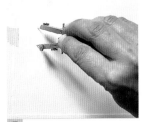

5 "Walk" the dividers all down one side to prick holes. Repeat for the other side unless using a T-square.

Layout basics

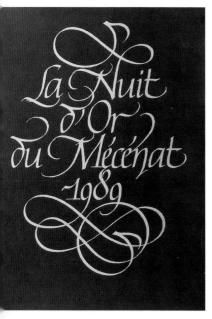

A simple centred layout can be made decorative with ornamental flourishes.

Layout is enormously important in controlling the space and light of a page. This applies whether you are writing a single name on a card or a whole poem. The words need to hold together in a coherent whole, so the key to successful design is positioning, with sufficient space all around – margins are all-important. Then you should consider the overall shape made by the cluster of writing: is it well-balanced, or does it bulge or drift unintentionally to one side? Finally, ask yourself if one word or group of words deserves special treatment for a focal point, perhaps by making it larger or bolder.

Function

Consider how the end product is to be read and test your trials by standing away from the work at the expected distance – from across the room if it is a poster. You will soon see whether adjustments in size and weight of the writing are necessary, or in its placing on the page.

For a name on a place card, make sure the writing is bold enough to be seen from standing by the table. Words inside a greetings card or in a book can be smaller, as they will be read at less than arm's length.

When working with a quantity of text, sort out what is most important and arrange it into logical groupings. For visual interest, consider varying the weight, size or placing of these groupings. If it is to be eye-catching, select one or two words to be written with impact; design the remainder in a secondary weight and size for reading more slowly once attention has been caught. Beware of choosing too many things to emphasize – they will cancel each other out.

Sketches and paste-ups

The traditional method of planning a layout is to use "thumbnail sketches". Use a soft pencil or a thin marker pen and sketch out lots of different ideas. Consider horizontal ("landscape") and vertical ("portrait") layouts, try emphasizing different words, and experiment with contrast in sizes. All the time look at the overall balance of the design and notice how the white space helps or hinders the design. Once you have put a few ideas on paper, write out the entire text on practice paper so that you can see the volume of words you are dealing with. Then cut the lines of text up and move them around until you have a satisfactory first layout. Try landscape and portrait designs.

When planning a layout, write out the text.

Cut up the lines of writing.

Arrange the lines carefully until you have found a satisfactory effect.

Thumbnail sketches for a summer festival – sketch out several ideas with a felt-tipped pen to determine emphasis and balance in the design.

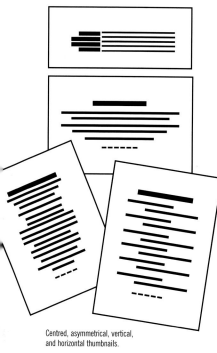

Centred, asymmetrical, vertical, and horizontal thumbnails.

Balance

A centred design is the simplest to balance. This works, whether vertical or horizontal, and is a frequent choice for formal designs such as certificates. The lines of text are balanced when they are approximately the same width, going in and out evenly, perhaps beginning and finishing narrower.

If you need to include a credit line, the poet's name perhaps, then include it in the central lining-up, at one side it will disturb the central balance.

You can be more daring and still maintain balance. Move lines asymmetrically for a livelier design. Look for overall balance; a line pulled to the left should be counterbalanced on the right. Watch the white space, too, so there are no holes in the middle of the design.

Margins

Always leave a space around all four sides of the text, to help the eye to see the whole shape. There are exceptions to this – for example, if you want to "bleed off" the edge for impact. Start by following the rules, then break them consciously if you are aiming for a particular effect.

Allow more space at the bottom, to stop the design seeming to sag on the page, and keep approximately the same width of margins at sides and top. For a vertical design, allow extra top margin; for horizontal designs allow extra side margins.

When you have sketched out some thumbnails, look at the gaps within the design and compare them with your margins. If the gaps are bigger, they will separate the areas of text, and this can spoil the design, unless you were planning to use the gaps for impact.

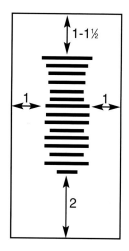

A standard balanced layout would have generous spacing at sides and top, with twice as much at the bottom.

Contrast and emphasis

Use different sizes, styles or weights of text for more visual interest. Consider the following:

- Heavier weight against lightweight
- Even quantities for balance or differing amounts for contrast
- Large against small. For emphasis, quantities of each should be different
- Two contrasting styles
- Capitals with lower case
- Formal against freeform
- Upright against sloping
- Opposing positions
- Employ the white space as a valuable tool
- Different colours
- Opposites: light against dark, warm against cold
- … and any combination of these

The contrast in weight gives emphasis to the text.

Examples of contrasting lettering

Design extras

Sometimes the design requires the addition of extra visual elements, such as logos, heraldic emblems, drawings, or borders. These must be designed into the layout from the start, not added to fill a hole, as they need to be considered and balanced with the writing.

Ask yourself if the extra element is really necessary, or whether re-designing the calligraphy for more impact might be more successful. If it is necessary – the client's logo on a certificate, for example – then take care to give it consideration by trying it out in different sizes and positions, just as you would with the text.

Beware of borders: they can overwhelm the calligraphy. They can look fussy or distracting. Keep them simple, particularly when you are first learning, and confine yourself to ruled lines of differing weights and distances, or simple repeat patterns. Always treat them as part of the design, along with the text, not as an afterthought. When you have your rough design drawn up, ask yourself if the border adds to the design or detracts.

Try to ensure that decorative features complement and balance the text areas.

Left to right: text and border fighting; text losing the fight; text wins.

Assembling the information

Posters and information sheets often contain a wealth of text, all of which the client feels is essential to emphasize, but somehow it has to be prioritized. If every word shouts, nothing is heard. Check the order of importance – for example, the What?, Where?, When? and Why? – and see which of those needs the most emphasis. Graduate the rest in size, weight, or placing. Group together blocks of information to make it easier on the eye.

Poetry and prose by comparison offer a simple task of perhaps treating the title separately from the main text. But having looked at what can be done with posters, you might like to be more adventurous. Explore the possibility of emphasizing some text within the poem instead of the title. But take care not to overdo it and make it a confused design. Keep asking yourself: does this improve it? Does this enhance the meaning?

Calligraphy gains impact by the way you place it on the page. If you are inexperienced in layout, play safe at first and keep your design simple, allowing the calligraphy to speak for itself. Developing more ambitious designs will come gradually, particularly if you observe the work of more experienced calligraphers and try to analyze how and why it is successful.

There is never just one solution to a design problem!

Posters need to grab attention, so dynamic layout is essential.

The hands

The 100 scripts demonstrated in the following
pages have been generally placed historically,
beginning with ancient Rome. The reader will,
however, find many modern versions included in
the historical sequence where these directly
relate to the historical scripts. A further aspect
is the inclusion of modern letters where none
may have previously existed, such as the "j",
"u" and "w"; also, the modern form of "s" has
been used throughout.

The hands selector

Roman

The Trajan and Rustic capitals are known to us chiefly through their use as inscription letters, although the Rustic was also used as a manuscript hand. The Uncial is of a slightly later date, the second century A.D. The Square capital, a manuscript hand but deriving from the inscriptional letter is later still, from the fourth-fifth century. Very few examples of this hand survive.

ABC
page 42 The trajan alphabet

A B C
page 44 Roman capitals, modern 1

A B C
page 46 Roman capitals, modern 2

a b c
page 48 Roman minuscule, modern 2

Λ B C
page 50 Rustic capitals

a b c
page 52 Rustic minuscule, modern

Λ B C
page 54 Square capitals

a B C
page 56 Uncial

Post Roman

These hands were in use from the sixth to the eleventh century. The Caroline minuscule, a modern looking hand, is the most significant. The Foundational Hand, devised in the early twentieth century as a calligraphic teaching hand, derives from the English Caroline minuscule.

α b c
page 58 Half-uncial

a b c
page 60 Caroline minuscule

a b c

page 62 Free caroline minuscule, modern

A B C

page 64 Free caroline capitals, modern

a b c

page 66 Foundational hand

A B C

page 68 Foundational capitals

α b c

page 70 Beneventan minuscule

Λ B C

page 72 Beneventan capitals, modern

u b r

page 74 Luxeuil minuscule

X B C

page 76 Luxeuil capitals, modern

Insular

The term Insular derives from the Latin *insularis* meaning of, or relating to, an island, and is used with regard to scripts from the British Isles in particular. It was here that the writing hands evolved away from the mainstream influences of continental Europe in the early Middle Ages. The most spectacular of these scripts was the Insular majuscule, more correctly known as the Insular Half-Uncial. The Book of Kells and the Lindisfarne Gospels are the supreme examples.

α b c

page 78 Insular majuscule

λ B C

page 80 Artificial uncial

a b c

page 82 Insular pointed minuscule

a b c

page 84 Saxon square minuscule

Gothic

Gothic scripts developed in northern Europe, in probably something less than a decade, in about 1200. These were preceded by the Proto-Gothic scripts deriving from the Caroline and Insular minuscule. The Quadrata scripts are easily recognized by their severe angularity and compression and were the hands of Bibles and prayer books. The secular hands for legal documents and commerce are cursive and designed for writing at speed.

page 86 · Proto-gothic minuscule

page 88 · Gothic textura quadrata

page 90 · Gothic quadrata prescisus

page 92 · Pointed quadrata minuscule

page 94 · Gothic minuscule, modern

page 96 · Gothic capitals, modern

page 98 · Gothic capitals 1

page 100 · Gothic capitals 2

page 102 · Gothic skeletal minuscule

page 104 · Gothic skeletal capitals

page 106 Gothic versal capitals

page 108 Lombardic capitals

page 110 Lombardic versals

page 112 Secretary hand

a b c

page 114 Secretary hand, modern

abc

page 116 Secretary capitals

a b c

page 118 Fraktur minuscule

ABC

page 120 Fraktur capitals

page 122 Fraktur flourished capitals

abc

page 124 Schwabacher minuscule, modern

ABC

page 126 Schwabacher capitals, modern

a b c

page 128 Batarde

ABC

page 130 Batarde capitals

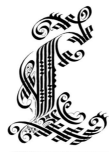

page 132 Cadeaux or Cadel

Renaissance

The Humanist Renaissance scripts were probably first developed in northern Italy by the poet and academic Petrarch in about 1350. By 1400 their use was widespread in Italy, as was their cursive first cousin, the Italic. By the end of the century the position of both hands was further secured when the Venetians used them as a model to cast their typefaces. Further refinements were incorporated in the mid sixteenth century when the scripts were adopted by the Papal Chancery in Rome.

page 134 Humanist minuscule

page 136 Italic

page 138 Italic capitals

page 140 Italic flourished minuscule

page 142 Italic swash capitals 1

page 144 Italic swash capitals 2

page 146 "Johnston" italic minuscule

page 148 "Johnston" italic capitals

page 150 Cancelleresca formata

page 152 Cancelleresca corsiva

page 154 Cancelleresca capitals

page 156 Rotunda minuscule

page 158 Rotunda capitals

page 160 Rotunda capitals, dual stem

page 162 Roman capitals as versals

Baroque

Use of the Renaissance scripts and the Gothic cursive scripts continued in this period, but there was a significant development derived from the cursive hands, and in particular the Italic, which satisfied the need for both clarity and speed. The Copperplate or Roundhand developed in England and quickly spread throughout the English-speaking world.

page 164 — Copperplate, Italian hand

page 166 — Copperplate, English roundhand

page 168 — Copperplate capitals

page 170 — Copperplate flourished capitals

Modern

The modern period really began at the beginning of the twentieth century with the re-discovery of calligraphy by such pioneers as Edward Johnston in Britain and Rudolf Koch in Germany. This paralleled the varying demands of the advertising industry and the demand for increasing novelty in type design and the innovations made possible by dry-transfer lettering. The later part of the twentieth century saw new and radical ideas emerging in the expressive uses of calligraphy with many conventions being challenged.

page 172 — Neuland minuscule

page 174 — Neuland capitals

page 176 — Roman minuscule, pointed nib

page 178 — Roman capitals, pointed nib

page 180 — Open roman capitals

page 182 — Brush script, broad-edged minuscule 1

The trajan alphabet

Taken from the inscription on Trajan's Column erected in Rome in 114 A.D., plus additional characters, this is the most influential capital script in the Latin alphabet. Although it is only one of many inscriptions from this era, it is regarded as the finest example and provides an important model to calligraphers and letterers. From the fifteenth century, when these letters were first seriously considered, until the late twentieth century, there was a belief that the key to drawing these exquisite letters lay in geometry. It was the pioneering work of the American, Father E.M. Catich, that finally showed their origins lay in freely drawn broad-edged brush lettering. These letters are based on his analysis.

ABCDEFGH

IKLMNOP

QRSTVXYZ

Points of interest

These letters set the standard by which other capitals are judged. Serious calligraphers need to know the letters' proportions, as well as the minutiae of the detail.

The pointed "A" (and "M" and "N") were made to facilitate cutting. The more natural ductus is a square top that was also frequently used. Note that there is no serif on the inner right leg.

The "U" is a medieval addition to our alphabet. The proportons of this modern "U" are from the "N".

The "W" is also a medieval addition. This "W" is drawn from two "V"s.

Basic structure

Although these beautiful letters are known to us from inscriptions, they were first drawn with a chisel-ended brush, before cutting. The colours on the letters describe the sequence of strokes: mauve = first stroke, red = second stroke, green = third stroke, yellow = fourth stroke.

Structure	Strokes			Group

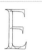

The "E" is often regarded as a defining letter. Once this can be drawn elegantly, the remaining letters should not prove too difficult. A well constructed "E" is arguably a supreme example of the calligrapher's art.

Holding the brush horizontally, begin outer tip of the serif, with the corner of the brush, and move down to the stem.

On reaching the base of the stem, turn your brush to 30° and move along baseline ensuring you leave a fillet.

With your brush at 30°, return to the headline, and move along to the end of the arm, and pivot your brush.

BDFK PR

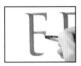

Repeat for central arm. At the end of the arm, pivot your brush between thumb and forefinger.

Move down the serif, lifting your brush at the same time. The arm and serif should be completed in one move.

To make the base stroke, turn your brush over and repeat the arm movement in reverse.

The "R" has the advantage, as an exemplar, of having more parts common to other letters than any other single letter. Notice the gentle swelling at the base of the tail, caused by the slight turning of the brush.

Draw the stem as for "E", but keep the brush horizontal, and finish the right serif on the tip of the brush.

Draw a half-sized semi-circle, stopping short of the stem for the "P".

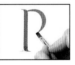

Turn the brush to 30°, and connect the bowl to the stem with a short horizontal stroke.

BCDG HOPQ S

At the point of connection, begin the tail.

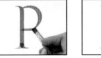

As you move down the tail, slowly turn your brush to the horizontal.

To finish the tail, move gently along the baseline and lift your brush.

Roman capitals, modern 1

These pen capitals derive from the classic inscriptions of ancient Rome, with subsequent modifications dictated by the use of modern materials. Pointed serifs are replaced by italicized slab serifs, and greater use has been made of curved strokes. The weight has also been increased, although you may wish to vary it.

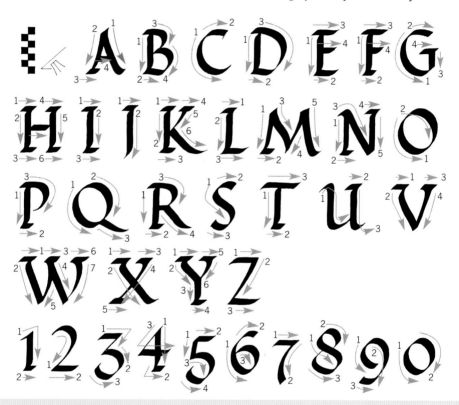

Points of interest

The capitals can be used successfully without the accompanying minuscule. The bold serif makes it possible to dispense with the fillet used in the classic form.

The "E" can be made with the stem cut away leading into the serif, or by joining the arms to the stem with fillets.

All the circle-based letters have thin joining strokes.

Try altering the pen angle to increase the shading and the variation between thick and thin strokes.

Basic structure

This alphabet is pen-drawn and consequently has a more rigid structure than the brush-drawn prototypes. The letterforms are more formalized, and serifs are bold rather than pointed.

Structure	Strokes			Group

The curving legs and the thin base of the left leg lends a degree of informality to this letter.

With the pen at 40°, draw the curved right leg.

Keep the pen at the same angle to draw the left leg; this will give a thinner stroke.

Still with the pen at the same angle, draw the serif and centre stroke.

U V W Z

If you include a serif at the top left side of the "N" make sure you include one on the "M".

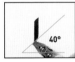

The stem starts below the headline and ends short of the baseline. Add a flat foot serif.

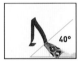

The centre diagonal can be curved or straight. If straight, add a head serif on the left.

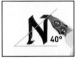

Draw the right stem and finish off with the head serif.

H K M X Y

Notice that the tail of the "R" follows an imaginary diagonal from the tip of the top serif.

Keep the pen at the same angle to draw the stem and the foot.

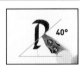

Lift and draw the bowl of "P". This can stay short of the stem.

For "R" connect the bowl to the stem. Then draw the tail.

B C D E I J L P T

This is a formal letter, but the freedom of the pen is still evident where one stroke sweeps into another.

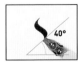

Draw the centre diagonal stroke first. It should not touch the head or baseline.

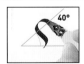

Add the curving head stroke. It should be short and not protrude into the centre stroke.

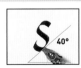

The lower stroke starts at the outer vertical. It must be well tucked so as to appear compact.

G O Q

Roman capitals, modern 2

These Roman capitals derive from letters used in ancient Rome. They closely follow the proportions of these letters but have been modified for pen writing. The letters can be used as display capitals. but will work equally well as medium- or small-text letters. Two types of serif formation are shown.

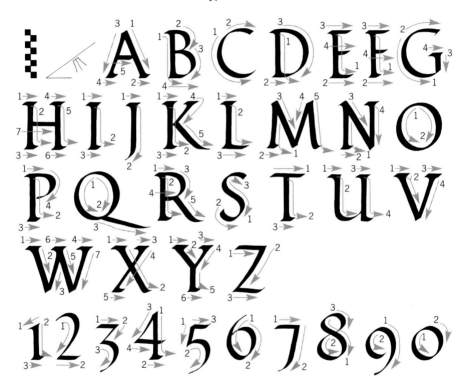

Points of interest

The serif on this alphabet can be varied.

The serifs of this "A" and "B" have been made with the pen held horizontally, and produce a serif much closer to the inscribed letter.

Notice the top serif of "S": this was made with the top arm starting at 35° and, on reaching the end of the stroke, pivoting to the vertical.

Basic structure

These are text Roman letters and designed to be written with an economy of strokes (as opposed to versals or built-up letters). The principal differences between these and inscribed letters is the greater degree of shading and the serif formation, which is bolder. In this alphabet all the serifs are bracketed.

Structure	Strokes			Group

 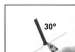

KMNR VWXY Z

The small fillet at the bottom of the right leg and the serif is more suggestive of an inscription letter than a pen-drawn one.

Begin by drawing the right leg, but curving to the right on the baseline producing a small fillet.

Now add the left leg and on reaching the baseline gently turn to the left.

With your pen still at 30° add the two serifs on the baseline. Complete with the cross stroke.

 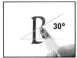 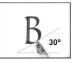

DEFHI JKLO QR

The top bowl of the "B" is noticeably smaller than the bottom bowl. Compare this to the bowls of "P" and "R".

Begin the stem with a small curve at the headline. On reaching the baseline make the curve more generous.

Starting at the first curve at the head of the stem make the upper bowl, stopping short of the stem.

Complete the lower bowl by joining the first stroke. From the left of the stem, add a serif.

 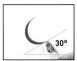

CQU

Notice the way in which a serif has been formed, twisting the pen to the vertical, simulating the brush.

Make a semi-circle. This is also the first stroke of "O" and "Q." Note the diagonal stress.

Return and make a headline stroke. On reaching the end twist the nib to vertical and lift.

Draw a short stem to connect the end of the first stroke. Finally, add a horizontal serif.

CEFG TZ

A small extra fillet may be added between the right of the base of the stem and the serif.

Draw a horizontal stroke at the headline. You can start below and end above the headline.

Draw a vertical stem turning slightly to the left of the base.

Complete with a small serif at the baseline.

Roman minuscule, modern 2

This minuscule alphabet has been designed to accompany the modern Roman capitals and is an excellent hand for more formal writing. Use the same pen for both capitals and minuscule.

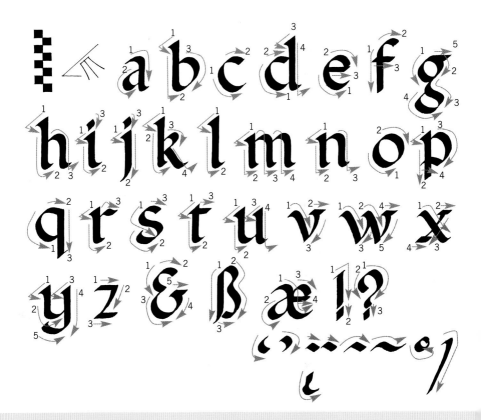

Points of interest

The letters are devoid of any individual excesses. In many respects this is a script most similar to type.

A slight slope will give the letter a less formal look. Use good but not excessive letter-spacing.

Note the characteristic carefully drawn wedge serifs.

Although ascenders and descenders may be increased to double x-height, it is common practice in modern work to reduce them.

Basic structure

The stems are straight and the bows are full. No letter has any greater emphasis than its neighbour and, as in many similar letters used as typefaces, legibility is of prime concern.

Structure	Strokes			Group

The bowl of the "a" is relatively generous. It is kept as low on the stem as possible.

Place the pen on the page at a 35° angle.

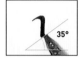

Carefully arc into the stem, keeping the stem upright.

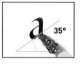

Starting one-third down the stem make a clear rounded bowl.

v w x z

The wedge serif is an important feature. It requires practice, but once acquired it is very satisfying to execute.

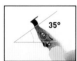

Make a small downward dash and a small curve back into the stem.

Starting at the beginning of the dash, make a straight stem, hooking at the bottom.

Lift and make a generous bowl, connecting to the hook.

d f h i j k l m n t u

The sweeping tail is unique to the "g". It is important to keep the top bowl small.

Make a fully rounded "o" shape. This will be the same proportion as the full "o" but smaller.

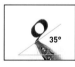

Continue the arc in a sweeping stroke to form the right side of the lower bowl.

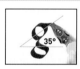

Complete the left side of the lower bowl and, finally, add the ear.

c e o s

The bowl is a full rounded arc. A serif can be added at the foot.

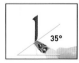

Start with the same stroke as the "b" but at the top of the x-height.

Add the tail, return and add a fully rounded bowl, finishing short of the stem.

The stem is connected to the bowl with a straight stroke.

q r y

Rustic capitals

These capitals date from the first century A.D. and were widely used throughout the Roman Empire until the eleventh century. The letters were either painted with an edged brush or pen-written as a manuscript hand for classical texts.

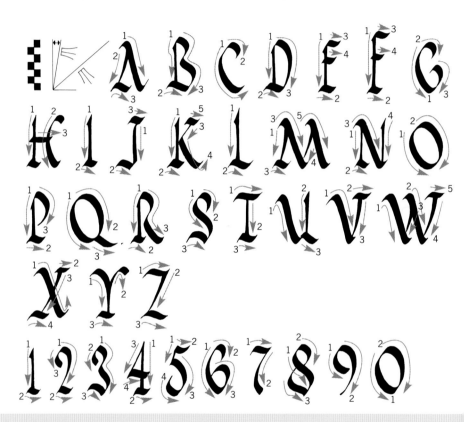

Points of interest

The letter is unique in that the straight stems are drawn with the pen held at or near to the vertical. The foot is very pronounced, producing a consistent rhythm across the page.

The "F" and also the "L" rise above the headline in order to differentiate them from "E" and "I".

Hold the pen between the vertical and a maximum of 10°. The thinner the stem, the greater the emphasis will be on the foot.

The slope of the upper curve of "D" will echo and follow the same angle as all other curves.

Basic structure

The dominant features of the Rustic capital are the unique thin stem and the bold foot coupled with the diagonal sweeping curved strokes. Although some individual letters may seem unattractive, the rhythm and flow of words when written as text makes the alphabet a very attractive calligraphic text face.

Structure	Strokes			Group

Remember to make the pen angle steeper as it moves to the left leg.

Make a fairly steep right leg of the "A", hooked at both top and bottom.

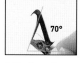

Holding the pen in a more upright position, make a tapering stroke for the left leg.

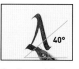

Keep the pen at the same angle to make the bold foot. Ensure all feet are at this angle.

N U V W X Y

A consistent angle is maintained. Allow the natural rhythm of the wrist to dictate the angle of the pen.

With your pen held at 50°, make a backward-sloping compressed arc.

Return to the head and make a tight downward sweep.

Return to the base and add a generous foot.

I O Q

You can increase the pen angle to 90° for a thinner stem.

With the pen at about 50°, move downwards and outwards and curve back into the stem.

At this point the pen may be vertical or no less than 50°. Make the stem and foot.

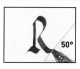

Return to the head and make the bowl and tail in a single stroke.

B D E F H I K L P T Y

The angles of the "S" show very little variation. Rounded strokes are inclined.

Keep the centre stroke of the "S" narrow.

Return to the head and make make a very tight downward sweeping arc.

At the foot, move along the baseline, connecting to the centre stroke with a generous arc.

C G Z

Rustic minuscule, modern

Designed to accompany Roman Rustic capitals, these letters use the same narrow vertical stem to contrast the downward sweeping foot and bold diagonal of the curved strokes. Historically, the Rustic capital would have been used alone, but these minuscule letters increase the options for modern usage.

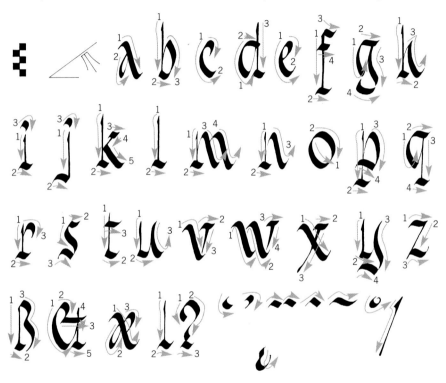

Points of interest

The letters are generally compressed and closely follow the ductus and letterform of the capitals.

Hold the pen at 0–10° to draw the stem. The narrower the stem, the bolder the foot by contrast.

Downward curving strokes should follow the same degree of slope as closely as possible.

Never put two narrow vertical stems next to each other; follow a thin vertical with a bold curving stroke.

Basic structure

The minuscule follows the unique form of the capital, the only script where the stem is drawn with a vertical stroke at 80–90°. This creates an exciting flow to the page, the eye being carried along by the boldness of the feet and diagonally by the boldness of the curving strokes.

Structure	Strokes			Group

The steep angle of the characters in this group follows the angle of the capital.

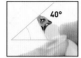

Hold the pen on the page at about 40°.

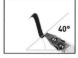

Make a fairly steep right leg of the "a", hooked at the top and bottom.

With the corner of the nib make a loop starting at about the centre of the leg.

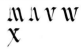

This alternative "f" has been drawn with the foot on the baseline.

Draw the stem at 80°, twisting the pen to 40° to create the foot.

Holding the pen at the same angle, draw a short sweeping stroke at the head.

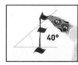

Add the centre stroke starting to the left of the stem.

The stem may be drawn with the pen vertical, twisting slightly as it approaches the foot in anticipation of the serif.

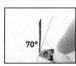

With the pen at 80°, move outwards, twist back to 70° and draw a near vertical stem.

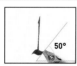

Turn the pen to about 50° and draw a foot.

Make a fairly steep right leg, hooked at the top and bottom. Finish with the tip of the pen.

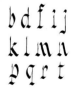

For rounded strokes, hold the pen at an angle of 50°.

Keep the centre curve of "s" as upright as possible.

Keep the top stroke as short as possible.

The bottom stroke extends further and is more generous.

Square capitals

This is a late Roman prestige book hand from the fourth century, clearly derived from classic inscriptions and adapted for text use. Very few examples exist. One reason for the script's short life may have been the length of time it took to write this hand as opposed to the Rustic or Uncial scripts.

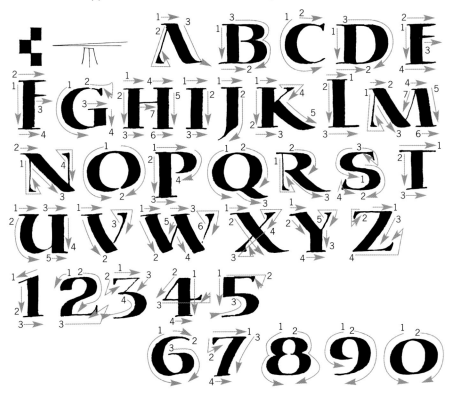

Points of interest

Although the letters seem laborious, as a text hand they have a certain elegance and authority that echoes that of the inscriptional letter.

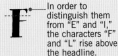
In order to distinguish them from "E" and "I," the characters "F" and "L" rise above the headline.

The "P" has a bold stem.

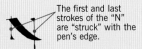
The first and last strokes of the "N" are "struck" with the pen's edge.

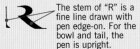
The stem of "R" is a fine line drawn with pen edge-on. For the bowl and tail, the pen is upright.

Basic structure

The letters are drawn with a "straight" pen: one with the nib cut obliquely. This enables the scribe to draw an upright vertical stem, with ends at right angles to the stroke. The letters are bold, written at about three pen widths, and wide, with good spacing and capital size interlinear spacing.

Structure	Strokes			Group

The free sweep of the diagonal strokes is in contrast to the formality of the straight strokes.

With the pen edge-on draw the left leg. This stroke can also be executed using the corner of the nib.

Use the corner of the nib to make a serif.

Return your pen to the horizontal, and sweep out to the right for the diagonal.

KM NVW XY

The "E" has very little to distinguish it from the "F", which has to be made larger to establish a difference.

Hold your obliquely cut pen at either the horizontal or a maximum of 5°.

Without altering your pen angle, draw the three horizontal strokes.

The horizontal arms are without any serifs.

BDF HIJK LPT

The reasons for the fine first stroke of the "R" is something of a mystery and goes against historical precedents.

The first stroke of "R" is a thin stroke. Draw this as the "A" with the flat of the nib.

Return the pen to horizontal, move to the left of the stem and draw a serif following through into the bowl.

Continue the previous stroke down to the right to make a tail similar to "A".

BMN VW

Using an obliquely cut nib makes it difficult to draw the usual bold spine. Note the inward-pointing bottom serif.

Make a half-sized arc starting at the headline.

Move to the right creating a thin spine. Draw another half-sized arc to the baseline.

Complete the terminals with two serifs drawn with the corner of the nib.

BOQ

Uncial

Originating in the second or third century, this was the script of the early Christian texts and is a Latinized adaptation of the Greek Uncial. The origins of our minuscule letters can be detected in this script, with some letters rising above the headline while others descend below the baseline.

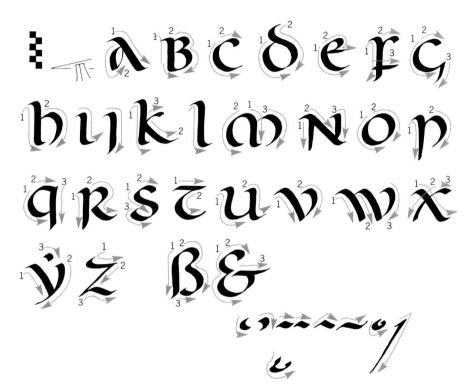

Points of interest

This script evolved as a practical and speedily written hand. These smooth unlaboured qualities should be retained in modern use.

The lead-in stroke flows easily into the stem, while the exit stroke leaves the stem without undue formality.

This form of "n" did not evolve until the Caroline minuscule, but is more useful for modern use.

The cross of the "f" occurs at the baseline and has a rudimentary descender.

This less cursive "e" was sometimes used on the more slowly written prestige manuscripts.

Basic structure

This script was originally written with a "straight" pen, one with the nib cut at an oblique angle. This enables the calligrapher to draw a vertical stem with the pen at 90°, making head and feet at right angles. If you use a square-cut pen then hold the pen a little off the horizontal.

Structure	Strokes			Group

The "a" is conspicuous by the sloping stem, which became a feature of late Roman and early medieval scripts.

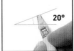

Hold the pen at a very shallow angle.

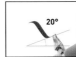

Make a wide diagonal stroke.

Start the bowl one-third down the diagonal. Move down almost vertically and skate back on the corner of the nib.

NVX

This "b" was adapted on later scripts when the top bowl was removed.

Begin by making the letter "i" but with a generous turned foot.

Return and make the top bowl to convert the "i" into a "B".

In a continuous stroke, link the bowl to the bottom foot.

fbi jklp R

The "g" is extremely simple in structure, it is a "c" with only a suggestion of a tail.

Start the letter by making a wide arc.

Return to the top of the arc and make a simple half arc.

The tail is a simple single stroke pointing to the rear.

cde moq τ

This "w" is a modern addition and provides an alternative to the "w" opposite.

This is the basic "i" stroke.

The "i" stroke appears again in the double form to make "u".

A simple addition gives us "w".

u

Half-uncial

This script was the precursor to the Caroline minuscule. The differences in the characters are the "g" and "r" and most noticeably the "n", which takes the form of a capital. The other significant difference is the use of an obliquely cut nib, which enables the stem to be drawn "straight" with a minimal pen angle.

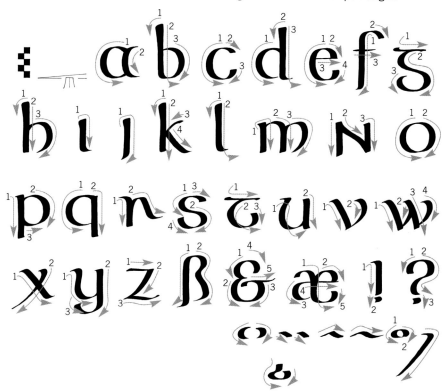

Points of interest

The ascenders have a clubbed serif. The "a" takes the shape of a conjoined "oc", although for modern usage the "a" takes an Uncial form when conjoined to "e".

It is advisable to retain this "n" for authenticity.

This alternative "g" is less readable in . modern use. Both "g"s begin from a bar.

This alternative "r" is acceptable, especially in modern use.

Basic structure

This is an upright small text letter. The upright stems and thin horizontals give the script a formal appearance. The obliquely cut pen is held as closely as possible at right angles to the stem.

Structure	Strokes			Group

Hold the pen as close to the horizontal as possible when creating this letter.

To make an "a", draw a semi-circle beginning to the right of centre.

Return to the top and make a small curve to the right. Close the jaws with a further arc.

The "pushed" pen will help to create the distinctive "clubbed" serif.

Start above the x-height and push the pen upwards and outwards.

Move across to head of stem and pull downwards with the pen horizontal. Finish the stroke with a tail.

Move to the top of the x-height and make a full bowl, keeping the pen at the same angle.

This sequence provides an alternative lead-in stroke for "l", "j" and "m".

For an alternative lead-in stroke, move across horizontally at the top of the x-height and down into the stem.

Return and make a slightly looping second stroke. This will also give an alternative "n".

For the final stroke make the loop fully curved, keeping the pen flat.

This small "t" remained the standard until the twelfth-century Proto-Gothic scripts created the modern form.

Begin the stroke with a slight twist above the line, finishing with a slight twist below it.

In a continuous stroke, move backwards to draw a full arc.

Move to the right at mid x-height and connect a half arc to the full arc.

Caroline minuscule

This reformed Half-uncial hand was developed during the late eighth century at Charlemagne's scriptorium at Tours. The hand is of major importance as our modern minuscule characters can be traced back directly to this script, the different letter being the "t".

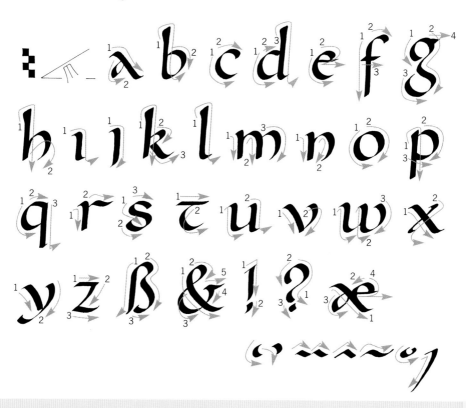

Points of interest

The ascenders have clubbed heads and are equal to the x-height (smaller in modern use). The "r" is wide, and the "j" and "w" are modern additions.

In modern use, this form of serif is sometimes substituted.

The letters flow naturally, with no single letter standing out more than its neighbour.

Do not allow the "s" to become too narrow – pull out the centre stroke.

The wide "r" is balanced by the wide and open "a". Together they produce distinctive word patterns.

This traditional "t" can be replaced by a modern "t".

Basic structure

The Caroline minuscule is a small text hand, wide in appearance and used with generous line spacing. The important innovation of this hand was to cut the quill at right angles and write holding it at a fairly consistent 30°+. The letters show a distinctive forward slope and have an easy fluency.

Structure	Strokes			Group

The ascenders on the continental Caroline are relatively tall at about two x-heights.

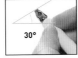

30°

Hold the pen at an angle of 30°.

30°

The club head of the ascender can be formed by pushing the pen upwards and then down into the stem.

30°

Continue the right side of the bowl directly into the tail in a single stroke.

The top bowl of "g" is also circular, but smaller than the "o".

30°

Make a wide semi-circular left arc.

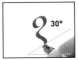

30°

Return to make the right arc and continue into the lower linking stroke. Add the lower open bowl.

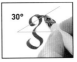

30°

Add the ear to the right side of the top bowl.

The "tucked-in" tail is a distinctive characteristic and also occurs on the "h".

30°

The stem of small letters begins with a hooked lead-in.

30°

Usually the final stroke is tucked under, although it may also be hooked away towards the next letter.

30°

The "m" follows the pattern of the "n", but repeat the first stem before tucking under the tail.

Keep the "s" wide by pulling out the centre stroke.

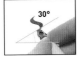

30°

Begin with the centre stroke and slope slightly downwards from the horizontal.

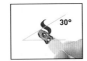

30°

Tuck the tail under the centre stroke.

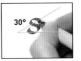

30°

Return to the top and complete the "s" with a short head stroke.

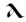

Free caroline minuscule, modern

This freely drawn script derives from the Caroline minuscule. It differs from it in the increased slope of the letters, the extension of the ascenders and even more on the descenders, in particular the "g". The letterforms of "a", "f", "p", "t", "w" and "y" also show variation, but the clubbed serifs are retained.

Points of interest

The letters are cursive and have an easy rhythm, the tall ascenders punctuating the small body of the letter.

This alternative "n" has a turned foot based on the proportions of the "a".

These more formal forms of "f" and "g" can be substituted where an interlinear clash is likely to occur.

Use a ligature whenever possible where "t" follows "s".

Basic structure

These letters have been drawn at four pen widths. The boldness this proportion suggests is negated by the letters' generous width. The apparent lightness is further emphasized by the tall ascenders, which are more than double the x-height.

Structure	Strokes			Group

The "a" sets the pattern for many of the other letters in this hand. Note the width and the generous volume within the counters.

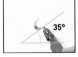

With the pen at 35°, make a wide loop.

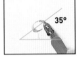

Move back to the headline and extend the top stroke.

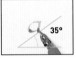

Draw the stem with a turned foot, making sure the counter is wide and not compressed.

The ascenders should be at least equal to the x-height, and the clubbed head tends to be rounded.

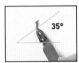

This is a wedge serif. A clubbed serif is made with the same ductus, but with a rounded and upward movement.

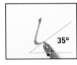

Draw the stem and give a wide sweep to create the lower part of the bowl.

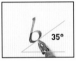

Complete the bowl with a wide sweep. Make sure that the counter has the same volume as the "a".

The open bowl is small and in contrast to the sweeping open tail. This may be reduced if space is insufficient.

The first loop of "g" is smaller than the x-height.

The link leads directly from the right loop; in this instance, it is more than three x-heights.

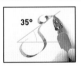

Add a loop to join the link; in this instance, the loop is not enclosed. Add an ear.

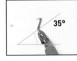

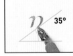

The "m" also gives the "i", "h", and "n". Note how the final stroke tucks under the letter.

This is the first stroke of "i", "j", "m", "n" and "r".

The second stroke of "m" is parallel to the stem.

To make "h" and "n" and the final stroke of "m", curve the stem and tuck under.

Free caroline capitals, modern

These free capitals, designed to accompany the Free Caroline minuscule, are also generously sloped forward at 15°. The cursive character is expressed in the use of swashes and flourishes, although "G", "J" and "Q" also descend below the baseline while the tails of "K" and "R" are allowed to extend forward.

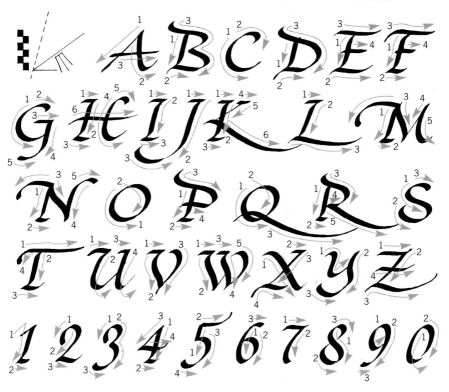

Points of interest

The top bowl of "B", "D", "P" and "R" arches upward and the tail of "J" sweeps below the baseline.

The "A" and "H" are here treated more formally, with the stems terminating in a serif.

In this "P", the top bowl loops over the stem. If this form is used, it should also be applied to the "B", "D" and "R".

The arms of a letter can be modified depending on spacing requirements.

This is an "M" without swashes; the same can also be applied to the "N".

Basic structure

These letters have been drawn at six pen widths and have a forward slope of 15°. The pen is held at 35°. The stems spring from the right of the top serif and finish at the left of the bottom serif. Optically, this suggests an even greater forward slope.

Structure	**Strokes**			**Group**

The combined effect of the 35° slope of the left leg and the 35° pen angle produces a hairline stroke.

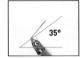

The left diagonal of the "A" has been drawn as a single downward strike, creating a sense of immediacy.

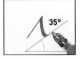

The right diagonal is slightly curved with a sweeping turned foot; this also helps the forward thrust.

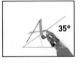

The cross-stroke cuts through both diagonals.

The top stroke of "B" extends beyond the stem and curves upward, in contrast to "M" and "N".

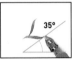

Begin the stem of "B" just below the headline. Generously pull out the bottom stroke of the bowl.

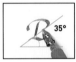

For the alternative top bowl, start well to the left of the stem and sweep over in a continuous movement.

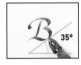

Connect the upper and lower bowls, making sure the counters are generous.

This form of "I" can be adapted to fit any straight-stemmed letter. It is ideal for starting a sentence or paragraph.

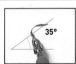

The swash can be added before the stem of any letter starting with a serif.

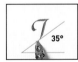

Either sweep the stem from the termination of the swash, or draw down vertically.

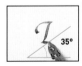

This alternative "I" has a swash – this letter now has almost versal qualities.

To achieve the relative width on the "S", pull out the spine, only allowing a shallow curve.

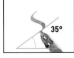

Begin the letter "S" with the spine.

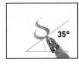

Then add the lower baseline stroke.

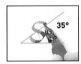

Follow with the upper stroke, retaining the angle of the slope.

Foundational hand

This basic teaching hand was devised by Edward Johnston in the early twentieth century. The hand was adapted from a tenth-century English Caroline minuscule, the Ramsey Psalter, now in the British Library. This manuscript was selected as an exemplar because of its clearly defined characters.

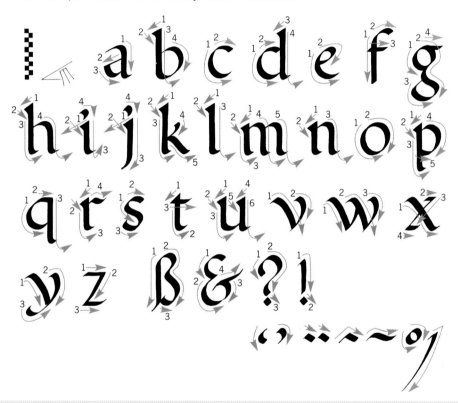

Points of interest

The characters have a consistent x-height and ascender height. They have an even weight and regular width, with no letter dominating.

The top bowl of the "g" should never occupy the full x-height.

The top of the "t" is only raised slightly above the x-height.

This alternative foot to the "p" can also be used on "q".

The centre stroke of "s" is nearly horizontal.

Basic structure

The "i" and "o" are the key letters to this script: the "i" defines stroke width and serif formation, while the circular "o" defines letter width. The pen is held at 30° and all of the strokes are made with a forward movement of the pen. There are no pushed or "skated" strokes.

Structure	Strokes			Group

The round "o" will dictate the proportions of many of the other letters.

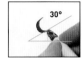

Start with a full half circular arc. Note the backward-inclined axis.

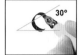

Repeat the arc in reverse on the right.

Join the arcs where the first stroke terminates, making the letter as round as possible.

c e p q

The first stroke of the "n" is the same as for the "i". Note the clearly defined serif at the start of the letter.

From the top of the x-height, make a short diagonal stroke to the left.

Without altering the angle of the pen, return to the stem. Draw the stem, with a rounded foot at the baseline.

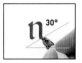

Arch into the right stem and turn the foot, as with the first stroke.

abdh
ijkl
mrtu

The top bowl of the "g" is circular, like the "o", but noticeably smaller.

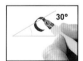

Starting at the top of the x-height, make an "o" but a smaller one than a full "o".

From immediately below the right side of the bowl, draw a curved linking stroke.

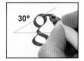

Draw an arc to the left to enclose the lower bowl. Finally, add the ear to the right of the upper bowl.

f

Because the "o" is wide, the "s" should also be as wide as practical. Make a long central stroke.

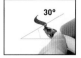

Begin the "s" with a wide, gently sloping central diagonal stroke.

With a tight, curving stroke, tuck under a short tail.

Return to the top of the x-height and complete the letter with another tight, curving stroke.

y z

Foundational capitals

These capitals have been designed to accompany the Foundational minuscule and, although distinctly Roman in structure, their proportion and scale is dictated by the minuscule. They can, however, be satisfactorily used alone without the minuscule. Their structure is basic and formal.

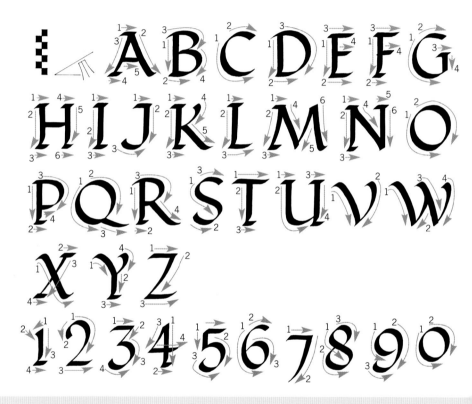

Points of interest

The capitals mostly use the slab serif. The letters are equal to, or just below, the ascender height of the minuscule.

Keep the pen at 30°. If the angle is too steep, the serifs will be too heavy and the stem too light.

If the down stroke of "Z" is too light, either alter the pen angle or add a horizontal centre stroke.

Make the bowl of "R" generous, half the stem height, and avoid excessive length to the tail.

This alternative tail to the "Q" helps to reduce the internal space.

Basic structure

It is best to learn this script in conjunction with the minuscule. The serifs are slabs, with a hook on the right of "A", "K", "M" and "R". Practice the structure of these letters by tying together two pencils. Once you are familiar with the proportions, angles and forms, it will be easy to use a square-edged pen.

Structure	Strokes			Group

The "I" forms the basis of all the straight-stemmed letters.

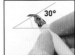

Hold the pen at 30° and make a short horizontal slab serif.

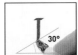

Draw the stem, finishing on a narrow, left diagonal.

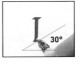

As you reach the baseline, move right and draw the foot serif. (Notice the small nick at the base of the stem.)

B D H J K N P R

The wide "S" has gently arcing head and tail strokes.

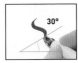

Keep the "S" relatively wide by beginning with a wide centre stroke.

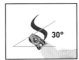

Make sure the tail is well tucked in.

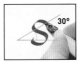

Finish with a short top stroke.

CGOQ

Perhaps the most distinguishing feature of the "T" is that it is the least obtrusive character in any of the hands.

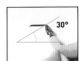

The top stroke of the "T" is straight, rather like an extended serif.

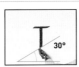

Begin the stem stroke at the top of the horizontal to conceal the join created by the pen angle.

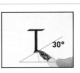

Add a serif at the foot of the letter.

E F

The curve of the "V" (and "A", "M", "W" and "Y") is a counter-balance to the straight-stemmed letters.

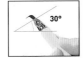

Begin this diagonal stroke with a hooked serif.

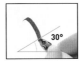

In a continuous movement, arc down to the baseline.

With the pen at the same angle, draw the right side stroke in a more pronounced arc.

A M W Y

Beneventan minuscule

One of the longest-lasting Post Roman scripts, Beneventan was developed in the middle of the eighth century and lasted until c.1300. Its use was most prevalent in southern Italy and centred on the Benedictine monastery of Monte Cassino. These letters have been regularized for modern use.

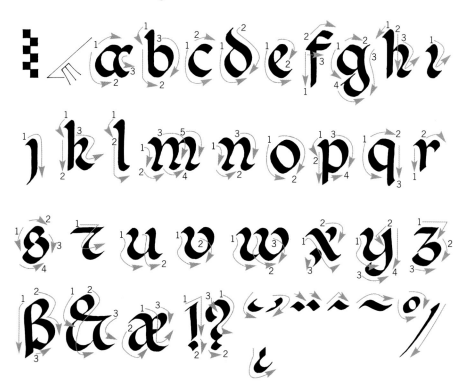

Points of interest

The apparent bold serifs of the minims are created by a twist in the stem at mid-point. This reduces its width, thus making the serifs appear bolder.

The half "r" may be used, but avoid confusion with "i".

The tall "e" is more historically correct and was often ligatured, the ligature stroke leading to or from the cross-stroke.

Keep your round letters full and have a consistent width.

Basic structure

The letters have a formal aspect, characterized by their regular width and a consistent volume of their counters. Ascenders and descenders are restrained in their use and the word is spacing clear and uncluttered.

Structure	Strokes			Group

The single-storey "a", which looks like an "o" and "c" joined together, was a feature found in Post Roman scripts.

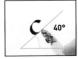

With the pen at 40° make a small upper arc, then return and complete the lower arc to make a rounded bow.

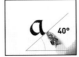

Close the bow with an arc on the right.

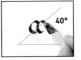

Return to the head and complete with a small arc at the top to make the "a" in the form of an "oc" shape.

c e g o q
ꞇ

The straight upright stem is a characteristic of this hand, the effect heightened by the abrupt turn at the foot.

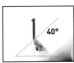

Make a small downward stroke at 40°. Without altering the angle, return and complete the stem.

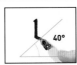

Lift the pen and make a small curved foot.

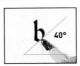

Then enclose the counter with a fully rounded bow.

ẟ f h ꞁ k
l p

The thin waist created by curving the stroke at mid-point makes a bold head and foot, which gives the hand a distinctive texture.

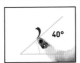

Begin the "i" with a tight downward curve.

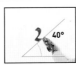

This curve can be repeated in reverse giving a continuous curve or be terminated with a small foot.

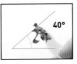

The dot was not used until the thirteenth century; however, you can include it for modern use.

m n r ꞇ u
w x y

This original form of "r" may look out of place in modern work, but will give authenticity in traditional work.

The "r" on the hands opposite is a modern version. Historically, the "r" began with a large downward sweep.

It is followed by a skated upward stroke above the x-height.

It is completed by a short horizontal arc also above the x-height, using the point of the pen.

m x y

Beneventan capitals, modern

These modern capitals have been designed to accompany the medieval Beneventan minuscule and use the same ductus. They have not been designed for single use. One characteristic of the minuscule is the apparent bold headline and baseline strokes, created by reducing the waist.

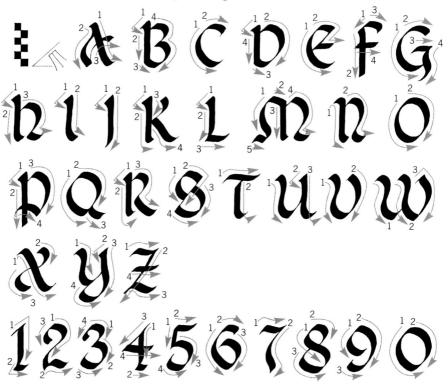

Points of interest

The letters retain the rounded, almost wedge-shaped serif of the minuscule. The upper arcing strokes of "C", "E", "F" and "G" tend to have a forward thrust.

Notice the slight change of direction between bowl and upper stroke.

The rounded serif has been used, the upper bowl springing from below the serif.

The top arm is thrown forwards.

Alternative "M", based on the minuscule "m". Note how the feet on this letter all face in the same direction.

Basic structure

The letters are designed to be unobtrusive. They combine easily with the dominant minuscule and enable the Beneventan letter to be used successfully in modern calligraphy. Wherever possible minuscule characteristics have been incorporated.

Structure	Strokes			Group

The slight change of angle from 40° to 30° also occurs on the "A", "K", "M", "N", "R", "U", "V" and "W".

Holding the pen at 40°, make a short diagonal stroke to the left and then move back into the stem.

Complete the stem by finishing with a rounded foot.

Make an arc that does not quite reach cap height, and a curving stem. Turn the pen to 30° for the foot.

DIJKL MRUV WXY

 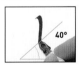 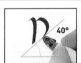 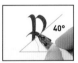

The width of the "O" will generally determine the width of the capitals.

Begin the "O" with a compressed left arc.

Lift the pen and return to the beginning of the first stroke.

Complete the letter with a compressed arc on the right.

CGQ

 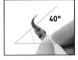 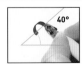

The width of the bowl will be determined by the width of "O".

As an alternative, the "P" can be drawn with a hooked serif. Also, the stem may be slightly bowed.

Return to the top of the stem and make an arc with the same proportion as the "O".

Complete the bowl by beginning to the left of the stem, and making a generous concave arc.

BFR

This is an alternative "S" with the bottom stroke concave instead of semi-circular, as it is opposite.

Make a small arc from the headline, stopping at the midway point.

From the top of the stroke make another half arc. Draw a hairline diagonal to the left.

Make a downward arc between the two arcs. Finish with a stroke from the base of the hairline.

ETZ

Luxeuil minuscule

This is possibly the earliest European minuscule alphabet, dating from the middle of the seventh century and developed in the monastery at Luxeuil in France. It has its origins in the Merovingian Court hand: although retaining its cursive qualities, it has been simplified.

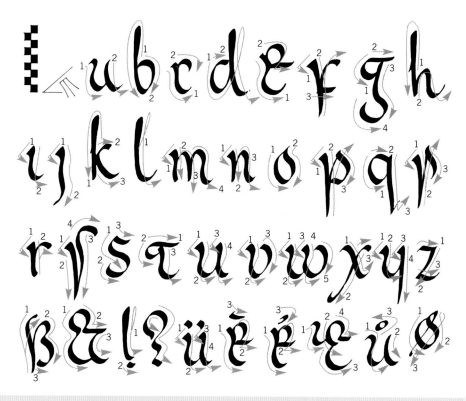

Points of interest

The fully rounded bowls contrast with the narrow letters such as "n" and "m". Ascenders and descenders are long, and letters were frequently conjoined.

The "a" has an open bowl, and in this instance the "b" is ligatured to "c". The "c" is made with a loop coming from a stem.

The "u" (or "v") has serifs, separating it from the "a". The suggested "a" shown here may be more suitable for modern use.

An alternative form of "e". The "e" is a tall letter rising above the x-height and represents a distinguishing feature.

Basic structure

Viewed as text, the impression is of small wavy compressed minims contrasting with the generous bowls of the rounded letters. Tall ascenders heighten the dramatic effect. The use of ligatures is frequent, particularly with the tall "e", and where convenient one letter may tuck in under another.

Structure	Strokes			Group

The cross over strokes are common to all ascenders. The stems terminate in generously rounded strokes.

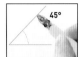

Hold the pen on the page at an angle of 45°.

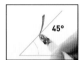

The ascenders are an enclosed loop: Move upwards, then back slightly to the left and down into the stem.

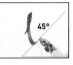

Keep the stem as though it is falling backwards.

The "p" is one of the wider letters. When using a quantity of text, this narrow/wide aspect may be exploited to add a distinctive character to the text.

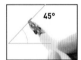

Begin by moving the pen slightly downwards to the left.

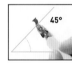

Return and draw the stem, slightly turning the foot to the right.

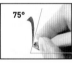

Move out from the stem and draw the right leg, finishing with an upward flick.

Begin with a short downward stroke to the left.

Then sweep back into the stem.

As you move down the stem, twist the pen so it is nearly vertical and finish on a point.

The letters in this script are of varying widths: the "n" is a narrow letter.

Move upwards and outwards to the right with the pen still nearly vertical.

Commence the bowl with an edge and make it wide and "s"-shaped.

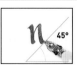

Complete the lower part of the bowl; this may stay short of the stem.

Luxeuil capitals, modern

Capitals were used during this period as decorative chapter or verse openings and based on the Roman capital. They were not used within the text to denote proper nouns or beginnings of sentences. These capitals have been created for modern use with the minuscule and have been designed using a similar ductus, pen width and letter characteristics.

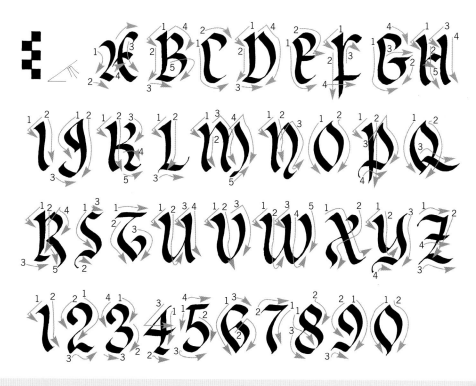

Points of interest

The letters have been drawn with a consistent internal space, avoiding the variations between wide and narrow letters that occur on the minuscule.

The bold serif is made with two strokes; the stem retains its characteristic twist.

Consider this "O", an upside-down version of the one shown above.

The broken arc of "C" and "E" of the minuscule have been retained and adapted for the "G".

Consider bowing the stem of "F" and bringing it to a point below the line.

Basic structure

The impression of the text, with its small compressed minims contrasting full generous bowls, should not be impaired by any emphasis on the capitals, which should naturally blend into the text. If you use the capitals on their own, do so with care – although the ductus you use could form a useful basis for experiment.

Structure	Strokes			Group

A characteristic of this hand is the pointed bow and the pointed, arched linking strokes.

Hold the pen at an angle of about 40°.

Now make a compressed bow ending on a point.

From the head, make the right side of the bowl "s"-shaped with a pointed top and bottom.

 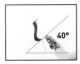 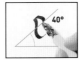 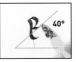

The curving of the stem is reflected in the broken head at the top of the letters.

Move two pen widths diagonally down to the left. Curve back into the stem. End with a foot.

Return to the head and sweep outwards in a wide bow.

Connect the top bow to the stem with a very thin stroke. Finally, draw the centre stroke.

 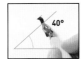 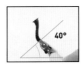 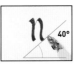

The "N" contains both a hairline between the arch and the right stem.

Begin by making a wedge serif.

Return to the head before making the stem with a slight curve and a rounded foot.

Move upwards from the stem into the right leg. Start with a hairline and end with a turned foot.

The tail of this "R" is shown as an alternative to the inward turning tail of the "R" opposite.

The "R" also starts with a wedge serif. On reaching the baseline turn to the left.

Add a curved serif at the foot, return to the head and add the bowl keeping a pointed bow.

Complete by adding the tail – this is a continuation of the bow.

Insular majuscule

More correctly termed Insular Half-Uncial, this is one of the most beautiful text hands ever produced. Originating in Ireland, southern Scotland and northern England, it dates from the seventh century. Two supreme examples are the Book of Kells in Dublin and the Lindisfarne Gospels in London.

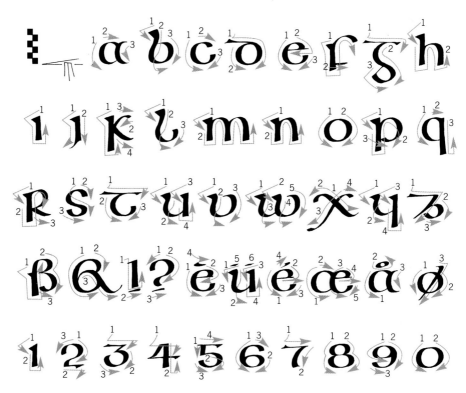

Points of interest

The eye is carried along by the bold serif on the headline. This effect is aided by minimal ascenders and descenders and by generous line spacing.

The "oc" form of "a" is characteristic, but the uncial form is an acceptable alternative.

Alternative forms of both "d" and "h" were frequently mixed within the script.

The letters are even width and weight.

Basic structure

These letters are written with a "straight" nib: a nib cut at an angle so that in writing the terminals are at right angles to the stem. This also produces a contrast between the thick and thin strokes, horizontal strokes being of minimum thickness.

Structure	Strokes			Group

The "o" is the basis for all of the rounded characters. Keep your pen as flat as possible for these letters.

Hold the pen on the page at 5°.

Holding the pen at this angle, make the first half circle.

Make the right side of the bowl. Notice the expanded character of the letter.

The straight-stemmed letters should never be executed with a single stroke. They are always wider at the baseline.

The wedge is pointed. It is made by moving the pen downwards and two pen widths to the left.

Move down the stem, moving slightly to the left and turning the pen horizontal.

Move slightly along the baseline, beyond the stem, before arcing back into the main body.

The darts on the letters in this group will require a lot of practice, but the end result will make it all worthwhile. This script is ultimately the most elegant and studying the reproductions of the Book of Kells or the Lindisfarne Gospels will be very helpful.

The dart will require practice: twist the nib, starting at 10° above the headline.

The dart should go to a point, then move into the horizontal.

Move along the headline, keeping your hand steady.

Make a positive wedge; the top can be horizontal.

Sweep back with a generous left arc to the baseline.

Lift the pen, move to the right and complete the character with half an arc.

Artificial uncial

This elegant script dates from the early eighth century and, as the name suggests, derives from the Uncial script. Its origins can be traced to Canterbury in southern England, although as its influence moved north it came under the spell of the Insular majuscule, which it clearly tried to both emulate and outshine.

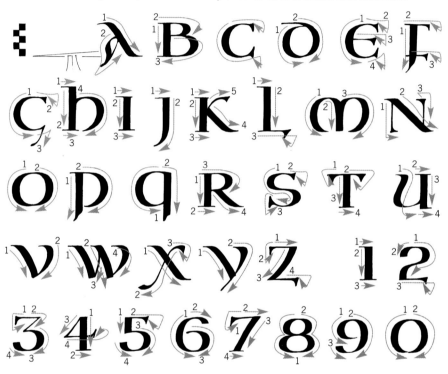

Points of interest

The straight stems with hairline serifs and the raised "L" have similarities to the Roman square capital.

Extending the hairline serif was a device used to fill an empty space. Notice the horizontal terminations of the stems.

This is an alternative "U".

These exaggerated serifs at the head and foot of "L" can also be used on the "H".

This alternative form of "Q" follows the Roman form as opposed to the Uncial.

Basic structure

This script has been written with a "straight" pen, one with an obliquely cut nib. This produces the square terminals to the bold upright stems and gives extremes of thick/thin strokes and hairline horizontal serifs. The full serifs on horizontal terminals are drawn with the corner of the nib.

Structure	Strokes			Group

The "A" is a wide letter with a "pointed" bowl that descends below the baseline.

0°

Start with a short sideward horizontal, holding the pen horizontally.

5°

Strike downwards with the full pen's edge. Add the foot serif.

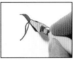

The bowl of the "A" may be drawn with the corner of the nib as a "skated" stroke.

KN

The small serifs on the rounded letters will require practice with the corner of the nib.

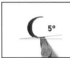

5°

Holding the pen horizontally, draw a semi-circle to the left.

Return to the headline and with the corner of the nib, move along the headline and draw a small serif.

Repeat this stroke again to create a serif at the baseline.

BCOE
ÇOPQ
S

The "H" and "L" rise above the headline and "A", "F", "J", "P", "Q", and "X" fall below the baseline.

0°

Hold the "straight" pen close to the horizontal and make a short stroke above the headline.

0°

Now draw a vertical stroke to the baseline. Add another hairline at the foot. This is the basic stem stroke.

5°

Arc just below the headline and draw a full semi-circular arc.

ოUV

The diagonal of the "N" is close to that of the Uncial "A".

To make the first and last strokes, draw a vertical hairline with the corner of the nib.

5°

Return the pen to the horizontal and draw a diagonal centre stroke.

Add the right leg. Make the serifs by drawing with the corner of the nib and filling in.

ȜCFG
STZ

Insular pointed minuscule

Originating in Ireland in the sixth century, this script was quickly adopted in mainland Britain and by the ninth century was the most favoured Anglo-Saxon hand. It took differing forms, the two most common being the square and the pointed minuscule. The distinctive pointed aspect is created by twisting the pen to the near vertical on the long descenders.

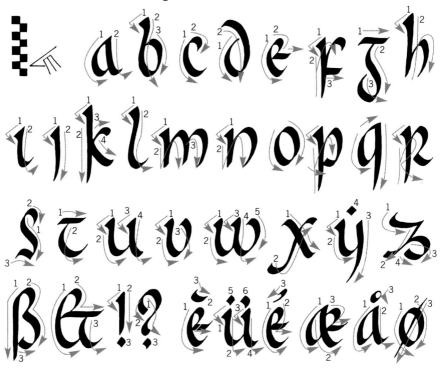

Points of interest

As with all cursive scripts, the letters were designed to be written with economy and speed. A certain amount of letter-linking will occur.

The wedge serif should be carefully drawn and followed by a quick, twisting downward movement into the stem, tapering to almost a point.

For the "h", "m" and "n" the twist is only slight, moving from about 40° to about 45°.

The large "e" was commonly used and could be ligatured to a number of letters.

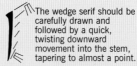

Do not allow too much space between letters, keeping the script aspect.

Basic structure

The pen is held at the dominant angle of about 40°, with a slight twisting of the pen towards the upright on small letters and a steep twist to the almost vertical on descenders. The letters can also be relatively open and slightly expanded in their aspect.

Structure	Strokes			Group

Demonstrated here, this modern version of "g" has the effusive tail of all the letters in this hand.

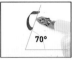

Begin with a generous stroke along the top of the x-height, then return and make a compressed bowl.

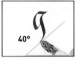

Starting with the termination of the first upper stroke draw the downward link.

Draw a hairline from below the upper bowl and complete the lower link using the corner of the nib.

The twisting of the stem from the dominant 40° to nearer 70° is a characteristic that gives the script its pointed aspect.

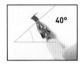

Begin the wedge with a distinct edge. Curve back into the stem.

Return and make the stem, twisting the nib as you go, finishing at about 70°.

Arc outwards in a compressed but smooth bow ending on the edge of the pen.

The width of the "o" is a determining factor regarding the width of other letters.

Start your stroke just below the upper line.

Then make a good circular sweep.

Make the other half to mirror the first.

The curving of the stem to make a bow was typical of nearly all scripts before the thirteenth century.

Make a good circular sweep downwards.

The cross-stroke is applied in a single movement.

Saxon square minuscule

This tenth-century script was used less widely than the contemporary pointed minuscule. Most commonly occurring in southern England, the script rigidly adhered to head- and baselines with generous line spacing, and has the appearance of a formal writing hand. The "e" and "n" are distinctive characters.

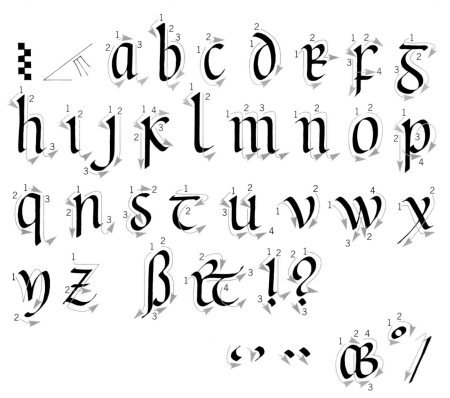

Points of interest

The narrowness of the characters helps to reinforce their upright aspect, although both "d" and "g" retain a roundness.

This is a modern "r", which can be used where the historically correct "r" would render the text illegible.

These are modern forms of "w", "v" and "y", and have been drawn to strengthen the compressed and upright character of this script.

Basic structure

The letters are a compressed minuscule. Their upright character is expressed chiefly in the stems of the characters and is aided by the discrete serifs at both the head and feet. With the exception of "r", the letters follow the Insular characteristics of the period.

Structure	Strokes			Group

The width of the "a" will determine the width of the other letters.

From the top of the x-height, make a short stroke to the right.

Return and sweep to the baseline and up into the stem.

Draw the stem and a discrete foot.

b c d o p q

The "e" is very distinctive in this hand, as it has a hooked serif as a starting stroke.

Hold the pen at 40°.

Make a stem, but bring out the foot to the right.

From the top of the stem, make a short loop and move outwards at the midway point.

f t

The straight cross-stroke at the head, instead of a rounded bowl, is indicative of the Insular scripts.

Start above the x-height with an upward flick. Move along horizontally and complete with a downward flick.

From this crossbar make an "s"- shaped loop descender.

Loop the tail back to join this stroke.

s

The "h" will also give you the widths for "m", "n", "u" and the traditional "r".

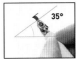

Make a triangular serif at the head by moving straight downwards and curving into the stem.

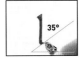

Make the stem as a separate stroke and turn the foot sharply.

Make a shallow arc and the right stroke with a turned foot, as on the stem.

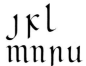

j k l m n p u

Proto-gothic minuscule

Depending on its dominant characteristics, this script is also known as late
Caroline or early Gothic. It was the prestige book hand throughout the twelfth
century. The club-like serifs on the ascenders are one of its distinguishing
features. The wedge serif on the small letters is pronounced.

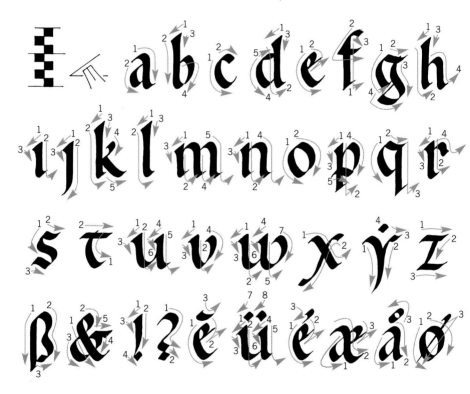

Points of interest

The ascenders and descenders
are relatively small, less than
double the x-height. Capitals
are generally twice the x-
height. Caroline capitals or
simplified Quadrata capitals
can be used.

Letters can be as bold
as three pen widths.

The emergence of the
modern "t". The stem
breaks the headline.

This letter is too wide.
Keep letters
compressed, angular
and upright.

Alternative form
for ascenders.

The dot on "i"
and "j" are
used on modern
scripts. The dot
on "y" was used
to distinguish it
from the Saxon
"thorn" sign.

Basic structure

For most of the letter the pen should be held at a consistent angle of 40°.
Letters are mostly separated, but just touching from the crossbar of "e" and the
feet of the straight stems. The wedge serif is more rounded than other scripts.

Structure	Strokes			Group

The wedge serif tends to have a "clubbed" appearance. Keep these serifs more rounded than sharp.

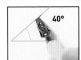

Begin the serif with a downward flick.

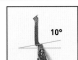

From the end of the flick, sweep backwards and downwards into the stem.

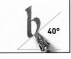

Loop at the bottom of the stem to make a foot.

d k l o

The top bowl of the "g" occupies the full x-height and is larger than on earlier scripts.

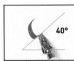

Commence below the upper line; do not sweep out too far.

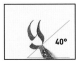

From the head, complete the right leg with a large "s"-shaped stroke.

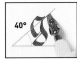

Make a diagonal hairline below the bowl. End the top horizontal and ear in one stroke.

**a c e q
s t v
w x z**

The compression of this script is noticeable in the straight-stemmed letters and, in this way, anticipates later Gothic forms.

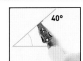

Begin the serif with a downward flick.

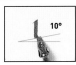

Return to the start of the flick and move vertically down the stem; flick at the foot.

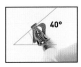

Complete the right leg of the "n" before returning to the serif and completing the triangular wedge.

**h i j m
r u**

The foot does not turn as on the other characters, but terminates with an upward flick.

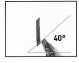

Make a vertical stem and flick the foot.

Begin to the right of the stem, sweep left to the top and move right to make the cross-stroke.

Return to the head and make the final stroke.

p ỹ

Gothic textura quadrata

One of the classic scripts of the later Middle Ages, Gothic Textura Quadrata was invented in about 1200 and continued in use for non-secular work for 300 years. The name denotes the "square" letter shape, and that the written page should have the appearance of being of a woven "texture".

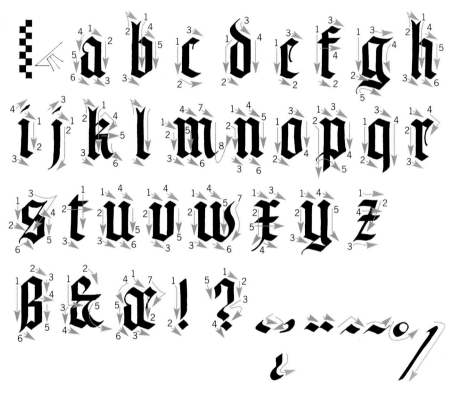

Points of interest

There is very little differentiation between letters, with many occupying the same width. The dot on "i" had to be invented to increase legibility.

The stem width, interletter space and interword space should be as close to each other as possible.

The split stem begins to the left of the stem; the right spur is added.

The half "r" is commonly used, and bowed letters are conjoined.

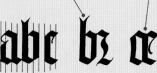

Basic structure

The letters are compressed; line spacing is accurate, about equal to the x-height; word spacing is equal to the width of "i". The letters shown here are very formal; they can become more cursive depending on the speed at which they are written. There are few angle changes.

Structure	Strokes			Group

The strokes that make up the "i" are basic for many of the letters and are easy to execute.

Hold the pen at 40°. Move diagonally to the right and make a diamond.

From the centre of the diamond draw the stem, stopping short of the baseline.

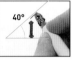

Add a diamond at the foot, centred over the stem. Add a dot to the "i".

j m n r
u v w y

The upper bowl of the "g" will give you both letter widths, and the basis for all enclosed letters.

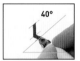

Move down vertically to make the bow. With the pen at the same angle, move across diagonally.

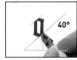

Make a mirror image to complete the "o". Note that the strokes may be slightly concave.

This "g" is shortened on the right, the overlap no more than a pen width. The tail is joined to the bowl.

a c c o q

The split stem also occurs on the "h", "k" and "l" and may take a little practice to get right.

Begin the split to the right of the stem, moving downwards.

Draw the spur with the corner of the nib.

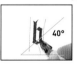

Draw the lower stroke of the bowl. Complete the bowl in one stroke, noting the slightly concave bow.

d h k l p
s

Never take the horizontal cross-bar above the x-height; the "t" is a small letter.

Start a diagonal just above the x-height. Move down to the x-height and along horizontally.

Draw a stem, stopping short of the baseline.

Pull out a diamond foot to the right. Add a skating stroke to the cross-bar using the corner of the nib.

f t z

Gothic quadrata prescisus

The full name for this script is "Gothic Quadrata Prescisus vel sine Pedibus" – "a Gothic textura letter with its feet cut off". It is an exact contemporary of the Quadrata, which it resembles in most respects, except for the absence of the foot diamond. Here the stem ends in a square cut-off section.

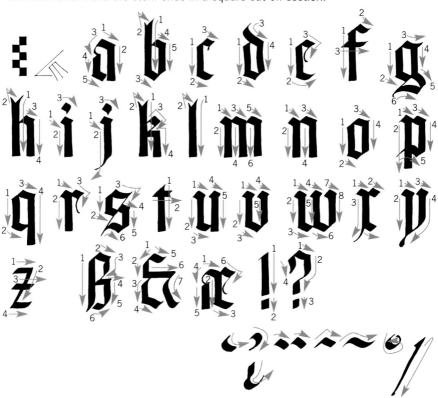

Points of interest

Interest lies in the ends of the letter stems for "a", "f", "h", "k", "l", "m", "n", "p", "q", "r", "t" and "u": they are at right angles to the stem.

Letter spacing is equal to about the width of a single stem.

Ascenders and descenders may be lengthened, depending on interline spacing.

This is an acceptable alternative form of the letter "y".

Basic structure

This script is similar to the Textura Quadrata, the significant difference being in the square formation of the feet. The square termination could be effected in one of three ways: The stroke begins at 40° and then is twisted progressively to the vertical, or twisted at the base of the stem, or outlined and filled in.

Structure	Strokes			Group

The "o" will determine the width and the basis of other letters.

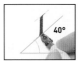

Starting below the x-height, draw a stem that stops just above the baseline.

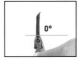

From the bottom of the stem, draw a diagonal line that stops at the baseline.

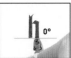

Repeat these strokes on the right to enclose the bowl. This letter is the basis for all enclosed letters.

The squared feet of letters differentiate the Prescisus from its contemporary, the Quadrata.

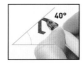

Start the split stem to the right with the edge of the pen.

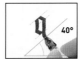

At the base of the stem, twist the pen from 40° to the horizontal to create a "square" foot.

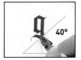

Arc a diagonal stroke from the stem, lift it and make the right stem. Turn the pen horizontal for the foot.

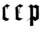

The bowl can be drawn straight or slightly concave.

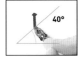

Begin the bowl as for the "o". The upper stroke is slightly bowed and extends to create an ear.

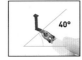

Extend the stroke downwards on the right side of the bowl, arcing slightly to the right.

Draw a hairline from the base of the bowl to the left. Connect it to the previous stroke with a generous arc.

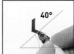

Note the alternative drawing of the right side as a continuous stroke.

Make a diagonal diamond. From the centre of the diamond, draw the stem.

Draw a slightly extended diamond to touch the baseline.

Repeat on the right. Using the corner of the nib, move to the right in an arc to make the tail.

Pointed quadrata minuscule

These letters date from the late medieval period and are influenced by wood-block printing. Although formalized, the characters can still be executed with a pen. The points are created by dragging the wet ink on the diamond with the corner of the nib.

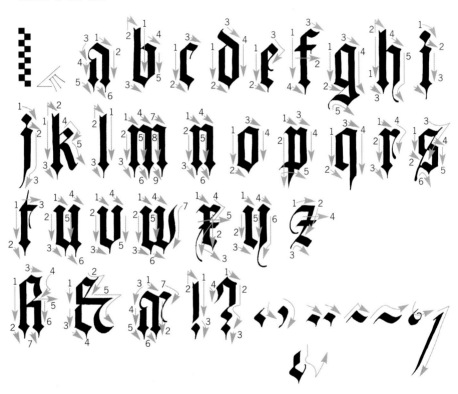

Points of interest

The compact quality of the Quadrata with minimal interletter and interword spacing is retained, giving the page the texture of weaving.

The space between strokes is about the same as the stroke width.

The diamonds are more downward-pointing than on the Quadrata.

Conjoining of letters is common practice.

The half "r" is commonly used, although both forms are frequently found in the same work.

Basic structure

When the script is written on a sloping base, the ink will flow to the bottom of the letter. This becomes even more evident on parchment. A feature is made of this by dragging the wet ink downwards from the diamond with the corner of the nib to make the point.

Structure	Strokes			Group

The split ascender also occurs on the "h", "k" and "l". Ascenders should be no more than an x-height.

With the pen at 40°, make a straight stem.

Draw a diagonal at the foot, dragging down the bottom corner. Make a small flick at the top left of the stem.

Draw a diagonal from the top of the x-height. Lift the pen and enclose the bowl.

dghkl opq

The top of the bowl may touch the stem, though it was common practice to separate them.

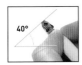

Make an extended diagonal. Return and skate a loop to the left, then draw a stem.

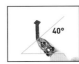

From the end of the skated stroke, draw the left side of the bowl.

Complete the letter with two diamond feet, dragging the wet ink down to make points.

On this alternative "y" the two strokes can be connected if legibility is likely to be impeded.

Draw a diamond at the top of the x-height.

From the centre of the diamond, draw a stem, ending with a diagonal or pointed diamond.

Repeat to the right, but end the stem with a skated tail.

jlrtuv wx

An "x" ending in an exuberant flourish. These adaptations may be used at your discretion.

From a diamond head draw a stem, finishing on the corner of the nib with a diamond foot.

Draw a diagonal to the right. For an extra flourish, skate back through the stem to below the baseline.

For a flourished "x", add a crossbar.

mnr

Gothic minuscule, modern

These Gothic minuscule characters are based on the letters of the German calligrapher Rudolf Koch and date from the early twentieth century. The alphabet uses Gothic split ascenders, diamond feet and bold strokes, which create a texture on the page. The pen is twisted to the direction of the stroke.

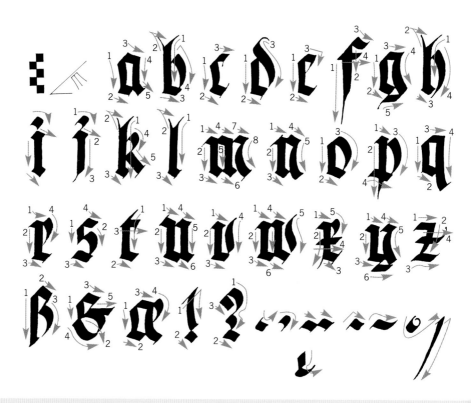

Points of interest

The dense blackness of the letters is enhanced by drawing many strokes to the full width of the pen with many directional changes.

One letter will frequently run into another. Any letter spacing is kept to a minimum.

The letters have frequent pen lifts and may be likened to a series of stabbing movements counterpointed by the sweeping strokes of the bows. The letters do not adhere to a fixed baseline.

Basic structure

The bold black letters are complemented by the Gothic feature of a freely drawn split ascender. Ascenders and descenders are truncated with the "f" retaining its dominant position, having a double-stroke stem and long tail. Provided the general rules are followed, the letters allow considerable personal interpretation.

Structure	Strokes		Group

 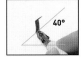 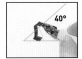 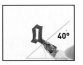

The "a" is a single storey letter that betrays its modern origins. It originates in the italic hand.

With the pen at 40°, make a diagonal hairline. Draw a curving stem, increasing the angle to 50°.

Add lower linking and head strokes at 50°.

Return to 40° for right side of bowl and foot.

 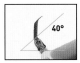

The split stem is exploited to the full and becomes a distinctive feature of this hand.

Begin well to the right of the stem and draw split and stem in one movement.

Skate outwards with the corner of the nib to draw the left split.

Draw foot as for "a". Gently curve the bow, finishing at a point, just touching the foot.

The extensive use of curved strokes gives a freer aspect than would occur in traditional Gothic hands.

Begin a diagonal at 40° to the right of the stem. Move down into the stem.

At the foot, turn the pen to about 50°.

Return and make a diagonal to the right at 40°. Draw the right stroke with a curve ending at 30°.

The centre stroke of "s" is broken. The top part is angular.

Draw a hairline diagonal to the left, followed by a straight half-length stem.

From the end of this stroke, draw a full arc to the left at 40°.

The headline stroke remains rigid while the baseline stroke has a slight curve.

Gothic capitals, modern

These capitals are based on characters originally created in the early twentieth century by the great German calligrapher Rudolf Koch. They can be satisfactorily reduced to five pen widths and can be used freely without strict adherence to the baseline. The "A" is the key letter.

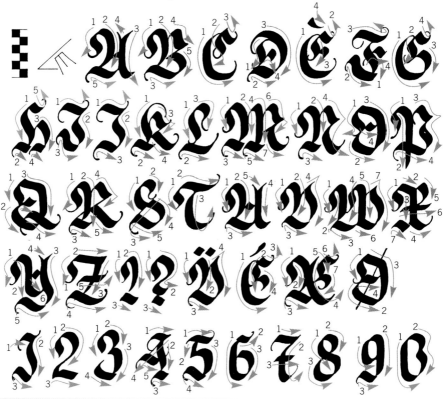

Points of interest

As with all Gothic capitals, it is not a good idea to use these characters for complete words, let alone sentences. When used with minuscules, try to keep the letters closely stacked.

When "skating" at the termination of a stroke, tilt the pen onto the corner of the nib and pull the wet ink into the desired flourish.

For a flourish at the beginning of a stroke, make the flourish from the first flick; then return to finish the stroke.

Basic structure

The pen is held at a consistent angle, except for the skated flourishes. As with the individual letters, the strokes tend to be packed closely together. As far as possible any interior spaces are neutralized with a diamond.

Structure	**Strokes**			**Group**

The strokes encountered in the "A" will occur in many other letters, which makes this letter ideal for practice. Probably the most difficult part is judging the amount of ink deposited on each letter in order to make the "skating" strokes.

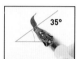

Begin by making this first "s" shape. Quickly, while the ink is wet, tip the nib onto its corner and make the flourish.

Return to the head of "S" shape and move downwards into the left leg, lifting the pen onto its tip at the base.

Now make the foot, then add the flourish, using the point of the nib.

 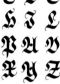

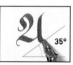

Make the right leg, starting from the head and finishing with an upwards flick.

Return to the top of the stroke and with the tip of the nib move upwards to create a split stem.

Finally, add the cross bar; this may be in the shape of a diamond.

The bend in the upper bowl ingeniously leads into a hairline stroke, which connects to the stem and in contrast sweeps out into a fully curved stroke to make the lower bowl.

Repeat Step 1 of the "A" letter.

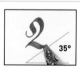

Repeat Step 2 of the "A" letter, following the line downwards. Then make the foot.

Add the flourish, using the tip of the nib.

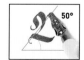

With the tip of the nib sweep away from the main stem and make the outer bowl.

Make a sharp diagonal back to the stem.

With a loop connect back to the foot.

Gothic capitals 1

These late Gothic capitals are based on the designs of Albrecht Dürer and can be used with the Quadrata or Prescisus minuscule. These letters, which originally appeared in the form of woodcut exemplars, begin to show the increasing divergence between the printed and the written letter.

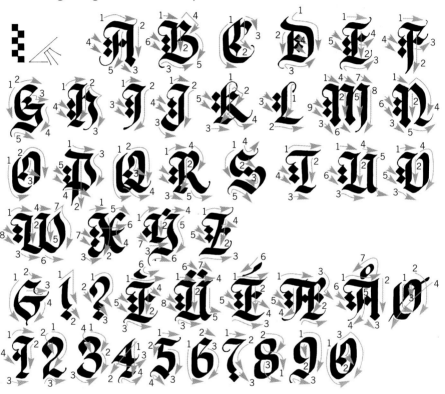

Points of interest

The use of diamonds is the obvious characteristic. In this rendering, there are a maximum of two per letter; Dürer sometimes used three.

The pen angle is constant and the stems are straight. Only the horizontal strokes show movement.

The diamonds appear to the left of the stem or within the counters of letters.

Basic structure

The letters are generally more compressed than most Gothic capitals.
Considerable use is made of diamonds, although vertical strikes are absent.
There are usually two diamonds, linked to the headline stroke by a skated
stroke. Single diamonds are used to reduce the volume of the counter.

Structure	Strokes			Group

The "A" is an ideal letter to practise on, as it contains most of the problems you will encounter on other letters.

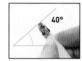

Hold the pen at an angle of 40°.

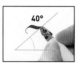

Make the headline stroke. Return to the left and, with the corner of the nib, skate wet ink into a curve.

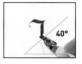

Make the stem well to the right and add a diamond-shaped foot.

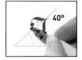

Return to the skated stroke and add two diamonds.

Next to the diamonds add the left leg and skate it into a tail, placing a diamond between the two stems.

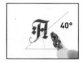

Experiment with skated strokes where opportunities permit at the foot of letters.

𝕭 𝕯 𝕳 𝕵
𝕶 𝕷 𝕸 𝕹
𝕻 𝕽 𝖀 𝖁
𝖂 𝖄

An alternative and more compressed "S" with two diamonds, which are drawn at a consistent angle.

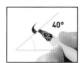

Make a small, half-sized arc to the left.

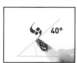

Immediately above and below the termination, add diamonds, or add a single diamond centrally.

Add generously curved head and tail strokes and a skated flourish to the tail.

𝕰 𝕱 𝕸 𝖅

This hand does not have the vertical hairlines that would usually run through the diamonds.

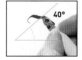

This alternative "T" is more traditional. Allow the top stroke a distinctive wave.

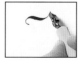

An upward skate stroke may be added at the termination of the top horizontal stroke.

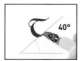

Make the stem a fully rounded arc. Consider placing one or two diamonds within it.

𝕮 𝕾 𝕺 𝕼

Gothic capitals 2

These Gothic capitals were used in conjunction with Gothic Quadrata and Gothic Prescisus minuscules, their size usually determined by their relative importance within the text. The wide capitals contrast with narrow minuscules. They were often enhanced by the use of colour or decoration.

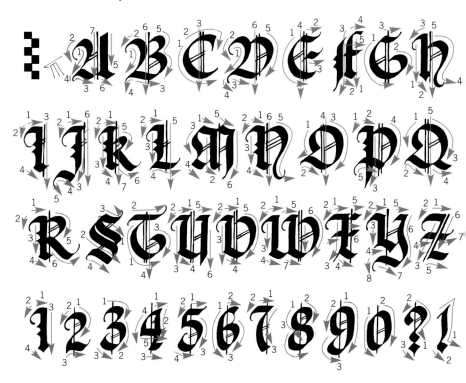

Points of interest

The straight vertical strokes can be embellished with either bulges or hackles, giving added weight to the stem. The spaces within the letters are neutralized with hairline verticals and diagonal strokes.

Hold the pen vertically to the paper and strike downwards at the angle of the blade.

Holding the pen vertically, strike diagonally at 30°.

With the pen at 30°, move out from the stem, then back. Repeat to create a succession of hackles.

Basic structure

The principal strokes are wide. The hairline verticals and diagonals can be made with either the corner of the nib, or with the blade of the nib held at the same angle as the stroke. The hackles or bulges are made with a single movement.

Structure	Strokes			Group

These capitals will require a little practice but are fun to do. Once you have mastered the "A", you will be able to resolve any problems you may encounter on the other letters. The basic structure of the letters is quite easy, contrary to first appearances!

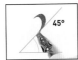

Make the first arc of the "A", finishing with your pen at an angle of 45°.

Return to the head and create the flourish by skating the wet ink.

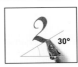

With your pen at 30°, add the left foot in a bold downward movement.

From the corner of your nib, return to the left of the foot and skate a flourish.

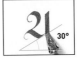

Holding your pen at 30°, move to the right and draw a vertical stem.

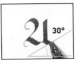

Add a diagonal foot to the stem, then complete with vertical and diagonal hairlines.

This "N" can have hackles protruding from the stem. There are no particular rules about their use, just avoid overcluttering.

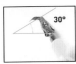

With your pen at a 30° angle, make a short horizontal serif.

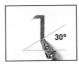

At the same angle draw the stem.

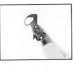

Return, and make a flourish with the corner of your nib.

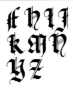

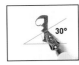

At this point, hackles may be added to the stem, or rounded off in the form of bulges.

Arch from the top of the stem in a wide sweep, and at the mid-point start to skate a long elegant tail.

Complete with a vertical hairline and two diagonal hairlines with the pen at 30°.

Gothic skeletal minuscule

This modern modified version of a Gothic minuscule is drawn with a split-dip pen. Although the same pen was used with the capitals, the technique differs: here a hesitant stroke was used, which helps exploit the rough texture of the paper. Capitals or minuscule can be drawn using either technique.

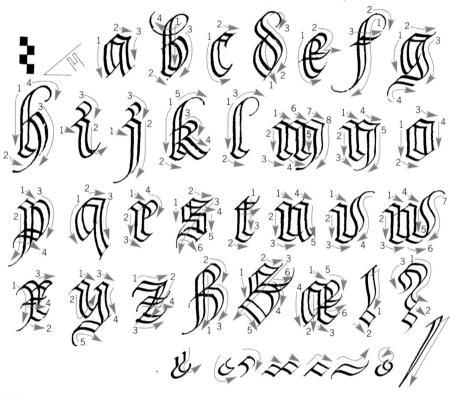

Points of interest

These characters present exciting word pattern possibilities. They are generally not suited for major text use, but ideal for shorter passages.

The strokes visibly cross over each other; the flourishes are made with the corner of the nib.

Instead of a hesitant stroke, the letters work equally well when spontaneously drawn.

This alternative "a" and "b" should not be used if the letters are italicized.

Basic structure

The letters have a decorative quality and can be exploited for dramatic emphasis. They have been drawn with a medium-sized split-dip pen. A variety of effects can be created using different techniques and paper.

Structure	Strokes			Group

This is a single story "a", as opposed to the usual Gothic form of a two-storey letter.

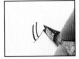

Starting below the x-height, make a bowed stroke, then skate upwards using the corner of the nib.

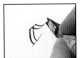

Return and make a headline stroke to connect to the top of the stem. End on the corner of the nib.

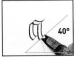

The stem gently curves and terminates with an upwards enclosing stroke made with the corner of the nib.

The straight sides of these letters contrast with the curves of other rounded letters and produce a lively script.

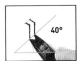

Make a short diagonal stroke to the right, then lift and make a short vertical stem.

Lift and add a foot, enclosing it with the corner of the nib.

Lift and repeat the first stroke, but terminate by turning below the x-height to the left. End on the corner of the nib.

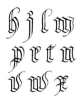

The liveliness is enhanced by the use of flourishes, which should be exploited wherever possible.

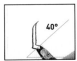

Starting above the headline move diagonally to the left and down into a stem. Lift and draw a foot.

Lift and return to the top of the x-height and enclose the counter with a generous bow.

Finally, return to the head of the commencing stroke and draw a flourish with the corner of the nib.

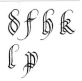

The play of cursive against straight will suggest different modified letterforms.

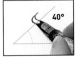

Start with a small curve to the midway point.

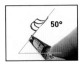

The centre stroke of "s" is broken: draw the top half with the pen at 50° and add a diagonal to the baseline.

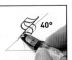

Start the lower centre stroke immediately above the upper centre stroke. Add the tail.

Gothic skeletal capitals

This is a modern modified version of a Gothic capital, drawn with a single split-dip pen. These capitals could be used singly as a versal or combined with the minuscule and used for headings or quotations. Legibility is a problem if the capitals are used together.

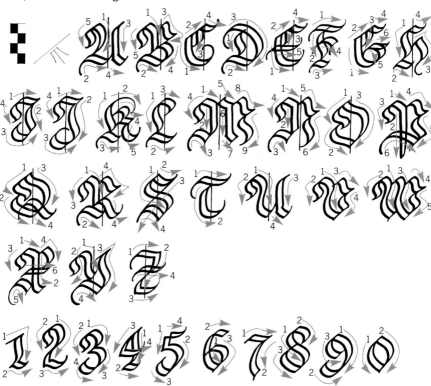

Points of interest

The letters are fun to draw and have considerable decorative quality. They can form the basis of a header, logo or opener, possibly using colour as an infill.

Wherever possible, straight stems are avoided: instead, stems are broken as with the "B", "D" and "M".

Bows are also broken, giving the letters as many facets as possible – as here with the "O" and "P".

Basic structure

These letters have been drawn with a medium-sized split-dip pen. They may look complex, but you will probably find them easier to draw than they first appear. The important factor is to hold the pen at a consistent angle.

Structure	Strokes			Group

Using a split-dip pen is no more difficult than a broad-edged pen; however, make sure that both halves have sufficient ink in them and do a short test before you write.

Holding the pen at 40°, make a short arc beginning at the headline.

From the baseline make an extended foot.

From the headline make a stem, stopping as you touch the left foot.

Add a foot to the stem, but keep a well-defined angle between the stem and foot.

Return to the headline and make the introductory swash keeping your pen at the same angle.

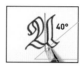

Make a vertical strike with the corner of your nib between the two strokes.

The short stems of many letters are compensated by the generous sweep of the foot. The hairline may be drawn with either the tip of the nib or by drawing the stroke with the flat of the blade.

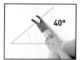

For "B" make a short lead-in before making a short stem.

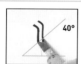

From the baseline form a generous sweeping arc.

Return to the headline, make a twisted bow and draw a diagonal to connect the bow, stem and foot.

Start to form the lower bow from the centre of the diagonal stroke.

Complete the lower bow.

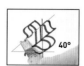

Make a strike vertically through the centre of the letter. Add a swash to the left to complete the letter.

Gothic versal capitals

These are modern characters drawn from Gothic capitals, but drawn with a split pen. As versals they have been designed to be used singly as an opening letter. They may form the basis for further elaboration with colour or additional drawing.

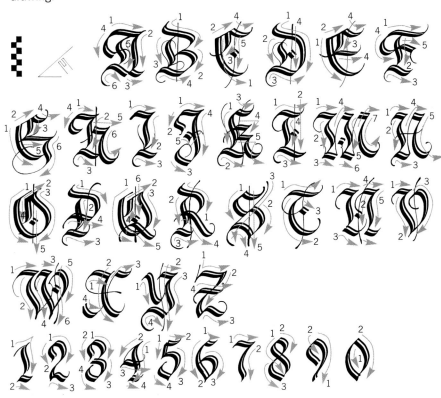

Points of interest

The pen used for these letters was made from bamboo, with the split nib cut to different widths. If you can't buy the pen you want, make your own.

Have fun with the skating strokes drawn with the corner of the nib.

If the pen is sharp enough, it can produce a very fine line.

Diamonds add an additional embellishment.

Basic structure

Straight lines are eliminated from these characters, only appearing as strikes through the letter. Skating strokes are employed, and the volume of the counter reduced by using diamonds. The letters may be used as an introductory initial for either Gothic or Italic text, and may form the basis for further elaboration.

Structure	Strokes			Group

As this is a relatively complex hand, it will probably be most helpful initially to concentrate on one letter. Once you have managed a satisfactory result, and established a rhythmic hand movement, you will find the remaining letters easy and fun to draw.

Hold the pen at 40°. Make a wavy headline stroke.

Immediately follow with a sweeping stem.

Keeping the pen at the same angle, add a foot.

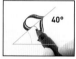

Return to the head of the first stroke and make a swash. Skating the wet ink, continue into a flourish.

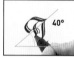

Then carefully add a short bowed left leg.

Draw a large generous left foot, connecting to the right foot. Return to the start of the stroke, and skate a tail.

You will probably find this minuscule form of "Y", adapted as a capital, the most satisfactory.

Make a short looping stroke, then skate upwards to the main stroke.

Make the stem with a distinct wave. This wave will be repeated on many of the other letters.

Complete with a wide sweeping foot and a top serif. Finally, add skated flourishes and hairline strikes.

This is an alternative to the "M" shown opposite, where the centre "V" starts from the top serif.

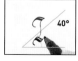

This alternative "M" avoids springing from the foot. Make the stem stroke a hairline stroke.

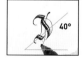

The second stroke now becomes the main stroke. The third stroke reverts to a hairline.

Add the fourth stroke, the feet, and serifs, and a hairline strike through the centre.

Lombardic capitals

These capitals date from the early Gothic period. While they served as display capitals and as chapter and verse openers, they did not quite achieve the status of versals. They continued to be used until finally ousted as a text hand by the Humanist hands of the Renaissance.

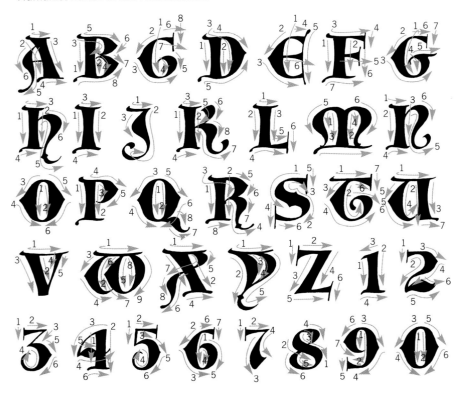

Points of interest

The letters are a combination of Roman and Uncial forms. In contrast to the Textura letters, they have almost no straight lines.

The stem is made from two opposing concave lines and usually separated.

The stem is enclosed by concave horizontal strokes.

Rounded letters take an ogee form.

The letter is drawn in outline prior to infilling. Shown here is an alternative "A".

Basic structure

The Lombardic capital is a built-up letter composed of at least two opposing concave strokes; these strokes may overlap to give a narrow waist, but it is more usual to draw them separately with the remaining internal space filled in. Bowed letters are usually pointed at their widest point, making an ogee.

Structure	Strokes		Group

The waisted stem and pointed ogee of the curved strokes give the Lombardic capital its distinctive structure. Note particularly the absence of skated strokes and the positive termination of the strokes, either rounded or flicked.

Begin by drawing the letter in pencil, or work from a traced-off letter.

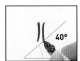

Holding the pen at 40°, draw the two concave strokes of the stem.

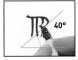

The headline stroke can continue into the bowl and finishes at the baseline, noting the pointed ogee.

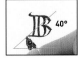

The baseline is drawn as a separate stroke, terminating in a rounded or flicked dot.

Finally, fill in the letter using a small paintbrush. The infill may be a different colour.

Then draw the inner strokes of the bowls, with the upper bowl slightly smaller than the lower one.

The points at the centre stroke of "S" use the "O" as a model.

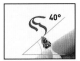

Begin the "S" by drawing the top part, to the point of the ogee, first.

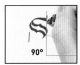

Complete the centre stroke and strike a vertical hairline at top right and bottom left.

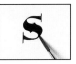

Connect to the hairlines, noting the "trumpet" shape of the stroke, and infill with a pen or brush.

Notice the trumpet-shaped head stroke also on "C", "G" and "S".

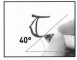

Begin the horizontal with an upward flick. Draw the stem from the rear of the horizontal.

Draw the tail, ending it with a rounded dot. Finish the cross with a second "trumpet".

Complete the letter by infilling it.

Lombardic versals

These letters are similar to Lombardic capitals, the principal difference being in their outline structure. Historically, these letters were embellished further with illustration or illumination, depending on the importance of their position on the page. They were chiefly used with the Gothic minuscule.

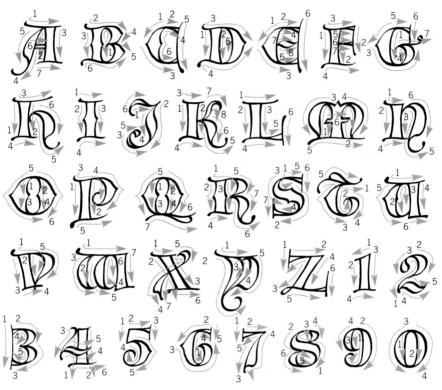

Points of interest

These letters have been drawn with a narrow broad-edged pen to give some variation in stroke width.

The letters have considerable potential for individual creativity. The interior or surrounding decoration can be of your own choosing.

One effective method is to place the letter on a coloured background – consider using a white reversed letter.

Basic structure

The stem of the letter consists of two concave lines; the bowls are usually broken into an ogee on its side. The letters themselves follow the Uncial characteristics and not the Roman form. They have almost no straight lines.

Structure	Strokes			Group

Arguably the most opulent letter in this hand, with the emphasis on the left leg and the tail.

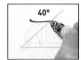

Draw a long horizontal headline stroke.

To the right of this stroke, draw the two outline strokes of the stem.

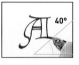

Add the sensuous strokes of the left leg, finishing in a sweep below the baseline. Add the foot serif.

The "M" has more of the appearance of a crown than a calligraphic letter.

With all bowed strokes it is advisable to draw the inner strokes first.

Onto this build the body or the ogee strokes.

Complete with the centre cross-stroke and connect the feet in a single serif.

Practise drawing, then, when satisfied, make a tracing placed between the head and baselines, before applying the tracing to your work.

Begin by carefully drawing or tracing the letter. Now draw a long undulating stroke at the headline.

Slightly to the right of the centre, draw the inner strokes of the bowl and tail.

Add the outer strokes of the bowl and tail. This may be rounded or an ogee. An added stroke is used on the headline.

The letter may be left, but it is usual to infill with colour.

The infill may then include additional colour and decoration.

As an embellishment, the terminal strokes may have swashes or flourishes added.

Secretary hand

This was the hand used for vernacular work from the thirteenth to the seventeenth century and was in contrast to the Quadrata's carefully drawn scripts used for religious writing. Essentially cursive, it was designed for writing at speed, although it could achieve considerable elegance in its own right.

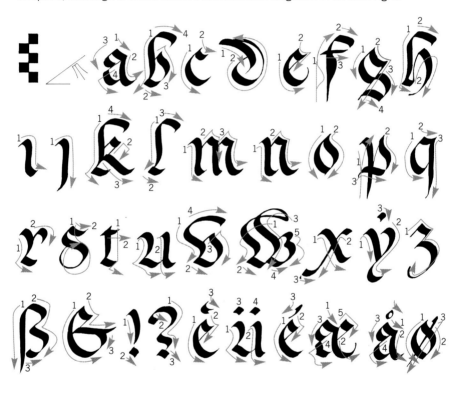

Points of interest

The strong "elephant's ears" serve as a linking device and gives the text a forward marching in step appearance. The "w" is large, having the appearance of a capital letter.

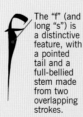

The "f" (and long "s") is a distinctive feature, with a pointed tail and a full-bellied stem made from two overlapping strokes.

Ligatures and contractions were common. This letter is a double "p".

A feature was frequently made of the tail of the "h" and the "g", which could either trail downwards from the baseline or sweep along the line just below the body of the letter.

Basic structure

The main body of the letter was kept relatively simple in form. All of the thrust and letter elaboration was carried on the ascenders and descenders, further emphasized by ascenders on both "v" and "w". The "h" arches from the foot and not from the stem.

Structure	Strokes			Group

The stems of "f" and "p" are the only instances of a change of pen angle. The pen is twisted to about 70°.

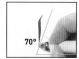

Commence the "f" as a single downward stroke, twisting the pen to a point.

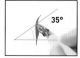

Return and twist outwards and to the right and back to the top of the x-height.

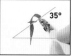

Add a cross-stroke and an "elephant's trunk".

The "h" is unusual in that the right stem arches from the foot and not the stem.

For the stem of ascenders start from the left and move downwards.

For "h" make a foot and skate with the corner of the nib upwards.

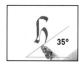

Curve downwards into the right leg in a single stroke. Lift and make the "elephant's trunk".

The "o" will provide a basis for many of the rounded letters.

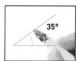

Hold the pen at 35°.

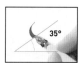

Make a relatively compressed curving arc.

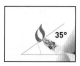

Complete the stroke with an "s"-shaped arc.

The "elephant's trunk" is a dominant characteristic.

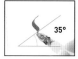

Begin with a bold "s"-shaped sweep.

Throw a forward stroke, return to the base and add the foot.

Lift the pen and complete the final stroke.

Secretary hand, modern

The original Secretary Hand was the calligraphic workhorse of the Middle Ages and usually written at speed and quite difficult to read for modern usage. This alphabet, while retaining the general character of the medieval script, will have greater legibility in a contemporary setting.

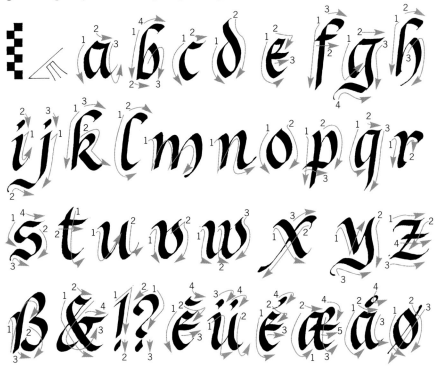

Points of interest

One of the principal characteristics that has been retained is the "elephant's trunk". Bring this forward with a positive thrust.

The alternative two-storey "a".

On the top and bottom lines consider using flourishes, and also extending connecting strokes as on the Fraktur.

An alternative hooked serif has been used here; this can also be used on the "m".

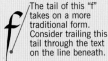
The tail of this "f" takes on a more traditional form. Consider trailing this tail through the text on the line beneath.

Basic structure

These letters have been drawn at about an 8° slope, with the pen held at about 40°. The "d" has been drawn upright with a slight ogee. A modern "w" is included, also with greater emphasis to leading and trailing strokes over the original Secretary Hand.

Structure	Strokes			Group

 acdegp qs

The "o" in some measure is a defining letter as it sets the widths for the other letters. | Hold your pen on the page at an angle of 40°. | Make a smooth curving arc to the left. | The right side of the "o" differs from the left, starting with a hint of a curve before enclosing the counter.

 ijnpru vw

This hand was created to be written at speed. We can see this in the fast flowing angles and curves of the "m". | Hold your pen on the page at an angle of 40°. | These first two legs of the "m" have been drawn at slightly different angles. | Return to the head and, with a strong outwards, downwards stroke, make the "elephant's trunk".

 fhkCp

The stem comes down straight to the base and the bowl is enclosed at the bottom by a straight stroke echoing that of the head. | With your pen at 40°, sweep into the stem from the right. Make the arch and right leg in one movement. | Make a slightly compressed arc filling the x-height. | Return to the head of the stem and make a bold forward thrusting, almost horizontal terminating stroke.

 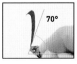 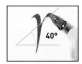 bru

This is a rouge letter in that it departs from the angle of 40°, becoming almost vertical at the end of the tail. | The stem of the "p" is made by twisting the pen from 40° to 70° to give a pointed tail. | Sweep back up the tail, make an arc then down into the bowl. | Lift the pen and make the final stroke to complete the bowl.

Secretary capitals

Accompanying the Secretary minuscule, these capitals formed part of the vernacular writing hand used between the thirteenth and seventeenth century. The hand was principally used for legal documents and book work of a non-religious nature.

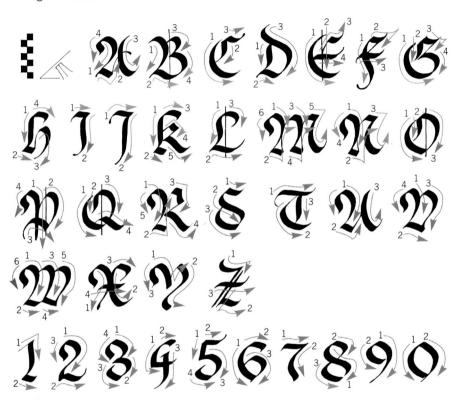

Points of interest

Added weight is given to some characters by the use of a vertical stroke. In some instances, this defines them as capitals.

The characteristic linking stroke tends to spring from the foot of a letter, not the stem.

On this alternative "F", a bold stroke leads into the base of the letter.

The large distinctive "w" of the minuscule can be used as an alternative capital.

The long tail can be extended below the x-height when the "H" appears towards the end of a word.

Basic structure

The letters owe more to the Gothic form than the Roman, and were designed to be written quickly. Although shown here as a series of separate strokes, where possible they would have been written in a continuous movement.

Structure	Strokes			Group

The arching into the right stroke from the foot, not the stem, is a characteristic feature of the Secretary hands.

With the pen at 40° make a stroke like a "2", then add an arced foot to the right.

Skate upwards and outwards in a wide arc from the end of the foot.

Make a large opposing arc, return, and add a swash to the initial stroke.

The left arc is a generous semi-circle and is repeated on "C", "G", "O" and "Q."

Start the "E" with the same stroke you used to finish "A", and strike a vertical hairline with the edge of your pen.

From the centre of this strike, move upwards and outwards to form the top arm.

Lift and carefully add the centre arm.

The bowl of "P" is large; Its volume is reduced by the steep curve of the bottom stroke.

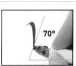 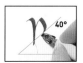 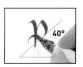

With the pen at 40° start the stem of "P" with a bold sweep. Turn the pen to 70° as you descend the stem.

Push the pen back up the stem and curve out to the right. Draw the bowl in one movement.

Complete the bowl with a bold arcing stroke through the stem and at right angles to it.

This "W" follows the form of the minuscule "w" (which in fact resembles the capital "W").

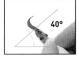

An alternative form of "W". Make a wide but almost horizontal "s"-shaped stroke.

Make a wide skating sweep outwards from the first stroke. End on the corner of the nib.

Move to the right and repeat the first stroke. Add a wide sweep and the right stroke.

Fraktur minuscule

The early Fraktur letters first appeared in about 1400 as a development of the vernacular hand. Within a century they had acquired status as a book hand and became the model for many type designs. They are still popular now, especially in German-speaking countries.

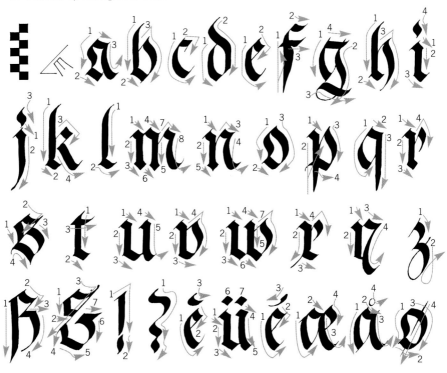

Points of interest

The characters are reminiscent of the Quadrata. The appearance of broken stems is created by using cursive strokes and the clear separated pen lifts between each stroke.

The "elephant's trunk" can be used as an alternative on the "b", "h", "k", and "l".

The fine line lead-in stroke should extend beyond the end of the subsequent stroke.

Fraktur is a compressed letter: the space between strokes can be as little as a single pen width.

Basic structure

Although many of the strokes are cursive compared with the Quadrata, the compressed proportions of the letter remain similar. Generally, the greater the number of pen lifts, the more elegant the letter. Wherever possible ensure that the very fine lead-in strokes overlap. Skating strokes are also used.

Structure	Strokes			Group

Start the stroke above the x-height. This will give you the characteristic "spike".

Hold the pen at 40° and make a very fine lead-in stroke starting above the x-height.

Move down to make a compressed arc.

Starting at the top of the x-height make a small arc for the top of the bowl and complete.

c g o p q s s z

The stem differs with other letters because it tapers to a point and on return swells with a double stroke.

Flick into the downward stroke; at the halfway point turn the pen almost to the vertical.

Finish on the tip of the nib, pushing upwards and outwards to create the belly.

Draw the head and finish with the cross-stroke.

h l j p q

The fractured elements of this hand are very apparent on the "g", with the two separate strokes of the bowl protruding above the horizontal stroke enclosing the top of the bowl.

Bring the pen downwards in a curving, but not circular movement.

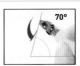

Make the upward link as a separate stroke, turning the pen to an angle of 70°.

Make the third stroke in a curving downward movement and skate the tail, using the tip of the nib.

a b d h m n p q

Complete the tail, finishing it with an upward flick, with the tip of the nib.

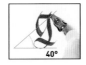

Return to the head and draw the cross-stroke, ensuring that the "ear" and "horns" are clear.

Fraktur capitals

For use with the Fraktur minuscule, these letters are much wider than their minuscule counterparts. With the exception of the stem of the "P", all the strokes are cursive. With the advent of printing the capitals were subject to increasing levels of decoration.

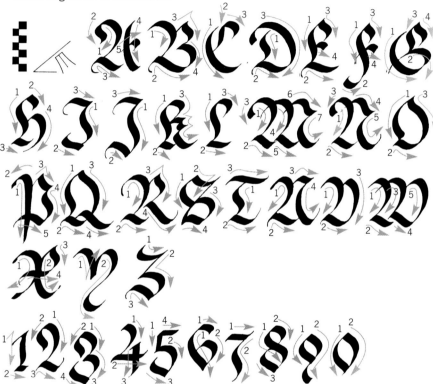

Points of interest

Although similar to Gothic capitals, Fraktur capitals tend to be more cursive, without the use of hairlines or spurs, and the use of fully rounded bowls almost eliminated.

This wide horizontal arc sweeping to the right, as on the "B", is characteristic and helps give the letters added width.

Notice the almost complete absence of straight stems, which are replaced by this curved stroke.

Try to avoid your capitals becoming too narrow – unless this is your deliberate intention.

This width should be regarded as the more generally accepted proportion.

Basic structure

As with the minuscule, the greater the number of pen lifts, the more elegant the letter. These pen lifts enhance the "broken" character of the letter, while at the same time maintaining a connecting rhythm. This rhythm also serves to link the component parts, and it is this balance that you should seek to maintain.

Structure	Strokes			Group

The height of the capital is about two-fifths above the x-height. All of the strokes show the cursive quality of the script and should never have the appearance of being laboured.

With the pen at 40°, make the first lead.

Make a small "S"-shaped stroke.

Return to the top of the "S"-shaped stroke and follow with an arch into the left leg.

Now sweep into the foot.

With the corner of the nib, skate a flourish from the left of the foot.

And now make a downward arc for the right leg. Finish with the crossbar.

The forward thrust of the headline stroke is less dominant on the capital than on the minuscule.

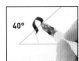

Make a short "S"-shaped stem, return and make a mini "elephant's trunk" stroke at the head.

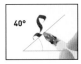

Add a generous foot and skate the left side.

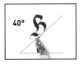

Finally, return to the mid-stem and bow the right leg, tucking it under the foot.

This is the only straight-stemmed letter.

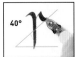

Twist the pen from 40° to 70° as you go down the stem. Return to the head and make the first arc of the bowl.

Make an "S" for the next stroke of the bowl.

Complete the bowl by crossing the stem with a bold foot.

Fraktur flourished capitals

This modern, freely drawn Fraktur capital is based on medieval German hands. This capital may be used as a basis for a versal or to accompany the flourished minuscule. It can also be used successfully to accompany the Fraktur minuscule.

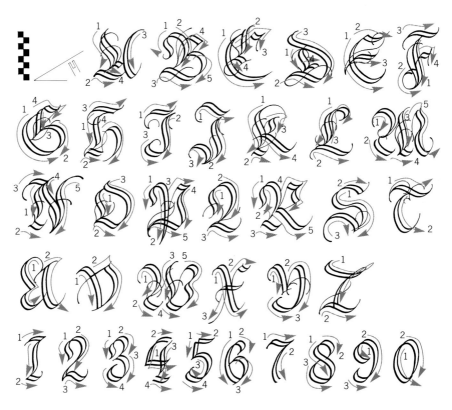

Points of interest

Almost without exception the strokes are curved, with the flourishes springing from stroke terminations or stroke junctures.

Where strokes are truncated, as on the stem, the sharp sweep becomes particularly evident.

This extreme cursive character is also noticeable on strokes that are used to terminate at the head and feet.

Notice the sweep of the curve as it slides beneath the body of the letter on the "C", "E" and "G"

On the stem of "P", turn the pen toward the vertical to produce a thin down stroke.

Basic structure

The letters have been drawn with a split-dip pen and written with an informal or cursive ductus. The use of a dip pen allows the nib to hold ink, which enables the flourishes to be added to the main construction of the letter. This contrasts with the "skating" stroke of the nib with attached reservoir.

Structure	Strokes			Group

 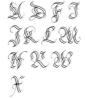

These letters may appear very complex and it is advisable to concentrate initially on a single letter. Once this has been mastered you will find that many others will follow the same pattern. The "H" is a good one to start with.

Place the pen on the page at a 35° angle.

Sweep into the stem. As you finish, ease the pressure and finish on the corner of the nib.

Now add the foot with the pen still at 35°.

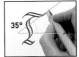 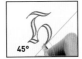

Return and carefully add the headstroke.

Return to the base and, with the corner of the nib, arc upwards, then down.

With your basic letter completed, draw the flourishes using the corner of the nib.

 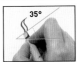 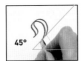 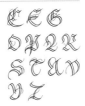

The breaking of the upper bow, which also occurs on "O", "P", and "R" is a typical factor of the "broken letter", which gives Fraktur its name. This characteristic is especially noticeable in the minuscule.

On "B", "P", "R" and "Q", start with the outer right loop.

Return and make a wide arcing stroke to the right, stopping before the baseline.

For the "D", "L" and "Q", bring the foot out generously to the right. End with the corner of the nib.

For "B," flourish upwards from the foot into the top bowl.

Make a generous bow to join onto the foot and complete the basic letter.

Finally, draw your flourishes using the corner of the nib.

Schwabacher minuscule, modern

The Schwabacher script originated in Germany in the late fifteenth century. It is a more cursive and simplified, and less pretentious form of the Quadrata while lacking the "broken stem" of the Fraktur. This modern version is based on a design by Rudolf Koch from the late 1920s.

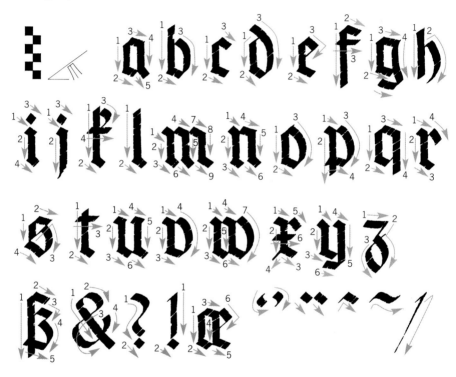

Points of interest

The strokes have been constructed using short jerky movements to give a textured effect.

 The stems begin with a simple diagonal stroke and are not split as shown on this alternative "k".

 The bow on "b", "h", "o", "p", "u" and "w" create a distinctive pattern.

 Note the change of angle of the two bottom strokes of "a".

 This is an alternative form of "z", and an alternative form of "n", with the foot removed.

Basic structure

The minuscule letters are constructed from two basic shapes: A straight stem contrasting a curved bow. This rigid formula is relieved by slightly varying the angles of the feet and the shorter strokes. When written calligraphically, the patterning of the words is relatively random in comparison to the Quadrata.

Structure	Strokes			Group

The stroke direction will randomly change from between 30–40°, as on the foot of the "a".

Begin the "a" with a downward diagonal stroke from the left, stopping before reaching the baseline.

Add the base of the bowl, then return to the head and add the top of the bowl.

Enclose the bowl by joining the head to the foot with a vertical stem. Add the diamond foot.

cgijm ngrt uy

The ascenders start with an angled stroke and are straight, unlike the split of their Gothic predecessors.

For "b", hold your pen at 35°. Starting above the x-height, draw a vertical stem, stopping before the baseline.

Make a wide foot along the baseline for the bottom of the bowl.

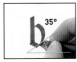

Complete the bowl with a generous curve from the top of the x-height. The "a" and "b" give the majority of strokes.

fhflo p

The contrast between rounded and straight strokes is no more evident than on the "o".

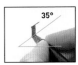

Move to the left from the top of the x-height, down towards the stem, stopping short of the baseline.

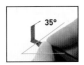

Draw a diagonal foot down to the baseline – as on the "a".

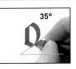

The right side of the bowl is fully curved, contrasting with the left side.

dpvw

This is a rouge letter in many scripts, not fitting in with any specific grouping. It can prove an interesting relief.

Begin the "s" as on the "a", but with a shorter vertical stroke.

Make a diagonal stroke to join the base of the first stroke. Draw a bow from the diagonal.

Join the end of the first stroke to the bottom of the bow with a steep downward stroke.

ʃʒ

Schwabacher capitals, modern

These Schwabacher capitals were designed by Rudolf Koch to accompany the minuscule. The letter retains its basic Gothic form, but has been reduced to its fundamental shape and all embellishments removed. The strokes have been constructed using short, jerky movements to give a textured effect.

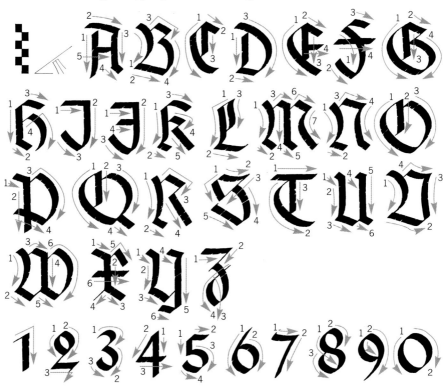

Points of interest

Although the letter has been reduced to its essentials, it retains a liveliness and fluidity. This is achieved by the slight changes of pen angle often used by Koch.

This curved stem occurs on the "B," "M", "N", "R", "V", and "W".

This alternative "L" is based on the "elephant's trunk" of "H" and "K".

The curved stem can also be used on the "U".

The curves on this alternative "S" reflect that of the minuscule.

The alternative "Z" is more legible in modern use.

Basic structure

Generally, all of the straight strokes are rigid and show little deviation. They are contrasted by the curved strokes, which show a backward lean and are wide in relation to straight-stemmed letters. The combination of these factors and their unpredictable application ensure that this Gothic script does not become static.

Structure	Strokes			Group

The stems of these capitals incorporate an interesting array of different curves, from the obvious to the hardly perceptible.

Make a downward stroke. Slightly move to the left at the bottom. Now, make a horizontal stroke.

Slightly increase the pen angle and add the foot.

Finally, draw the cross-bar.

The stem of "B" begins in a wide arc and terminates in an almost straight stroke for the lower bowl.

For "B", make a curved stem. Add a downward stroke to reach the baseline.

Return to the headline and draw an angular "boxed" upper bowl.

Make a curving stroke to create the lower bowl. The "A" and "B" give you most of the strokes needed.

The first stroke of "N" is a repeat of the "B" and is in direct contrast to the straight stem of the otherwise related "H".

Draw a curving stem starting at the headline and stopping short of the baseline.

Return, make a short upward stroke to the right, and move along the headline in a downward direction.

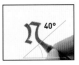

Arc the right leg in reverse to your first left stroke. A slight foot may be added.

The "O" (and "Q") are wide, round letters. The inner volume is reduced by means of a vertical downward stroke.

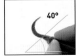

The "O" provides the remaining strokes of "C", "G", "Q" and "T". Start with a semi-circle.

Make a vertical stroke from the headline, and connect to the inner counter.

Finally, add the right semi-circle.

Batarde

This elegant hand is the French equivalent of the English Secretary or the German Fraktur hands. It originated in the late thirteenth century as a lowly text hand. By the mid fifteenth century it had sufficiently departed from its Gothic origins to be regarded as a sophisticated hand in its own right.

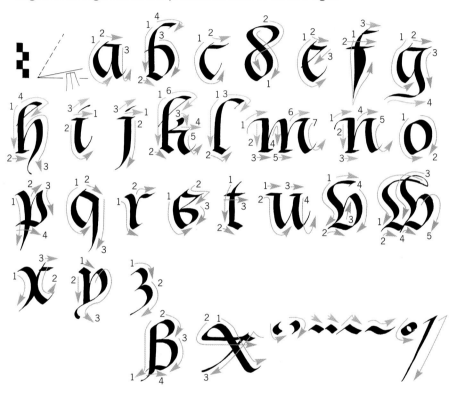

Points of interest

The alphabet above shows all of the letters drawn vertically. Historically, the "f", long "s", and the tail of "p" were often drawn with a strong diagonal slant.

The half "r" is interchangeable with the "r" above.

The hairline tails of these letters were often dragged down into the body of the letter on the line below.

An alternative "a". Use one or the other, but do not mix.

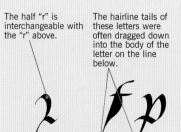

Basic structure

The bold body of the letter is contrasted by exquisitely fine hairlines used to connect strokes within a letter and letters within a word. The script is usually written with a "straight" pen, giving bold uprights and slender horizontals. A quill is probably best for this script; failing this, a sharp-edged nib can be used.

Structure	Strokes			Group

The two variations of pen angle may be seen on the "a", starting at nearly 60° at the left bowl, reducing to nearly 10° at the right stem.

Start the bowl of "a" with a fine hairline just above the x-height.

Return, and make a horizontal stroke extending beyond the stem.

Make the stem, finishing with a sharp upward flick.

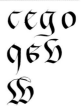

The "elephant ears" of the Secretary hand have been reduced to a serif on the ascenders of the Batarde.

Begin the stem of "b" at the right, finishing left before reaching the bottom of the x-height.

Add the lower part of the bowl in a downward movement.

Complete the bowl, starting at the left and crossing over the stem. Return, and add the top forward flourish.

The full-bellied double stroke of the "f" is characteristic. The pen angle of the cross-bar is almost at right angles to the lower stem.

The "f" requires practice. Start with the corner of the nib, using the full nib width on the letter body.

Twist to the vertical to make the hairline tail. Push the pen upwards and outwards to the top of the x-height.

Add the head-stroke and cross-stroke with the pen at a flat angle.

The abrupt changes of pen angle are evident in this hand. Imagine the hand dancing. This will give you the clue.

Holding the pen nearly horizontally move along the top of the x-height and down into the stem.

Add a foot and skate upward to the headline.

Move directly down and curve the right leg with the pen still flat. End by flicking upwards.

Batarde capitals

This set of capitals is in fact modern, dating from the 1920s, and of German origin. It works very well with the Batarde minuscule and is also compatible with the Fraktur minuscule.

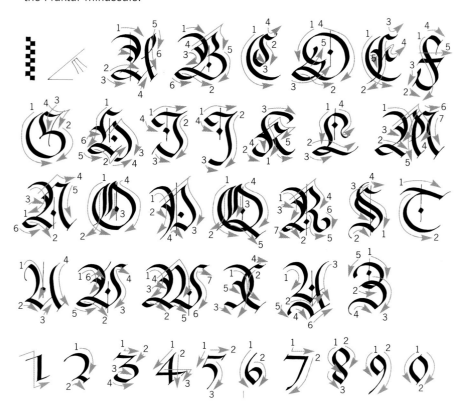

Points of interest

A full, rounded arc is common to many letters; some strokes overlap with hairlines. The diamond is used to fill space in the counter of a letter.

This is an alternative "S". If you decide to use it, make sure that it cannot be confused with the "G".

If extra weight is required, as at the start of a paragraph, you can make the main stem a double stroke.

Basic structure

This script is more generously proportioned than the minuscule. Hackles and diamonds give the letters more bulk. The letter strokes are fully rounded and take up a considerable amount of lateral space.

Structure	Strokes			Group

Although only two letters are demonstrated on this page, once mastered they will provide a good basis from which to understand the structure of the remaining letters. Most of the strokes are contained within these two examples.

Make a fully rounded arc ending in a hairline that stops short of the baseline.

Follow this with a second arc in the opposite direction, but below the first.

Make an upward tail from the end of the first arc.

Now, to the right of your first stroke, draw the stem crossing over the tail of the previous stroke.

Then, from the head of the stem, make a loop cutting through the stem.

Finish by adding a hackle, a hairline made with the corner of the nib. Finally, add a diamond.

These letters have a generosity of width, particularly noticeable in the rounded letters. The use of hairlines and diamonds helps to reduce the inner volumes.

Begin the "D" with a small arc, starting at the headline.

Starting at the left of the arc, make a long sweeping stroke that touches the baseline.

Return to the beginning of this stroke and link these two strokes with an upward arc.

Make a wide semi-circular arc to the right, creating a bowl joining the top and bottom.

From within the left part of the counter, make a downward stroke to join the outer loop.

Finish with a flourish, a hairline and, finally, a diamond.

Cadeaux or Cadels

These are probably the most complex of all versals. Originating in France in the early fifteenth century, they have remained in use as an introduction for indentures, deeds and charters until recent times. One of their chief attractions is that they can be as varied as you wish.

Points of interest

Space is always allowed between strokes. All major strokes are only joined by a connecting thin stroke.

A stroke can be made more dominant by adding hackles.

Bulges can also be used to make strokes more dominant.

The centres of these strokes have been made narrower by the angle of the pen.

These fine strokes are made narrow by using the corner of the nib.

Basic structure

This versal is a built-up letter consisting of a series of separated interweaving strokes linked together by finer cross-strokes. Because of the complexity of this versal, only the letter "L" is shown, but this technique can be used for other letters. As a starting point, the Secretary or Fraktur capitals are ideal.

Structure	**Strokes**		
Each stroke should be clearly separate from its neighbour. Allow a maximum of one pen width between each stroke.	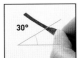 To make a simple stepped box stroke, move diagonally downwards, using the full pen width.	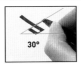 On reaching the termination, move to left, using the edge of the pen, move back, parallel to first stroke.	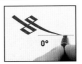 Move four stroke widths to right. Draw first box in reverse. Exit using a full pen width between first and last strokes.
This detail is from the head, showing a directional change.	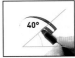 Sweep in a wide arc away from the stem, stop, move left and push back.	With practise this stroke can be drawn without a pen lift, following the directions in the first sequence.	This form of box allows for a small change of direction, and avoids overlapping strokes.
This stroke is ideal for adding weight to an arm or horizontal stroke.	Create a symmetrical grid, with three lines of equal length.	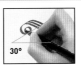 Create a swirl leading from the centre stroke.	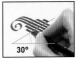 Complete with a series of reducing boxes, added to the outside of the first three strokes.
This detail is from the left of the stem, giving added decoration.	Sweep upwards and outwards, then loop back over the stroke you have made.	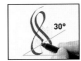 Now draw a parallel stroke, one pen width away from the your first stroke, stopping abruptly.	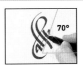 Move left at right angles. Push back to within a pen width, then follow the outer arc and move sideways.

Humanist minuscule

This is one of the most significant and defining of all Western scripts. Originally derived from the Caroline minuscule, its popularity peaked in the mid fifteenth century. It was fashionable in Italy, where it was used as a small-text hand, but most importantly provided a model for the Venetian type founders.

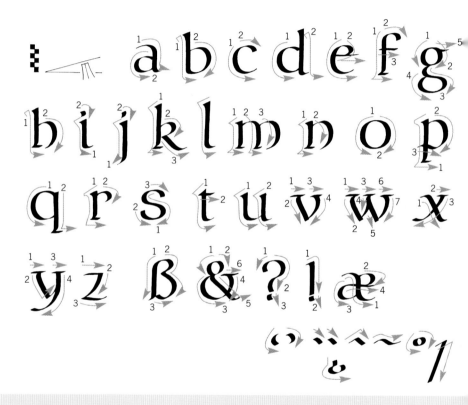

Points of interest

This hand can be written with either a "straight nib" as above, giving a vertical stress, or a "slanted" nib, giving a diagonal stress.

This "abc" has been written with a "slanted" nib. The diagonal stress is particularly noticeable on the "c".

The wedge serif can be substituted for a simple horizontal "slash"-type serif.

Basic structure

This script was often written in small or very small sizes and is arguably most effective at these sizes. Each letter is unambiguous and clearly defined. In modern use, ascenders and descenders are no more than three-fifths of the x-height. Use good interlinear space. Word space needs to be no more than "i".

Structure	Strokes			Group

The bowl of the "a" is relatively small, at probably no more than half an x-height.

The "a" is always two-storey. Make the top, stem and foot in a single stroke.

The bowl can be completed in a single stroke, or the bottom part can be drawn first.

Return, and connect the bowl to the stem.

coqs

On some versions of the Humanist minuscule the wedge serif is replaced by a simple horizontal stroke.

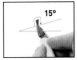

To make the wedge serif you can either push the pen upwards and outwards and down into the stem...

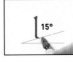

...in a single stroke, or lift the pen to make the serif with two strokes.

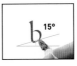

For the "b" give the stem a generous sweep along the baseline before completing the bowl.

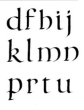

dfbij klmn prtu

As with the "a", the bowl of the "e" remains relatively small. In neither case should it be larger than the examples given.

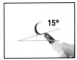

Draw the left of the bowl in a single stroke.

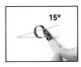

Make a small looping stroke and reconnect to the upper inner part of the first stroke.

Complete with a horizontal strike. This may connect to the following letter.

coq

Both bowls of the "g" are enclosed, with the top bowl smaller than the x-height.

The "g" is the most complex letter. Make a small arc, smaller than the x-height.

The link can continue from the second arc, or can be drawn separately.

To complete the letter, draw in the ear.

os

Italic

The Italic hand dates from about 1400, originating in the Humanist minuscule, from which it is chiefly distinguished by the single-storey "a" and by the full bowl and open tail of the "g". The letter is generally more compressed than the Humanist minuscule and has a forward, but not pronounced, slope.

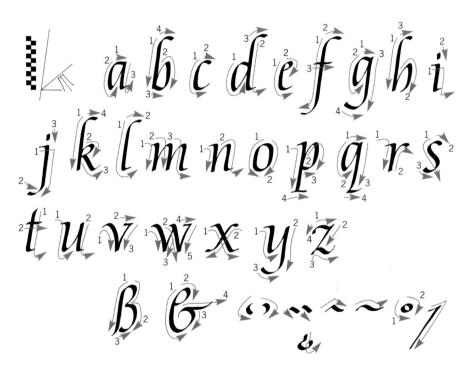

Points of interest

Probably the most common text hand used today, this Italic can be used in many forms (compare this with "Johnston" the more informal version).

Note that the outer bow loops back to the head of the stem before descending into the stem.

The interior space within letters should contain the same apparent volume as here in the "n" and "d".

The initial serif can form an important feature and care should be taken in its formation.

Where "t" follows "s", these two letters can be joined with this attractive ligature.

Basic structure

This is a formal Italic script with regulated letter shapes. The "a" and "n" provide the basis for most letters in this alphabet. The letters have a forward slope of about 8° and should not exceed this angle. Connecting strokes should spring from the base and join at the head as closely as possible.

Structure	Strokes			Group

Note the skating connecting stroke moves upwards at an abrupt angle, then connects very high on the stem.

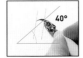

Holding your pen at about 40°, make the first small horizontal stroke at the head.

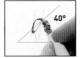

Return to the first part of the stroke, make the bowl. With the corner of the nib, connect to the end of the first stroke.

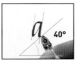

Draw the stem noting the angle of the foot, which has more of a sideways than a linking inclination.

The serif at the top of the "d" sweeps to the right. This represents a break with earlier traditions where it inclined to the left.

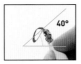

The first strokes of the "d" (also "g" and "q") are the same as "a".

Starting at about 2 x-heights, sweep down gently to the left and straight down into the stem.

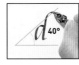

Lift and return to the top of the ascender and make a full serif to the right.

The "n" largely defines the straight-sided letters, particularly the slight variance of the angle between the serif and stem.

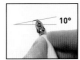

Make a short stroke at about 10° at the top of the x-height.

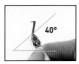

Turn the nib back to 40° and draw a straight stem.

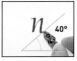

The arching stroke starts low down near the base of the letter, flattening at the top before returning to 40°.

The pen angle will produce a strong diagonal axis. Despite the curve, the sides of the letter seem straight.

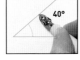

Hold the pen at 40° and write at a slope of 8°. Move to the left with a circular movement.

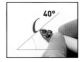

Draw a compressed semi-circle to the left.

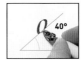

Repeat with a mirror image on the right; note proportion of the oval to determine other letters.

Italic capitals

These formal capitals are made to accompany the Italic minuscule, and have the same ductus and angle of slope as the lower-case version. The letters are based on earlier Renaissance models. Generally, the capitals are only used with the minuscule, but they can be combined if care is taken with the overall design.

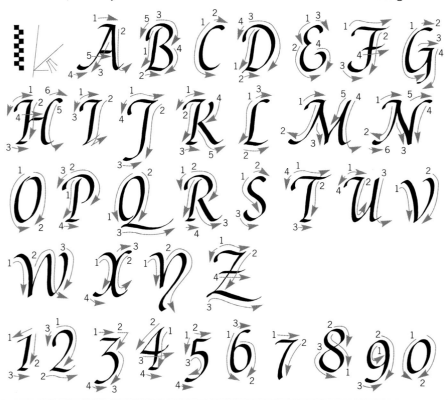

Points of interest

Most letters have a small, disciplined swash, but this is kept to a minimum and does not invade the preceding space.

The "W" in the alphabet is more historically correct, but many prefer this form for modern use.

These are alternative forms of "X" and "E".

This upward strike was favoured by earlier calligraphers. Apply to "I", "K", "P", "R" and "T".

Basic structure

These formal italics are used unobtrusively within text in the manner of modern capital usage, where the minuscule dominates and provides the textural colour. The forward slope is the same as for the minuscule; the height of the capital is generally less than the ascender height of the minuscule.

Structure	Strokes			Group

The commencing stroke carries a small swash and is a distinctive feature of many capitals.

Holding the pen at 40°, draw the top serif. (Top serifs may be left as this without further elaboration.)

Draw the stem. (Note the fine connection between the serif and the stem.)

Add the foot serif. The pen may be flattened to about 30°, producing a narrower foot.

B D H I J L M N P R T U X

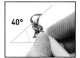 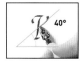 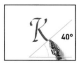

A small swash is added to the top serif. This may be more exuberant at the start of the sentence or paragraph.

This top stroke is inward turning. It is also acceptable to make this stroke outward turning.

The tail starts at the stem, but only just touches it. Do not start the tail from the mid top stroke.

The capitals are compressed and the "S" will define the width of many letters.

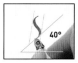 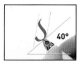 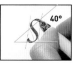

The centre stroke of "S" gives the slope of the letter.

To keep these slopes, tuck in the bottom stroke.

Bring out the top stroke. Both of these strokes are rounded without an inclination to follow head or baselines.

C E G O P Q

This "V" is also the basis of the "W" and also describes the first stroke of the "Y".

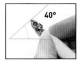

The first stroke of "V" and "W" starts well to the left of the 8° slope.

Start both of these letters with a wide arc reaching to the baseline.

The second stroke is more nearly upright, the combined strokes averaging about 8°.

W X Y

Italic flourished minuscule

These freely drawn italics have added flourishes on the ascenders and
descenders, and a "diamond" at the midway point on the body of the letter.
Although modern, the letterform derives from the late Renaissance italics.

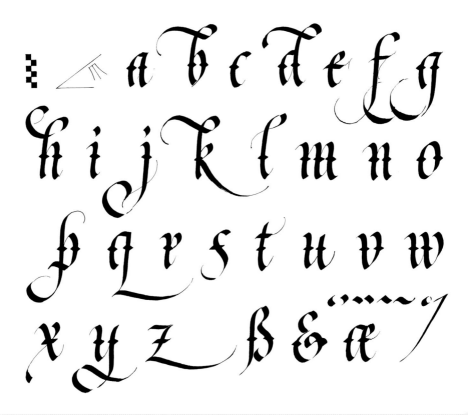

Points of interest

The diamonds give added
weight to the body of the
letter. The flourishes are
relatively restrained, but can
be extended for ascenders on
the top line and descenders
on the bottom line.

The flourish can be
adapted. Here the
bow has been
brought forward
beyond the stem.

Where "s" is
followed by "t",
always try to join
them with a ligature.

Try using the capital
form of "r". This is a
good space filler.

Basic structure

These letters have been drawn quickly with a felt-tipped pen and have not been re-touched. The principal strokes are connected by thin hairlines drawn with the corner of the pen. Drawn with the pen at about 30°, the letters slope slightly forward from the vertical.

Structure	Strokes			Group

The "a" is a defining letter setting the widths for many of the other letters. The diamonds occur at about mid x-height.

With the pen at 30–35°, complete the left bowl and skate up to the stem.

Draw a horizontal headline stroke before moving down into the stem and skating up into the next stroke.

Finally, turning the pen to a slightly more upright angle, add the two diamonds.

The exuberant flourishes and swashes, together with the diamonds, are the characteristics of this italic letter.

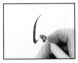

Begin the ascender to the right of the stem and sweep downwards, then up on the corner of the "b."

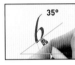

Draw a bowl and connect at the base of the stem.

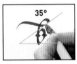

The length of the flourish and how much it projects forward of the stem is at your discretion.

The letters confined within the x-height are the poor relations of this hand. Only the diamonds give them added status.

The "n" begins with a pot-hook serif, using the corner of the nib.

The second stem is almost the same as the first. Notice that the letter has the same width as "a".

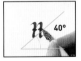

Complete the "n" by the addition of two diamonds.

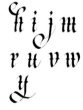

The "p" has both ascenders and descenders. All letters in this hand should be adapted to fit the space.

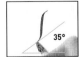

Here the "p" has both an ascender and a descender.

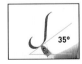

A flourish is added to the lower stem.

The lower bowl has an almost horizontal stroke crossing the stem.

Italic swash capitals 1

These Swash capitals accompany the Italic minuscule, and can be used in conjunction with or as an alternative to the Italic capital. The letters of the Swash capital were well established as a prestige letterform by the early sixteenth century, principally in Italy and Spain.

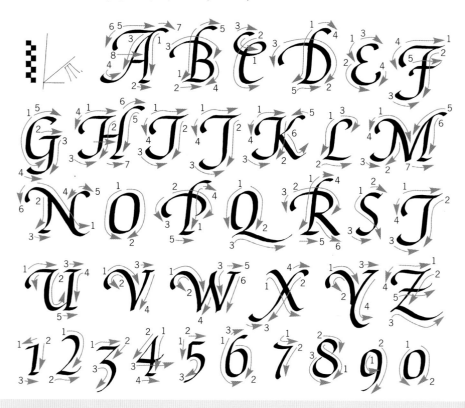

Points of interest

Whereas the calligrapher has little room for variation in the minuscule, the capital gives full opportunity for expression.

Flourishes can be added to the swashes.

The swashes can also be compressed and elongated.

These are alternative and more formal versions of "C" and "N".

Basic structure

The Swash capital should be drawn with the same pen as the minuscule. The swashes may extend horizontally, curving through the stem and finishing to the left. They can also be a vertical extension of the stem above the headline. In both instances they end with either a blob or a fully formed terminal stroke.

Structure	Strokes			Group

Although a simple letter, the "I" contains many of the characteristics found in other letters.

Form a long sweep along the headline; this will determine the length of the swash.

Sweep back and downwards to form the stem finishing with a sweep to the left.

Add a generous wash to the head and complete with a wide arc at the foot.

B H J K K L M P R T U

The swash capitals do not adhere to a rigid cap-height. This is noticeable where a stem breaks through the bowl.

Extend the stem above the headline. This also occurs on the "B", "P" and "R".

Starting at the headline well to the left of the stem, make a bold arc almost touching the baseline.

Add the forward swash and also at the top of the stem. Enclose the counter with a short stroke at the foot.

B C H P R T U V W Y

 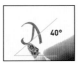

This is a slightly different variation again of the "N" with an outward loop at the foot.

The "M", "N", "V" and "W" all start with a wide outward sweep from the headline to the baseline.

Next draw the left leg. Note the alternative form of serif from the hand shown opposite.

This alternative right leg rises above the headline and terminates with a wide flourish.

A F K M

 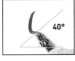

The "Q" is an "O" with the tail added, although on the "Q" the right side may be more rounded.

Both "O" and "Q" are relatively restrained and slightly square in shape.

When drawing the "Q" do not connect, but pull the outer stroke to below the baseline.

Any exuberant flourishes should be reserved for the tail.

C E O S

Italic swash capitals 2

These capitals may be used to accompany either the Italic minuscule or the Italic flourished minuscule and have been quickly drawn. It is, however, important to keep all parts of the letter sharp – quick but not hurried.

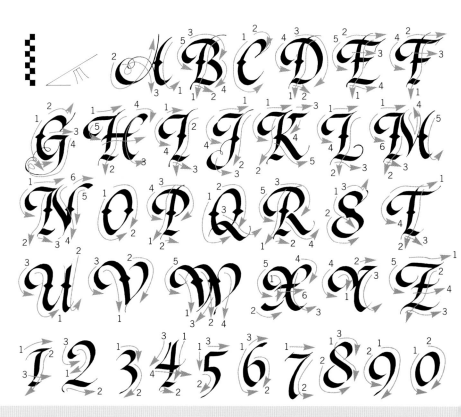

Points of interest

The swash, which projects to the left of the stem, usually occurs only on straight-stemmed letters; rounded letters may sometimes compensate by including hairlines. In this hand, the rounded letters are compensated with diamonds.

Alternative form of "E", avoiding possible confusion with the "F".

An alternative form of the headline serif ("T" and "M"), which can also be used on "F", "J", "K" and "L". This will have the effect of giving more weight to the letter.

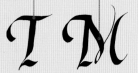

Basic structure

These letters were drawn with a felt-tipped calligraphy pen, which is ideal if your work is for reproduction and not display. As a general rule, it is advisable to use the same pen for both minuscule and capital.

Structure	Strokes			Group

These swash capitals are freely flowing and have been written quickly. This free approach is particularly noticeable on the "A".

Holding the pen at 30°, draw the right leg with a gently arcing stroke.

Begin the left leg at about the mid-point and, well away from the first stroke, skate upwards.

Return to the beginning of the first stroke, and skate a loop, connecting to the base of the first stroke. Add a diamond.

HM NRY

Notice the change in the order of the stroke sequence. As with all the stroke sequences, find the order that suits your hand best.

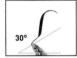

Begin with a hairline, before descending into the stem. Terminate well to the left of the stem.

Sweep through the stem with the upper bowl. Add a swash.

Draw the bow of the lower bowl, and connect the bowl with a baseline stroke. Add a diamond.

DEF HIJ KLM NPR

The "S", together with the "O", are the least flourished letters in this hand. Additional skating or hairlines may be introduced.

In a gently sweeping downward movement, draw the spine of the "S" first.

Now, add the lower loop in an almost semi-circular movement.

Add the upper loop, and a diamond, terminating in an upward flick.

CGOQ

The swash on the "U" sweeps naturally into the left vertical and provides a contrast to the right straight stem.

Make the left stroke of the "U" to show a distinct curve, then sweep upwards.

Draw the right stem vertically, in contrast to the first stroke. Leave a small gap between the two strokes.

Add the swash to your first stroke, and complete with two diamonds.

VW XZ

"Johnston" italic minuscule

This alphabet is based on the italics developed by Edward Johnston, which he used extensively during the later part of his career. He came to regard "sharpness" and spontaneity as key parts of letter-making. The evidence for this is seen in the hairline, which overlaps other strokes.

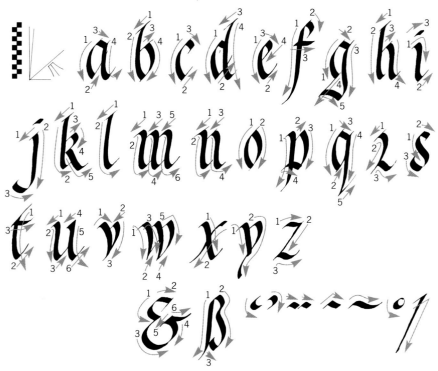

Points of interest

The letters are compressed, with minimal letter spacing. Where opposing bows occur, these are conjoined.

Letters usually start with a hairline stroke, quickly executed with the corner of the nib.

The hairline may extend beyond the letter.

The length of the ascenders and descenders varies, depending on the letters and space of the lines above and below.

Basic structure

Johnston designed this italic to be written quickly. However, unusually for a quickly written letter, there are a considerable number of pen lifts.

Structure	Strokes			Group

The single-storey "a" marks this script out as a true italic. The tight bow to the left of the bowl occurs on all of the rounded letters.

With the pen at 35° begin with a hairline, moving to the flat of the nib to make the bowl.

Lift and make a hairline into the stem. Return to make the headstroke.

Starting slightly above the x-height draw a curving stem with a hairline termination.

c e g o q

Keep your nib as sharp as possible and, with very light pressure, make hairlines as fine as the pen will allow.

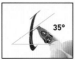

Lift and draw the curved stem. Make a short hairline in an upward movement.

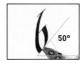

Make another hairline upwards from the stem to start the bowl.

Draw the bowl with a full nib, starting below the top of the hairline.

d h k l

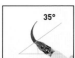

Where the bow of two letters occur opposite each other it is acceptable that they conjoin. This also helps letter spacing.

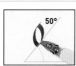

Increase pressure on your nib as you move down the stem.

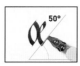

Make a mirror image to the right keeping the letter compressed. Note the pointed ends.

Repeat the first stroke of the "o". Make a small bow to enclose the counter of the "e".

a b c d e g
p q s

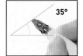

The "r" shown in the hands is a half "r", and it is perfectly acceptable to mix with the full "r".

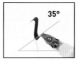

Holding your pen at 35°, make a short upward curving stroke.

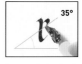

Draw the stem. The foot is a reversal of the first stroke.

Return to the head and make a narrow hook.

a f h i j k
l m n t u v
w x y z

"Johnston" italic capitals

These capitals have been drawn to accompany "Johnston" italics. Whereas italic capitals are usually Roman-based, these are derived from Gothic characters. It would be equally acceptable to incorporate Renaissance italic capitals (pages 138–139) as an alternative.

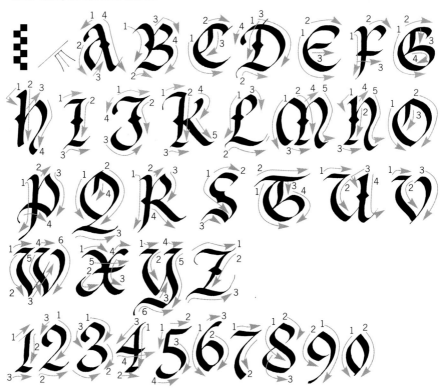

Points of interest

The width of the capitals contrasts with the compression of the minuscule. Hairlines should be used within or as joining strokes where possible.

If it seems too spindly the stem can be strengthened with a diamond.

Notice the change in relative widths between capitals and minuscule.

A vertical strike at the angle of the italic can help give added weight to a letter.

Basic structure

Gothic forms are prevalent in those capitals that accompany the minuscule. Generally, unless a lot of design consideration is given to a specific application, the letters should only be used singly within the text. Vertical strikes and diamonds may be used or omitted as required.

Structure	Strokes			Group

This is an alternative "A" taken from the Rennaissance capitals. The serif at the head may be omitted.

Begin with the left leg of "A" and add the foot.

Now draw the right leg with a wide downward sweep.

Add a serif at the same angle as the foot. At the same angle, add the centre cross-stroke.

C J K U V W X Y Z

The free-flowing, round cursive quality of this script is particularly evident in the "B".

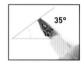

Hold the pen on the page at an angle of 35°.

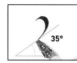

Then, make a wide sweeping bowl.

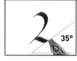

Make an equally generous foot; this will become the base of the bowl.

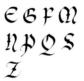

E G F M N P Q S Z

Return and make the upper bowl, starting with a hairline stroke.

Move downwards to make the upper bowl.

For the lower bowl move horizontally, then sweep downwards to accurately join the foot.

The "H" is also an alternative form and based on the "I".

Commence the head stroke and complete the trailing stroke with the corner of your nib.

The right side is an arcing stroke, beginning above the headline and ending with the corner of the nib.

Next add a head fillet, lift, and finish with the cross-stroke.

D F I K L P R

Cancelleresca formata

The Cancelleresca, developed in the Papal Chancery in the middle of the sixteenth century, has its origins in the earlier italic hands. It was regarded as the "de luxe" writing hand and is more upright and less cursive than its first cousin, the Cancelleresca Corsiva. This is a modern version.

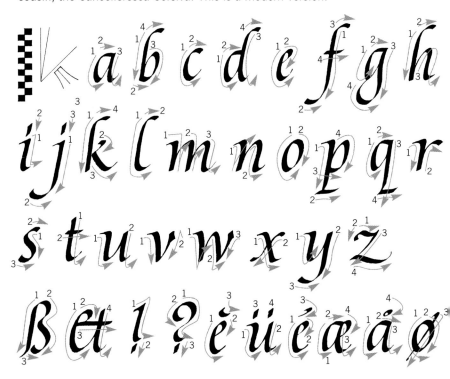

Points of interest

Although the ascenders are relatively tall, there is less tendency to elaboration. No single letter or group of letters dominate, giving the text an even overall colour. Letters may join, but the general effect is of individual, carefully drawn letters.

a The join is high on the stem, and the stroke skates from the bowl to the top of the stem.

n The serif is well defined; a slight vertical twist at mid-stroke will help suggest a waist to the stem.

d The ascender can be increased in height on the top line.

f The descenders can be increased in length on the bottom line.

st The "s" and "t" ligature. Historically, on prestige work the letters were separated with generous letter spacing.

Basic structure

The relatively upright character of the letters is a good indication of a more slowly drawn and considered letter, with the curves shallow and constrained. The alphabet has a quiet elegance, although allowing itself the occasional flourish on the top or bottom line. The letter adheres to a consistent x-height.

Structure	Strokes			Group
The round bow on the left of the "a" is repeated on all rounded letters.	Hold the pen at 40° and a slope of about 8°.	Make a top stroke from the bowl to the stem. Return to make the left of the bowl. Skate upwards to complete.	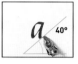 Move downwards and twist upwards on reaching the bottom to make the foot.	*c d e g o p q*
The ascender is relatively tall at about two x-heights.	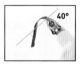 Begin the ascender to the right and sweep downwards into the stem, return and draw the serif.	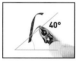 Move to the bottom of the stem and arch upwards to the right.	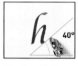 Move down into the right leg and make the foot.	*b f k l*
The widths of both rounded and straight-sided letters should appear visually the same.	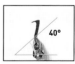 The serif can be made either as a movement outwards from or inwards to the stem.	At the base of the stem skate sharply upwards and turn.	Then move down into the right leg. Add the foot as on the "a".	*i j m p u y*
The first stroke is a defining stroke in this hand.	Draw a serif at the top of the x-height, keeping it relatively angular. Move down the stem.	Make a tight turn and skate upwards.	Move downwards and complete with the foot.	*i v*

Cancelleresca corsiva

The Cancelleresca corsiva was developed in the Papal Chancery in the Vatican in the mid sixteenth century and is the first cousin of the Formata. It was written with a considerable forward slope, facilitating greater writing speed, and in this respect anticipating the latter Copperplate scripts. This version is based on Cresci's exemplar of 1570.

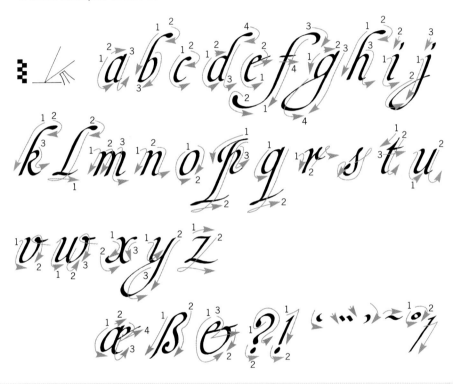

Points of interest

The distinguishing feature of the Corsiva is the terminating "blob" at the top of the ascenders. This was exaggerated by many contemporary scribes.

The stem of the "a" rises above the x-height.

In modern work the introductory and trailing strokes tend to be drawn open.

The swash and the tail may be exaggerated where space allows.

When writing with a quill, the springiness of the nib allows a large "blob" to be drawn.

This is an alternative form of "s".

Basic structure

The letters fitting within the x-height tend to be compressed and the junctures start and end near the top and bottom of the stem. By contrast, letters with ascenders or descenders are exuberant, with flowing ascenders terminating in a "blob", and descenders with sweeping tails capitalizing on interlinear space.

Structure	Strokes			Group

 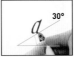

The width of "a" will define the width of many of the other characters. The stem characteristically rises above the x-height.

The slope of these letters is about 30°. Draw the outer bowl, but note the narrow oval form.

Return to the head and draw a short stroke to the stem.

Starting above the x-height, draw the stem ending in a small foot.

The two legs are rigidly parallel. This is also noticeable in "h", "m" and "u".

The "n" is also narrow, about the same width as "a". Note the small lead-in stroke.

Draw the right leg, beginning near the top of the left leg.

Like the "q", the small foot occurs on the "n". This may be extended where it connects to another letter.

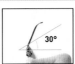 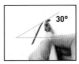 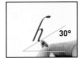

Formality is relaxed on letters with the ascenders. Note the delightful rounded "blob".

The "h" is the same width as "n". The ascender is about twice the x-height.

Return to the head of the ascender. Press on the nib and loop to make as large a "blob" as possible.

The right leg is the same as the "n".

This "p" provides a contrast to other letters, with the foot drawn as an enclosed loop and a swash at the head.

The script has generous ascenders and descenders. The "p" has a bold swash.

Return and make the stem and the slightly upturned foot, in one stroke if possible.

Make the bowl. Note that it is open and about the same width as "n".

Cancelleresca capitals

These graceful capitals can accompany the Cancelleresca Formata or Corsiva, and date from the mid sixteenth century. The letter forms may seem exaggerated to the modern eye; the beads remain a feature, but are less in evidence than on the Corsiva. Generally, capitals would not be used collectively, but in association with the minuscule.

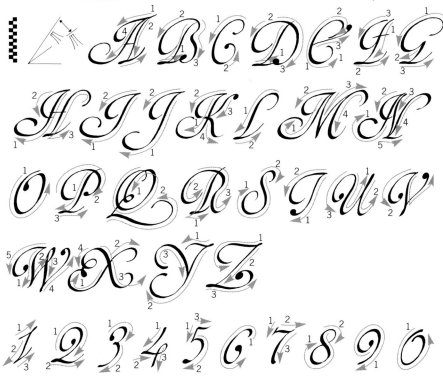

Points of interest

Swashes are an important characteristic and may be exaggerated where space permits. Notice the end of the feet, with the overlapping stroke following the baseline and finishing with a sudden upturn.

The forward slant is more pronounced than on other italics.

Here are some modern alternative strokes.

Basic structure

In a number of instances the pen is twisted from the basic angle of 35°, to the much steeper 55°, giving a thin stroke. With some practice you will be able to change the angle as you write – and you will find it a very satisfying movement. The pronounced forward slant of the letters is an important feature of this hand.

Structure	Strokes			Group

Three main strokes go downwards from the head, so the character can be achieved in a few fluid lines.

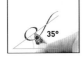

Start the left leg with the pen at 55°. Adjust this to 35° at the base. Make a generous loop.

With the pen at 35°, make a tight swash, almost touching the left leg.

Loop the foot with an upward flick. Add the cross-stroke.

The pen can be twisted to give a thin stroke, as in the stem of the "B". To make the bead draw in increasing circles.

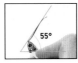

The stem is similar to the right leg of the "A". The stroke crosses over itself to meet the bead.

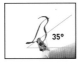

Make the two bowls in a single stroke with the pen at 35°. The bead is then added.

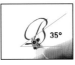

The swash is downward, as opposed to outward, and almost reaches the baseline.

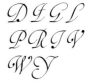

The oval stroke is made with the pen at 45° – a compromise between the two basic angles (35° and 55°).

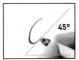

The "O" is constructed from two strokes. Draw the left loop first with a tight curve at the base.

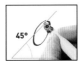

Pick up the second loop at the top. It should run parallel to and nearly touch the first stroke.

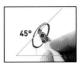

Finally, return to the top and draw the bead with a circular movement.

This simple stroke is twice as high as it is wide.

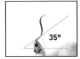

Draw the downward centre stroke first with the pen at about 35°.

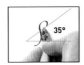

With the pen at the same angle, add the top stroke.

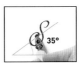

Draw the bead and then loop back to join the centre stroke.

Rotunda minuscule

The dominant Italian script, developed from the Caroline minuscule, had established its own distinctive form by the twelfth century. The script remained popular until the eighteenth century and was also widely used in Spain. In size its use varied from small text hand to large letters, as used in choral antiphona.

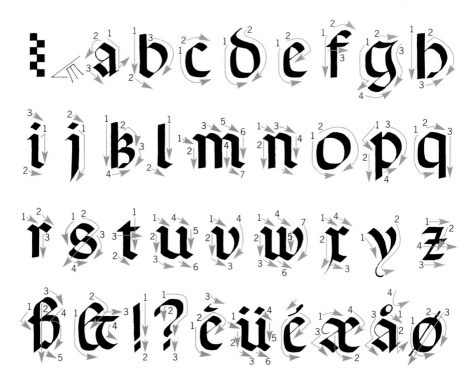

Points of interest

This is the most formal of scripts, especially when used in larger sizes. Each stroke is precise, almost geometric and meticulously crafted.

Conjoined letters can be used in any combination where there are two opposing bowls.

The half "r" can commonly replace the full "r".

The two halves of the "o" are different: the left stroke has a distinct angle, while the right is fully rounded.

This more Gothic form of "a" can be used as an alternative.

Basic structure

Although the base of some letters is square, this is a "slanted" pen letter with the pen rotating from about 30° to the horizontal at the foot. The formal precise structure of the letter allows for little individual interpretation.

Structure	Strokes			Group

The ascenders are characteristically short and the counters are full.

Begin the stroke with the pen at an angle of 90° and make a strong vertical stem.

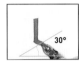

Before reaching the baseline stop and move down diagonally to the right at 30°.

Return to the top of the x-height and complete the bowl with a semi-circular stroke.

b ƀ q z

These are two alternative forms of feet for the right leg. Whichever one is used repeat for the "m".

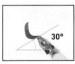

Begin with a short diagonal stroke at 30° before abruptly moving down into the stem.

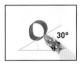

Repeat the first diagonal and move down into the right leg.

The second leg can finish with either a short sweep or an upward flick.

a f i j l
m r t u
v w r y

The left stroke of all bowed letters is angular compared to the semi-circle of the right bow.

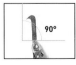

Hold the pen at a consistent angle of 30°–35°.

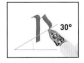

Make the right stroke fully curved, devoid of any angularity.

c d e g
p s

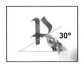

Occasionally, we can find examples of the Gothic influence, as in this stem and bowl of the "p".

Make a vertical stroke. At the foot twist the pen to horizontal.

Add an upward diagonal stroke to the right at 30°. Draw a wide bowl.

Complete the bowl with a horizontal stroke through the stem.

b o

Rotunda capitals

These Rotunda capitals accompany the Rotunda minuscule, and may be used with, or as an alternative to, the dual-stemmed Rotunda. However, in practice they would generally be used with the smaller text sizes. The Rotunda capital is very geometric in structure, with vertical stems and right-angle terminations.

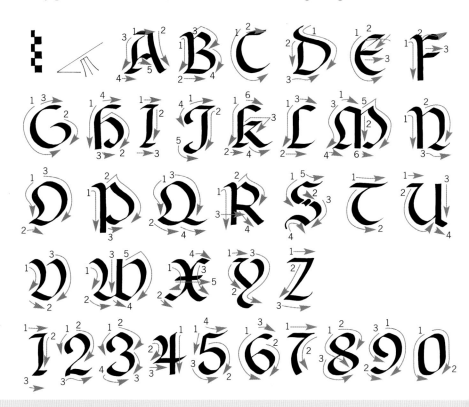

Points of interest

This script combines Roman and Lombardic characteristics, the "E", "H", "M" and "N" showing the most noticeable Lombardic traits.

The angle of the initial stroke leading into the stem may be used on "F", "N" and "R".

The alternative minuscule form of "S" can also be used for the capital.

The straight stems of this alternative "M" follow those of the minuscule.

This alternative "C" utilizes the basic structure of the minuscule "o".

Basic structure

The formation of these letters is broadly similar to that of the dual-stemmed capital, although the single stem will give the letter a much lighter look. The letters are characterized by the sharp-cut, precise and clearly defined letter forms that are particularly noticeable when used in the larger sizes.

Structure	Strokes			Group

The wide aspect of this letter is characteristic of this script.

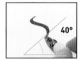

Starting above the headline, make a wide outward sweeping arc to the right.

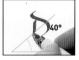

Make a short stem starting about one-third of the distance from the start of the previous stroke.

Now join the stem to the base of the arc with a generous foot.

A characteristic of the Rotunda is that on symmetrical letters one side is never the mirror image of the other.

Make a short downward stroke to the right at a 40° angle.

Turn the nib so that it is horizontal and move downwards to make the stem.

Return to the commencement of the first stroke and at 40° make an "s"-shaped stroke to the baseline.

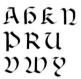

With the pen at the same angle move along the baseline to add a small foot.

Near the top of the centre stem add a short hairline to reach the headline. Make a wider "s" shape on the right.

Finally, complete the letter by adding an inward turned foot.

The left side of "C", "G" and "T" is rounded, corresponding to the right side of "O" and "Q".

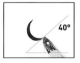

Make a fully rounded semi-circle.

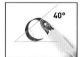

Now make a short stroke at the headline, but showing very little curve.

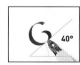

Make the tail with a half-sized semi-circle.

Rotunda capitals, dual stem

Powerful and geometrically formal, these capitals accompany the Rotunda minuscule, and were one of the principal and enduring medieval and Renaissance book hands in Italy and Spain. This dual-stem version would have been used in conjunction with the minuscule on medium and larger texts.

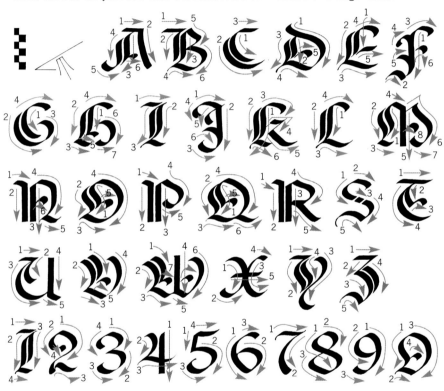

Points of interest

The dual stem produces a very bold letter; and where straight stems occur, their base is cut square and at right angles to the stem.

This is an alternative dual-stemmed "S".

Notice the wide outward sweep of the lower bowl; this occurs on the "D", "H" and "R".

This is an alternative "F". On the single-stem version above, weight is added with the inclusion of hackles and bulges.

An alternative fill-in where counters occur: a striked stroke and a diamond.

Basic structure

This letter, with sharp angles and some right-angle terminations, follows the structure of the minuscule. The gutter between strokes remains as close to a constant width as possible, and the dual strokes are parallel. The only monoline letters are "F" and "J" and sometimes "S". The dual stroke is only used once.

Structure	Strokes			Group

The distance between the two strokes should be kept to a minimum. There is never more than one double stroke on any letter.

Hold your pen on the page at about 40°.

Make a straight angled stroke from the headline down into the stem, angled away to touch the baseline.

Make a shorter stroke parallel to the left of the main stem stroke, but without lead-in terminations.

 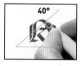

Add a small foot to the main stroke.

From the centre of the main stroke, move outwards at 40°, across horizontally, and return at 40°.

Complete the letter by adding a head terminal. The "B", "E", "I" and "L" are basically similar to this.

 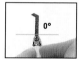 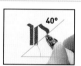 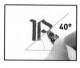

The right-angle dual step occurs on the "N", "P" and "R".

Make a short downward stroke to the right. Turn the nib until horizontal and move downwards to make the stem.

Return the pen to 40°. Make the right stem parallel to the first and return to head. Make a wide outer bowl.

Complete the bowl with a tucked-under terminal stroke.

 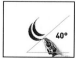

The "C" and the "G" are the only rounded letters and contrast the verticality of most of the hand.

Make a semi-circular stroke from the headline to within two pen widths of baseline.

Make a parallel semi-circle two pen widths from the headline and reaching the baseline.

Add a short head stroke from the first stroke and complete with a tail from the second stroke.

Roman capitals as versals

These are the most formal of the versal letters, and they are principally used in conjunction with the Humanist minuscule. Because of their formality, they can also be used separately from their versal context to create a bold caption or phrase. In structure, they closely follow the Roman form.

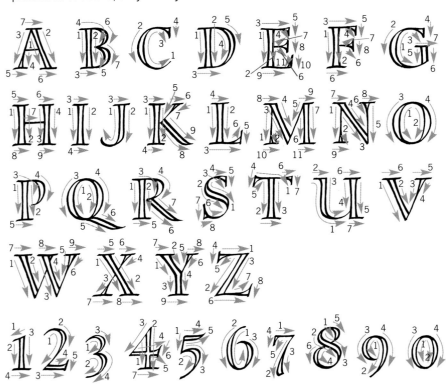

Points of interest

The serifs from a main stroke are unbracketed and formed from a single horizontal stroke, although the thin strokes separate to form a vestigial serif.

The pen is held at an angle, producing thick and thin strokes. Keep the serif ends as sharp as possible.

Sketch in the letter first and always begin with the inner stroke; then build your thickness onto it.

Colour can be added within or surrounding the letter, or both.

Basic structure

These letters follow the classic Roman form as closely as possible. The stems have a gentle waist, widening out towards the ends. The letters are drawn with a narrow, broad-edged pen held at 35°. The thin strokes are drawn a single-nib width.

Structure	Strokes			Group

 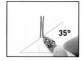 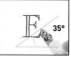 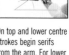

Serifs leading from a double stroke are drawn as a single line. Serifs leading from a single stroke are built up with a double stroke.

Accurately sketch in your letter before commencing.

Start with the stem in two thin, parallel strokes.

On top and lower centre strokes begin serifs from the arm. For lower and top centre, begin from the tip of the serif.

The "G" is based on the letter "O".

Draw the upper part of the semi-circle first. Return and complete the inner bowl.

On the outside of the bowl, add the second stroke.

Draw the top serif. Complete the "G" with a double stroke stem and horizontal serif.

 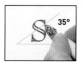

The counter on the upper part is always smaller than on the lower part.

The "S" is one of the more difficult letters, so begin by drawing the centre of the centre stroke.

The axis of circular letters may be upright or tilted, but be consistent.

Add the thickness to either side of this stroke, followed by the serifs.

 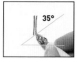

This "R" is drawn with the pen held horizontally, giving greater shading between thick and thin strokes.

Begin by making the twin strokes for the stem.

Draw a horizontal serif at the head, leading to the inner, upper bowl.

Add the outer bow. Draw a serif on the stem and then the tail.

Copperplate, Italian hand

The "Italian hand" dates from the middle of the seventeenth century and has its origins in the Cancelleresca cursive scripts. As with all Copperplate scripts, the pen is sharpened to a point and the variation in thickness is a product of pressure and not the angle at which the pen is held.

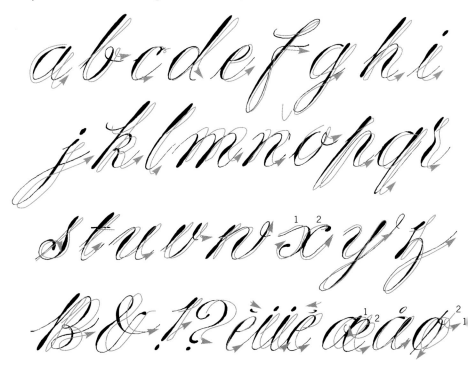

Points of interest

The ends of straight strokes terminate with a distinctive "blob", contrasting the even thickness of the English Roundhand script. Note the extreme angle of the slope.

Straight strokes are created with an overlapping movement.

Ascenders can be up to double the x-height. Consider flourishes at line endings.

Keep connecting strokes high on the stem. Not enough space here.

The half "r" is shown on the alphabet above. The use of the full "r" or half "r" is dependent on whether the preceding stroke trails from the top or the bottom of the letter.

Basic structure

The letter derives its shape from a very flexible and finely pointed nib, used with differing amounts of pressure and at an extreme angle. The angle of slope is at 40° from the vertical. These letters are one of the ultimate cursive scripts, with not only one letter, but where possible several written in a single pen lift.

Structure	Strokes			Group

The letter "a" will provide the basis for most of the rounded letters.

Loop the head and move downwards into the bowl, increasing pressure. Release and move up into the stem.

Increase pressure and make a loop. Move downwards, releasing the pressure.

The increase in pressure should fill the loop with ink.

The loops can be more exaggerated, the only proviso being that they are full and not open.

The loop at the head of the stem is to the right of the stem.

At the base of the stem the stroke is looped to the left and upwards to the top of the x-height.

Increase pressure in the centre of the stroke before turning into the hairline.

Where a "k" and also an "h" is used to commence a word introduce a flourish, otherwise use a straight stem.

Start with a stroke to the left of the stem, loop back over the stem and end with a straight stem or flourish.

Draw the upper bowl. From the straight stem this will be one continuous movement.

Loop at the end of the upper bowl at the stem, then draw the tail.

The ampersand shown in the hands is used with a running text. For a dramatic display use the one on the right.

The ampersand is one of the most beautiful characters. Find an excuse to use it!

Draw the cross-over strokes as close to a right angle as possible and avoid tight loops.

Throw your strokes as far forward as possible, contrasting with the main text characters.

Copperplate, English Roundhand

By the start of the eighteenth century this script had superseded the Secretary Hand as the business and vernacular writing hand. Its appeal lay in the speed and clarity in which it could be written. It spread across the world through British trading links and through the engraved Copperplate instruction manuals.

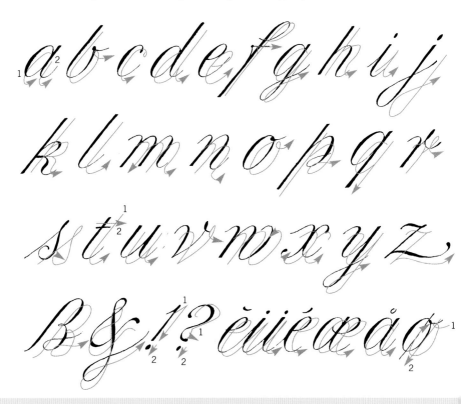

Points of interest

The stems of the letters are straight and can be drawn with the nib less pointed than for the Italian Hand. The thinner strokes can be made with the nib dragged on its corner.

A variant of the Roundhand allows the ascenders to be looped, as on this "h" and "f".

The bowl of the "p" can be open as on the "n".

The use of the original "w" was widespread, but is difficult to read in modern usage. This is a suggested modern variant.

Basic structure

To achieve the 40° slope it may help to keep the work as far to your right as possible; this will assist by giving greater flexibility to the wrist. Traditionally, the pen was held at right angles to the surface, with only the tip of the little finger touching the paper.

Structure	Strokes			Group

The English Roundhand is more formal than its Italian equivalent. We see this in the straight stems without loops.

Begin the stem with pressure on the nib. Ease pressure to the base and make a loop.

Continue upwards in one movement, or lift and start at the top of the bowl moving downwards.

The "f" is the only letter that occupies the space of both the ascender and descender.

Start with an open loop to the right; increase the pressure as you move down the stem keeping it straight.

Just below the top of the x-height move out to the left and then horizontally along the x-height.

This is an alternative "f" without the loop. Where a double "f" occurs you may use both types together.

The loop of the tail of "g", "j" and "y" can be adapted and lengthened depending on the inter-linear spacing you have available.

The first stroke of "g" is the same for "o". Increase the pressure at the midway point on the bow.

Begin the right stroke with pressure, releasing near the tail loop. Add pressure, then release to cross the tail.

An alternative tail. You will find this useful on the bottom line of a block of text.

The formality of the Roundhand as shown in the "h" with its parallel sides, and again on the "m", "n" and "u".

The first stroke is drawn completely straight with an even pressure on the nib.

Arc outwards from the stem until you reach the top of the x-height.

The outer leg is parallel to the stem and the trailing stroke echoes the curve of the arc.

Copperplate capitals

These capitals accompany the minuscule of both Italian and English Roundhand. In contrast to the flourished capitals, they are generally used within a body of text where emphasis or decoration is not a requirement. As with all Copperplate capitals, they should be used on their own with extreme discretion.

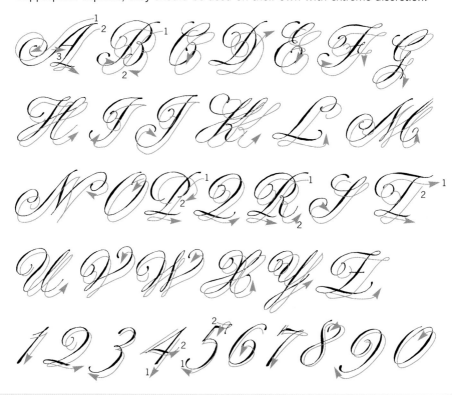

Points of interest

The capitals, unlike the minuscule, are devoid of any straight lines. The stems move downwards in a gentle swelling and sweeping line, terminating in either tail or loop.

Let your letters join together naturally and adapt them where necessary.

Avoid thick strokes crossing one another. The ideal is a thin stroke crossing a thick stroke. The contrast becomes apparent between the cursive capital and the straight lines of the minuscule when these two "P"s are compared.

Basic structure

The letters are sloped at 40°. The progressive swelling of the strokes is produced by increasing the pressure on the pen. The nib must be pointed. The flourish of "B", "D", "P" and "R" projects considerably to the left of the stem.

Structure	Strokes			Group

A series of bold black lines ruled at 40°, placed under your writing sheet, can be helpful in maintaining the angle of slope.

Your ellipses should be centred over the 40° slope. Keep your work well to the right.

Move upwards in a swift stroke to form the left leg.

Then sweep down and loop for the right leg. Finish by adding the cross-stroke.

Notice how low down on the stem the bowl commences. This also applies to "B", "P" and "R."

Start to the right of where the stem will be, increase pressure as you descend, release and loop to the left.

Cross over to complete the bowl. The bowl is small, the preceding ellipse is much larger.

Now in a continuous movement create the stem.

The "G" and "Y" unusually for capital letters both descend below the baseline.

Begin the flourish to the left. Make a generous bowl and then loop back through it.

Loop upwards making a lower bowl.

Make the lower counter and sweep back through the tail.

The open bowl of the "Y" stops before reaching the baseline.

The fourth type of flourish, beginning midway and rising to the headline…

…before moving downwards into the body.

The loops at the top and bottom of the stem are tight and contrast with the openness of the flourish.

Copperplate flourished capitals

Characters printed by copperplate engraving were introduced in the sixteenth century. This set exacting standards that few scribes could match with their quills. These capitals are based on a seventeenth-century model, but regularized to give a more typical width.

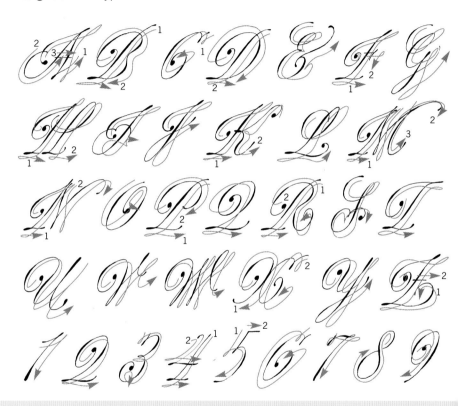

Points of interest

The circular terminating dot provides a focus on each letter and the large downward bow provides a distinctive characteristic feature.

The bows of "B" and "R" gently undulate, and the usual separation of the bowl is removed.

This is an alternative "H"; a further modification could include a loop and a foot.

An alternative "Q"; the usual "Q" was identified by following the "u" in Latin-based languages.

Basic structure

The letters are created using a finely pointed, as opposed to a square, nib. The variation in stroke thickness results from varying the pressure on the nib. As with all copperplate scripts, these letters should be written with the minimum number of pen lifts; the forward slant helps with this and also adds speed.

Structure	**Strokes**			**Group**

Practise with "D" first. Place a sheet of bold diagonal lines at 40° under your worksheet to give you the angle of slant.

Although the letters are designed to be written spontaneously, you will initially find it helpful to pencil them in first.

The large downward outer bow should ideally be completed in a single stroke. Terminate with a blob.

Draw the stem to cross over the bowl at a point about midway between the outer bow and bowl.

The foot of these capitals is almost parallel to the baseline. Allow the loop to fill with ink.

Start by drawing the stem as the first stroke.

Start low down with a blob. Move upwards increasing the pressure. Release the pressure as you cross the stem.

Increase the pressure again as you reach the outer parts of the upper and lower bowls, then link to the foot.

The bowl of the "G" does not descend to the baseline. Allow the linking stroke to connect to the following letter.

Start at a midway point on the bowl and complete the lower half in a single stroke.

Starting at the uppermost point draw the top part of the letter and connect.

This letter has been drawn as a monoline letter and thickness is added later.

The "M" is usually a wide letter. In these capitals it takes up no more width than other characters.

Start the left leg with the same stroke as "B".

Draw the bow low down to the left of the stem.

The rest is completed in one stroke. The loops are tight, allowing them to fill with ink.

Neuland minuscule

These modern minuscule characters are designed to complement the capitals originally created by Rudolf Koch in the early twentieth century. The individual strokes are more segmented than on the capitals to accommodate the boldness of the characters.

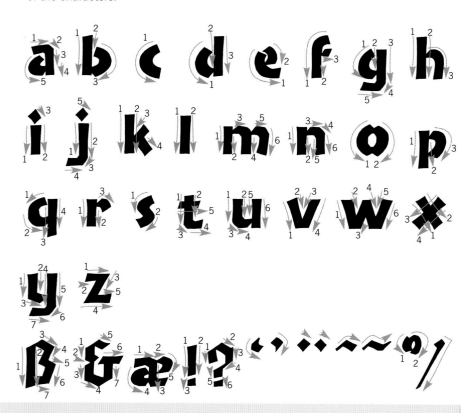

Points of interest

Straight-stemmed letters generally adhere to the x-height and are squarely cut along it. A few curved characters break the line at an acute angle.

The stems are slightly concave. The ascenders and descenders are restrained.

Keep a good wedge of white between strokes.

This is an alternative "d".

Basic structure

As with the capitals, these letters allow for a high degree of personal interpretation and are built up from overlapping strokes. They can also be made by drawing in fine outline and filling in, or they can be cut out from paper. The latter method is particularly suitable for large-scale work.

Structure	**Strokes**			**Group**

h

The x-height is approximately 2.5 nib widths, with the ascender about a single nib's width.

You will probably find it easier to sketch them in pencil first.

These letters are outlined with a fine pen after outlining in pencil.

If you use this method remember that your model should be based on a broad-edged original.

b d j k l m n q r t u y

s

The "c", "e", "o" and "s" can be drawn as a filled-in letter.

The curved strokes are generally larger and break the line of the x-height.

The "s" is built up from segments, using a pen the same width as the stroke.

Note that the letter always terminates at a right angle to the stroke.

a b c e g o p q

e

The "c", "g", "o" and "q" are similar letterforms in this hand. Note the top of the bowl does not connect with the stem.

Because of the boldness of the letter the centre stroke is drawn with the pen edge-on.

The pen is twisted through 90° to draw the lower part in a single stroke.

c g o q

g

Similar to the "e", the top of the bowl of the "g" does not connect with the stem.

Make a straight stem to a full pen width.

Alternatively, make it from two strokes from a narrower pen to form a slightly concave stem.

The bowl can be made in three separate segments or by twisting the pen in one stroke.

j p q y

Neuland capitals

These capitals are based on the letters designed by Rudolf Koch in the early twentieth century. Originally, they were supposedly cut out of black paper. They are vigorous and bold, and work well when closely spaced. Ideal for large-scale work, they also work well with modern Gothic minuscule.

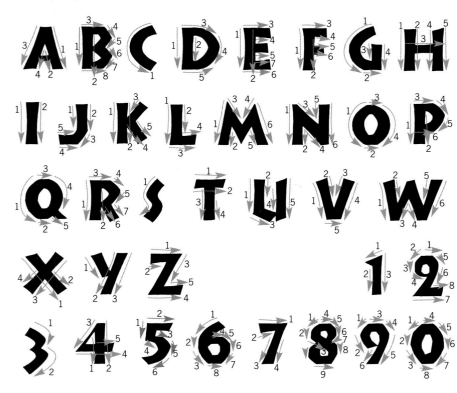

Points of interest

Most letters adhere to a square head- and baseline. Where a broad-edged pen is used, the pen angle is as far as is practical to right angles to the direction of the stroke.

The stem and straight strokes are concave.

Most letters will be the same height but where they break away keep the strokes noticeably above or below the letter height.

These letters can be constructed in a number of ways.

Basic structure

The letters are a freely drawn sans serif with concave straights and curves constructed from a number of irregular straight segments. Each letter is of a similar total weight, although strokes can vary. As long as these rules are followed, there can be a personal interpretation in their structure and execution.

Structure	**Strokes**			**Group**

The stem width can vary between 2.5 and 3.5 stem widths.

Letters can be drawn directly with the pen or laid out in pencil first.

The outlined traced letters can then be overdrawn with a pointed or a broad-edged pen.

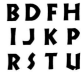

B D F H I J K P R S T U

This "O" clearly shows the manner in which the letter is made up of a number of segmented strokes. This is the best way to draw the hand.

Outline with either a fine pen or pencil.

Then fill in the letter. The first method will produce a complete letter.

This letter has been drawn with a broad-edged pen in a single stroke.

C D G Q R

This illustration shows the letter built up with a broad-edged pen of about two-thirds of the stroke thickness.

Build the letter up in segments with the pen at right angles to the stroke.

Note the termination of the curved strokes that rises above the cap height. They are at right angles to the stroke.

Alternatively, fill in an outlined letter.

C G

On the straight strokes the two strokes overlap closing at the centre to produce a single concave stroke.

The right diagonal aligns with the head- and baselines.

The terminations of the left diagonal are at right angles to the stroke.

Note that all the terminations are at right angles to the stroke.

A M N R V W Y Z

Roman minuscule, pointed pen

These minuscule letters have been designed to accompany the pointed pen capitals. Built up from a series of small strokes made with a pointed pen, they generally follow the form of the Humanist minuscule and are slightly more compressed than the capitals.

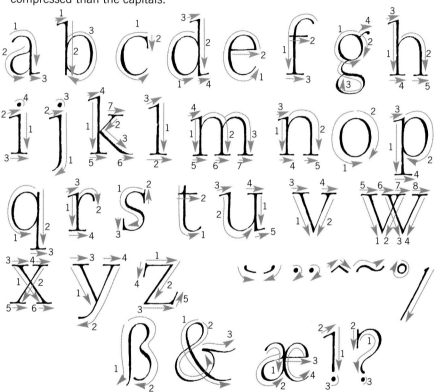

Points of interest

The head serifs are slanting, but follow the form of the other serifs. They are not wedge-shaped, and they terminate in a small blob.

Note the difference in angle of the two serifs.

The "w" can be drawn in two different ways.

The axis of the rounded letters follows the manuscript form and is slightly tilted backwards.

Alternative single-storey form of "g". (This form should be used if the letter is italicized.)

Basic structure

Drawn with a pointed pen, the letters are carefully built up from pencil layouts. Although the design may be freely adapted without adhering to a formal structure, the drawing of each letter should be meticulously considered and very little left to chance or accident.

Structure	**Strokes**			**Group**

The bowl starts at about mid stem. Avoid making the counter too small.

Build up the letter in stages, starting with a pencil or traced letter. Start by inking the letter with a fine stroke.

Build up your bolder strokes, paying particular attention to the distribution of thick and thin.

An alternative "a": straight-stemmed and single-storey.

The width of "n" is determined by the width of "o" and the serif formation of "i".

The first stroke is the same as for the "p", but shorter and provides us with an "i".

The arch is almost semi-circular. The width will be consistent with other letters, appearing the same.

Another arch converts the "n" into an "m". Note the smallest fillet on all letters between the stem and serif.

The critical point to observe is the volume within the counter. This volume should appear the same on all letters.

The top serif is slightly inclined, which is suggestive of the wedge serif of earlier scripts.

The bowl of "p" (and "b", "d" and "q") derive directly from "o", which should be used as a model.

The angle of the "v" should determine the degree of slope as far as is practical on the "w", "x", "y" and "z".

First draw the "v". Note: serifs crossing the stem are horizontal.

This "w" is made by overlapping two "v"s. Serifs are joined with space between them.

An alternative "w." Outer strokes are steeply inclined.

Roman capitals, pointed nib

These letters are built up with a series of pointed pen strokes. As they lack cursive qualities, they do not fall into the category of a script; nevertheless their elegance, derived from Roman originals, endears them to many calligraphers. Although the letters are light in weight, the shading adheres to original forms.

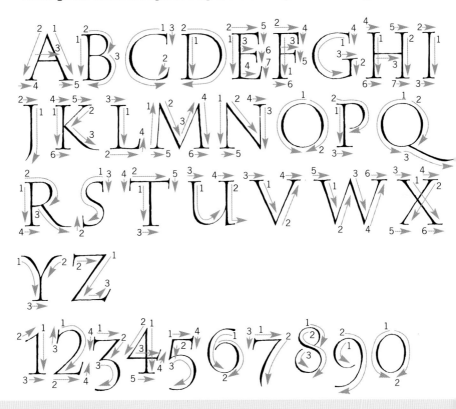

Points of interest

Serifs are lengthened and close examination reveals them terminating in a small blob. The letters are spacious without any compression.

The letters will work well without adherence to a formal structure. As long as the shading remains correct, the forms can be freely adapted.

The shape of this alternative "U" will work well when used informally.

Do not use the tail of the "R" as a prop as here, but let it gently flow away from the bowl.

This is not a spontaneously drawn letter. Carefully work out exactly what you want to do in pencil first.

Basic structure

The letter proportions will remain close to classic originals and show a range of different letter widths: "E" and "S" are narrow letters, while the "C", "G," "O" and "Q" are nearly circular. The letters are built up slowly, ideally on textured paper, in a series of small strokes using a pointed nib.

Structure	Strokes			Group

If your strokes are hesitant, so much the better. Better still is if your strokes are broken by the texture of the paper.

Carefully build up your letters from pencil drawings. Do not look to either spontaneity or chance.

The left leg follows historic precedents by being lighter than the right.

Make the serifs generous and ensure that there is a small fillet between the serif and the stem.

MN V
W X Z

If the "P" does not join the stem allow the round bowl to taper away. It can be marginally smaller than the bowl of "R".

The first stroke is almost identical for all upright stem strokes.

The bowl of "P" can join the stem.

Use the outer tip of the top serif to form an imaginary axis for the diagonal of the tail.

CGO
QU

The top bow of the "S" is always marginally smaller than the bottom to prevent a top heavy appearance.

The centre stroke of "S" moves forward in a smooth sweep.

Continue the arc around, lift the pen and finish with a serif.

The top serif does not extend beyond the bottom bow.

B

An alternative "W" to the one shown opposite is demonstrated here.

Start by creating a "V".

Create another "V", conjoining the two horizontal serifs.

A M N
V W

Open roman capitals

These Roman capitals are freely based on the script of the renowned Icelandic calligrapher Gunnlaugur Briem. The underlying principle of this script is the classic Roman inscriptional letter, whose relative proportions and distribution of thick and thins it follows.

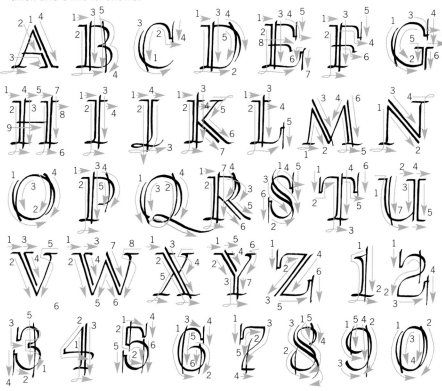

Points of interest

The formality of the Roman letter is broken by allowing one of the stem and bowl strokes to project beyond the end of the letter without termination.

The unterminated strokes present opportunities for flourishes and swashes on arms and tails.

An alternative square-headed diagonal. This can also be applied to "A" and "M".

An alternative "R". The bowl is not connected to the stem.

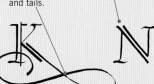

Basic structure

The thinner strokes of the Roman letter are drawn as a single stroke. The bolder strokes are drawn as two separate strokes, not as a double stroke. The narrow broad-edged pen is held at an angle, allowing a degree of shading to occur within each individual stroke.

Structure	Strokes			Group

As a preliminary to drawing the letters, plan them carefully, working either directly in pencil or a tracing.

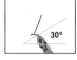

Begin with the left leg. Notice that the serif is looped.

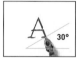

Draw the inner right diagonal stopping short of the cross-stroke. Add the cross-stroke, inner diagonal and serif.

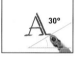

Complete with the outer right diagonal parallel to the inner stroke and add a serif to the right.

Notice the way horizontal serifs loop over and also how thickness is added to the bowls by the use of a strike.

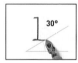

Begin with the top serif, move down the outer stem, then left at the foot, loop and proceed to the lower bowl.

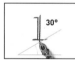

Draw the inner stem starting above and finishing below the head- and baselines.

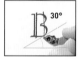

Draw the top and bottom bowls in a single stroke, then end with a single strike on the inside of the bowls.

The serif formation is different when applied vertically where no looping occurs.

Move to the left from the headline and make a slightly curving stroke to the baseline.

Return and complete the inner part of the top serif.

To the left of the first stroke make the outer bowl, proceeding through to the tail. End with a serif at the head.

This is quite a difficult letter to draw. Careful pre-planning will pay dividends.

Begin the spine above the cap height and sweep through to the lower serif.

Begin the lower spine stroke at the cap height and sweep down below the baseline.

Finally, with a vertical stroke draw the serifs.

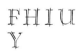

Brush script, broad-edged minuscule 1

These letters are based on the scripts originally pioneered by the American calligrapher Arthur Baker. As informal letters they are particularly suitable for small amounts of text. Once the ductus has been mastered, the letterforms should form an adaptable basis for expressive calligraphy.

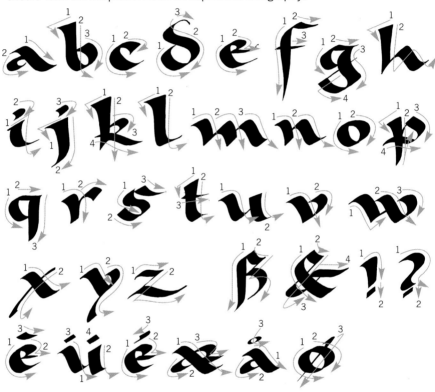

Points of interest

Drawing these massively bold letters with a stroke of about two brush widths requires very considerable expansion of the letterform.

For informal use, the ascenders (and descenders) can be adapted and increased in height as part of an overall design concept.

Freely use connecting strokes; it is not necessary to adhere to a consistent x-height.

Basic structure

Although the alphabet has been drawn with a brush, consider also using a broad-edged dip pen. In either instance, twisting the pen or brush as the individual strokes are made is an integral feature of the letter. The generous wide flow of letters such as "h", "m" and "n" is particularly important.

Structure	Strokes			Group

This is an alternative to the "d", opposite. The ascender inclines to the left, following traditional forms, but retains a bold serif.

With the brush edge, make a downward sweep to the left. Then make a wide sweep to the baseline.

With the brush at 45° make a bridge into the right leg.

Finally, connect to the first stroke to complete the bowl.

The angle change is particularly noticeable in the first stroke of the "m". This can also be seen on the "h", and the "n".

Make the stem with the brush at 45°, and arch into the right leg.

For the descenders, start at x-height and make the stem as for "h".

Return, skating upwards and outwards.

The illustration for the "h" shows particularly well how the bold ascender is formed, commencing with a fine downward stroke.

Starting at 30° and the brush edge-on, make a short headline stroke, before arcing back to finish at 45°.

With the brush edge-on and still at 45°, move upwards, to the right to create an arch.

Finish with a wide outward sweep, terminating with an upward flick.

The "p" is the most complex letter in this hand.

Move down the stem to the baseline. With the brush edge-on, move upwards and out.

Create a bowl with the brush at 45°, turning the brush on its edge at the end of the stroke.

Finish with a cross-stroke, joining the bowl to the stem.

Brush script, broad-edged minuscule 2

Many brush aficionados will claim that the brush gives far greater control than can ever be achieved with a pen. Perhaps this script will give you the opportunity to decide for yourself.

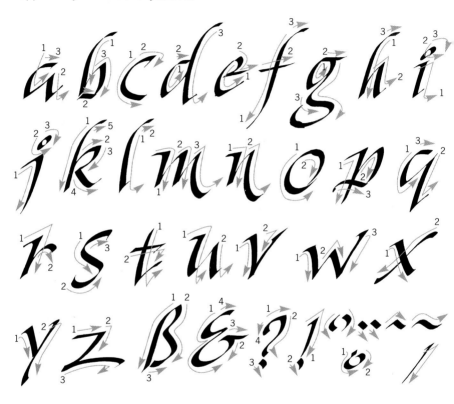

Points of interest

The connecting strokes are very angular and drawn with the corner of the brush.

Although these letters have been drawn with a similar ductus, the bows are more rounded and the brush held more horizontally.

When drawing an informal letter, serifs, lead-in strokes, terminating strokes and stem angles can be interpreted in various ways.

Basic structure

These letters were drawn with a chisel-ended, broad-edged brush. For this script it is important the brush is in peak condition and holds its chisel edge when loaded. You will also find that gouache will give you better results than ink because it can be mixed to a thicker consistency.

Structure	Strokes			Group

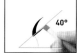

The bottom angle which connects the bowl to the stem is at about 35°, which is also the general angle at which the brush is held.

Make sure your brush is full. End the first stroke with the tip of the brush.

Move down into the stem, then upwards into the terminating stroke.

Finally, add the headline stroke keeping it separate from the stem.

dghiq tu

A slight gap is allowed between the stem and the lower part of the bowl. This also occurs on the "q" and the "g".

Begin with the corner of the brush, slightly twisting and increasing pressure as you move down the stem.

Then add the bottom of the bowl.

Arch upwards from the base of the stem and with a sharp downwards turn complete the bowl.

dfhk ln

This is an alternative "e". The step-by-step is derived from the "c".

The "c" could commence as an "a", but the alternative form introduces variety.

Return to the headline and add the top stroke.

Finally, add the cross-stroke.

cgoq s

The "m" and "n" demonstrate the up-down movement of this script. These strokes can be applied to "h".

Make a hairline stroke and move downwards into the stem. The serif fillet can be an add-on.

Arch upwards and down to then create the middle stem.

Arch upwards into the right leg. It is larger and more sweeping to give contrast and informality.

hijnp ruvw y

Brush script, broad-edged capitals

These broad-edged capitals are relatively informal, although adhering to a not-too-rigid cap height. The letters are very bold and expanded, and built up from two separate strokes.

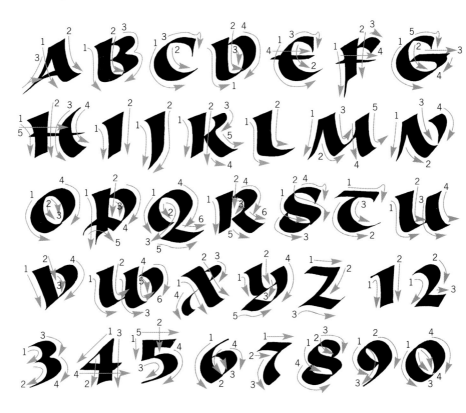

Points of interest

Straight-stemmed letters have a serif to the left of the stem. The right side is straight and pointed.

Notice how the first stroke is used to form a serif before it sweeps into the stem while the second stroke is vertical.

The serif can be made by twisting the brush.

This is a more formal "M." Once you are familiar with the ductus, try creating your own variations.

Basic structure

The letters can be made with a wide chisel-edged brush or built up from two strokes using a narrower brush. The advantage of a narrow brush is that it draws stems and bowls with a double stroke, which gives differing curves and angles. Ensure your brush is in good condition and when loaded gives a fine chisel edge.

Structure	Strokes			Group

The first stroke of the "A" is freely drawn descending below the baseline. This may be repeated on the "M" and "N".

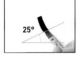

Begin with a single stroke sweeping downwards to the right.

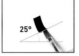

Add an additional thickness to this stroke.

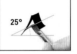

Turn the brush onto its corner and with a quick flick draw the left leg and the cross-stroke.

Avoid the tendency in this hand to reduce the volume within the counters. Pull the bowl away from the stem.

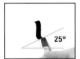

Make a short downward stroke to the left, then sweep back into the stem curving into the lower bowl.

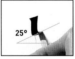

Now make a second stroke parallel to the first to thicken the first stroke.

Now draw the upper and lower bowls in a single stroke. Add the outer stroke.

To produce the top serif is one of the most elegant movements in brush calligraphy. Refer to the Trajan inscription.

Holding the pen at 25°, make a semi-circle.

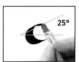

Then add a semi-circle on the inside.

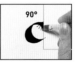

Move along the headline, brush at 30°, and as you reach the end twist your brush to the vertical.

Despite the apparent informality of the hand, distribution of thick and thin strokes follows that of classic inscriptions.

Make a single downward sweep to the left, return and make the inner diagonal.

Thicken with the second diagonal and a fine connecting stroke to the right leg.

Complete the letter with a double stroke.

Casual brush script

This Brush Script, freely based on the dry-transfer script, Nevison, is characteristic of many scripts that appeared in advertising in the 1950s. The letterform derives directly from the paints and brushes used to create them.

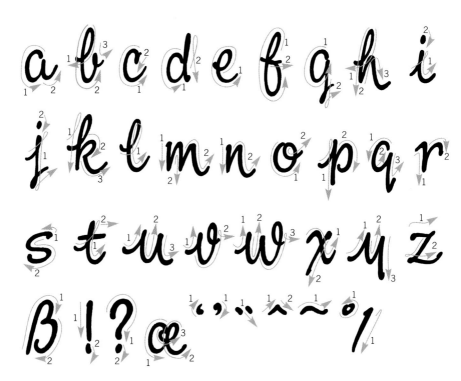

Points of interest

The letters simulate a natural handwriting, refined by the change in writing material. They utilize the viscosity of the paint for effect. Two-stemmed letters are narrow, while rounded letters exhibit full counters.

Notice the relative widths of rounded and straight-sided letters.

Make sure that the ligatures logically connect to the following letters.

Basic structure

This monoline brush script needs some pre-planning: write out your letters first with a felt-tipped pen, then analyze them, making corrections before you start. The letters are designed to be linked in a continuous movement. The paint needs to have the right consistency for the letters to be drawn effectively.

Structure	Strokes			Group

a

The bowl is lower than the right stroke – this variation is important to give the letters movement.

With a loaded brush of gouache mixed to the consistency of cream, make the first bead.

From the first bead, with the brush nearly upright, make the bowl in one movement.

Loop and anticipate the next letter.

c d e g o s

b

The height of the entry and exit strokes can be varied depending on the position of the surrounding letters.

The "b" has a generous loop for the ascender.

Complete the loop and make a wide sweep for the bottom of the bowl.

Complete the ligature to the next letter.

f i j l p t

h

Keep the loop rounded and away from the stem. The trailing stroke is lower than the stem, suggesting movement.

The "h" begins, like the "b", with a generous loop for the ascender.

Make a tight loop down into the straight stem.

Move quickly upwards and down into the right stroke.

k x y

m

The upright strokes are more compressed than the rounded strokes.

Begin with a bead. Then move quickly downwards and upwards.

Loop over and down into the central stem, then back up.

Move into the final loop in the same continuous movement.

n r u v w z

Casual brush script capitals

These capitals accompany the minuscule, and are freely based on the script designed for dry transfer lettering. Use gouache paint mixed to a creamy consistency on a loaded, slightly rounded brush.

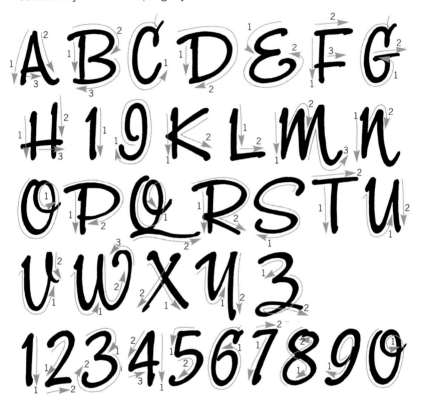

Points of interest

The letters must be written using paint and a brush. This requires different skills than writing with a broad-edged pen. You can practise the wrist movements with a felt-tipped pen (and plenty of paper).

Notice the difference in the widths of the letters. A tight up-and-down movement contrasts with a wide horizontal stroke.

Alternative forms of "Q" and "E". Notice the low cross-stroke on the "E" that also occurs on the "F" and "H", above.

Basic structure

This is a monoline brush script capital that does not strictly adhere to the cap height. The letters vary considerably in width; letters with two or more stems are narrow, as are the round letters "C", "G", "O" and "Q". Some linking of letters occurs between capital and minuscule.

Structure	Strokes			Group

A

The left leg is almost straight, in contrast to the curve of the right leg. This is important in most free scripts.

Making sure your brush is fully loaded, draw the left diagonal in a single stroke.

Next draw the right diagonal and hook the end to create a connecting stroke.

Finally, add the cross-stroke, starting on the far side of the left diagonal.

KXH

B

A characteristic of this script is the variation in letter width. Notice how wide the "B" is.

Start below the headline, moving up and then down into the stem.

Sweep a generous arc over the stem to create the top bowl.

Move straight into the lower bowl. Note that the top bowl is larger than the bottom bowl.

DEF
LPR
T3

O

Note the narrowness of the "O" compared to that of the "B".

A firm downward movement creates the first stroke of the oval.

The right side of the bowl can be a separate stroke, starting at the top.

Return and add the connecting loop. This loop can be adapted to link to the next letter.

CG9
QS

M

The movements required for this grouping are stiff and angular.

Move upwards to create the serif before making the downwards stroke.

Use an up-and-down movement. Try not to break the flow.

The right leg sweeps upwards in a final flourish.

nuv
wy

Brush script, formal minuscule

Many of today's brush scripts had their origins in the advertising industry. Starting in the United States in the 1940s, they quickly spread to Europe. Although some of the more basic forms were translated into type, their intrinsic freedom kept their development firmly in hands of the calligrapher.

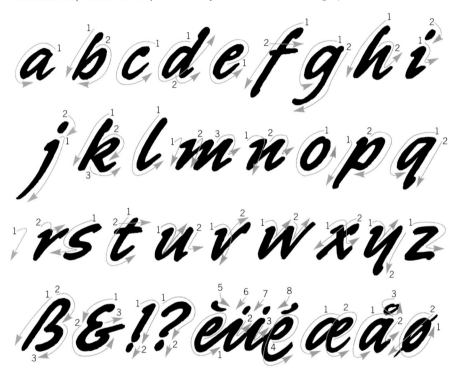

Points of interest

As with most calligraphy, the tool largely determines the letterform. In this instance a slightly rounded sable and very wet paint were used.

In a formal script the letter's will not deviate to any great extent from their accepted form and generally adhere to their baseline.

The principal strokes are slightly bowed, but the letter's thrust is largely expressed in the forward throw of the arch.

Basic structure

Although a formal brush script, this script should give the feeling of spontaneity, beginning with a slightly hesitant blob, moving into a positive down stroke and then thrusting forward into the arch. Although writing with a "dry" brush is perfectly acceptable, this model has been drawn keeping the paint very wet.

Structure	Strokes			Group

The short stroke at the head of the bowl is a separate stroke connecting the bowl and stem.

Begin with a bead of paint and move into the first stroke.

Move straight into the joining stroke.

Complete the head of the bowl and move straight into the right stroke and bottom hook.

b d e g
o p q s

The "r" can be difficult in regard to spacing. Adjust the forward right arch in relation to the space needed.

Throw the first stroke well forward to the right.

On straight-sided letters begin outwards from the stem and then move quickly downwards.

Arch back but closer to the stem than on "n". Terminate with a loop and connect to the following letter.

j l m
n p v
w x y

It is usual practise to exaggerate the size of the upper portion of the "s".

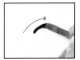

The "S" starts with a strong upward thrust from below the centre.

Tuck the almost horizontal short centre stroke beneath the first stroke.

Sweep the tail away to the left. It is usual to make the top part larger than the bottom.

c x

Note the slight bowing and thrusting of the strokes. This creates an added tension, which would be missing if the strokes were straight.

Move vigorously down the stem of the letterform.

Sweep abruptly away into the connecting stroke.

Finally, move directly down into the stem.

f h i j
k l m
r t u v
w y

Brush script, formal capitals

The capitals, by their very nature, are less cursive than their accompanying minuscule and contain more horizontal strokes. The tension of the minuscule is reflected in these horizontal strokes, with an upward sweep away from the stem. The stems are also more bowed than on the minuscule. The capitals can be used effectively on their own.

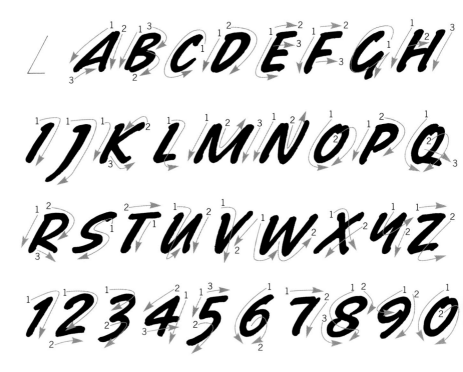

Points of interest

Generally, the capitals should be no more than one-third larger than the minuscule and can be smaller than the ascender.

This "R" and "S" follow the general form of a standard capital.

When compared to the script capitals alongside, the lack of tension becomes apparent. Note how the dynamic is heightened by increasing the size of the upper part of the body. and also by tucking in the tail of "R" and the centre of the "S".

Basic structure

On these brush capitals the rounded strokes are more circular than on the minuscule, and the accentuated up-down rhythm becomes a flowing movement. This is noticeable when comparing the capital and minuscule "M". As with the minuscule, these letters have been drawn with a heavy-bodied flowing paint.

Structure	Strokes			Group

The initial pool of paint commences from inside the arc of circular strokes and on the outside left of straight strokes.

Begin with a good pool of wet paint and then drag this with a circular movement.

Lift the pressure on the brush, so that the top of the right stroke is narrower.

Continue the stroke into the tail, slightly bowing it.

 O Q S

The upward thrust of the inner strokes is characteristic.

Make the first stroke with a gentle curve, using the ball of your hand as a fulcrum.

Return to the head, and gently pull a curving stroke downwards.

Then move sharply outwards and upwards. The final leg should have a greater bow.

AKN U Y

Notice the small introductory hesitant "blob" which occurs to the left of the straight stems.

Begin this exposed stem with a small upward movement from the left.

Follow this with a slightly curving stem; the bottom stroke may be a continuous or a separate stroke.

Notice how the vertical strokes have a bow as on this "M".

BDEF HIJP RTW Y

The head stroke is characteristically long, bringing the middle stroke below the centre with a short trailing stroke.

The "S" commences with a strong upward thrust from below the centre.

A small centre stroke...

...turns and sweeps aggressively backwards.

C G

Ashley script

This script is one of the early "free brush" scripts and dates from the 1930s. It was designed by Ashley Havinden. It is said to have come about as the result of drawing Garamond italic very quickly to fulfil a design brief late at night. The Garamond characteristics are clear in the lower-case letters.

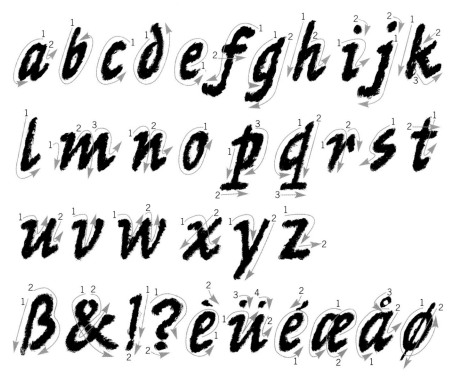

Points of interest

The impression is that these letters were created with a very old brush with any vestige of a point long since gone. This hand was created with a very dry brush.

The consistency of the slope may vary between letters, which helps to enhance a feeling of spontaneity. This can be further helped by not strictly adhering to the line.

These letters were drawn with the very dry brush moving through the letter in a circular movement.

Basic structure

These letters, using the same letterform, have been drawn with the same brush, but with wet paint. Ensure that there is plenty of paint in your brush, enough to complete each stroke in one easy movement. The essence of this script is that it should look spontaneous and not laboured.

Structure	**Strokes**			**Group**

The counter of the "a", in common with other enclosed letters is reduced to a minimum.

Place a wet bead of paint at the head of the bowl; think where you want the next stroke.

Then, quickly draw the bowl in one movement.

Keeping your brush loaded, draw the stem, flicking up at the tail.

b c d o p

For letters with straight sides the ductus is more angular with an up-and-down movement.

Keep the stem of the ascenders straight.

The arch begins at almost mid-stroke moving outwards at an acute angle.

The right leg is almost parallel to the stem, and the connecting stroke is abrupt.

*i j k l
m n r t*

The "p" and "q" show their Garamond origins: a large foot forms a serif at the bottom of the stem.

Make a descender stem similar to "h", but starting above the x-height.

The foot of both "p" and "q" is a pronounced horizontal "slab".

The bowl of the "p" is rounded and is almost the reverse of the "b".

f g q

The centre stroke of "s" is horizontal. This is important, helping to "throw" the top and bottom strokes.

The first stroke of "s" is short moving downwards to the left at about 45°.

The centre stroke is also short, but horizontal at the midway point.

The third stroke follows the angle of the first stroke, but is slightly longer.

e x

Ashley script capitals

This script was originally designed by Ashley Havinden in the 1930s to accompany the minuscule. However, it does not have any of the charming Garamond italic characteristics of the lower-case letters.

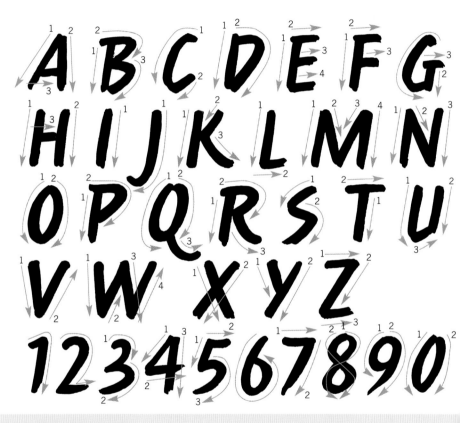

Points of interest

These capitals adequately accompany the minuscule, and should, therefore, be reserved as an accompanying script for use with the minuscule and not regarded as a script in its own right.

Note the loop on the tail.

This alternative "O" is based on the "Q", with a more satisfactory junction at the top.

This alternative "D" is more in character with other letters where a bowl joins the stem.

Basic structure

The letters are rough-hewn and remarkably lacking in any of the subtlety of the lower-case letters. The stems are straight with a tendency to the concave. The tails of the "K", "Q" and "R" are slightly looped.

Structure	Strokes			Group

B

The "B" is a good letter to start with.

Draw a straight stem at a slight angle.

Begin to the left of the stem. Make the top of the bowl almost horizontal.

The lower bowl is the same shape as the top but slightly larger.

F H I J K L P R

G

The angularity of the stem and cross-stroke contrast with the gentle curve of the bowl.

Begin the "G" with a blob before making the outer bowl.

Add a small juncture to create the lower part of the bowl.

The stem and the cross-stroke are straight and angular.

C Q U

R

This letter shares many characteristics with the "B".

Make the initial stroke straight, as for "B".

The second stroke is also similar to that of the "B" and gives you a "P".

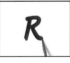
Now add the tail, noting the curve.

B K P Q

S

The rough-hewn nature of this letterform is most obvious in the "S."

Begin the "S" with a downward sweep to the left at about 45°.

The centre stroke is short and almost horizontal.

The bottom stroke follows the same direction and angle as the first.

C

Bold script minuscule

This freely adapted script is based on a design by Roger Excoffon dating from the early 1950s and released under the name "Choc". It is probably easier to build up the letters from a series of multiple strokes than try to create them from a single stroke.

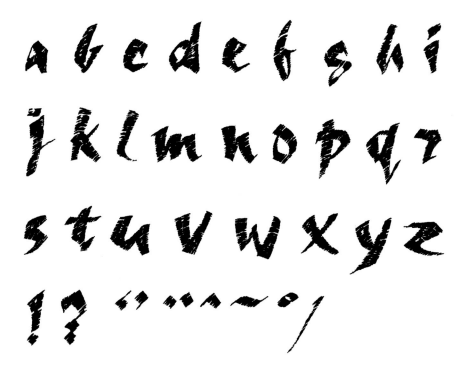

Points of interest

The letters should lock into each other to produce a distinctive word pattern rather than relying on the individual letter shape.

The letter shapes do not have to be rigidly followed and can be adapted to different requirements.

This full "r" is an alternative to the half "r" above.

Notice the different heights of a multi-stemmed letter – this helps give the letter movement.

The pen hesitantly moves down the direction of the stroke.

Basic structure

The underlying characteristics of this anarchic script are its bold weight and relatively constant x-height. The script has been drawn on absorbent paper with a felt-tipped calligraphy pen, using a series of hesitant lines with the pen moving down the stroke. Draw out your letters before you start.

Structure	Strokes			Group

Move your pen in short, stabbing, hesitant movements, following the direction of the stroke.

First, outline the letter in pencil.

Start at the head of the right leg. Make short diagonal movements, working back and forth to fill in your outline.

Move to right of first stroke and add additional thickness. Turn the pen to near vertical and draw bowl.

The "h" marches forward with the stem at a pronounced angle.

Draw the outline.

Begin with the pen at right angles to the stroke. Return, move to the right and add additional thickness.

Arch upwards into the right leg. At the same angle, draw the right leg, and add additional thickness.

Add weight to the heavy top stroke with an additional parallel set of lines.

Draw the outline.

The top stroke is the bold stroke. Return and add a further pen width at the top of the stroke.

The light stroke of the stem drawn with the pen edge-on provides contrast. Finally, complete the bowl.

Make sure that the top of the letter does not rise above the top of the x-height, and also has a definite tail.

Draw the outline.

Make a double upward stroke, before returning to the central spine.

Add the downward stroke. Finally, draw the two finer connecting strokes below the baseline.

Bold script capitals

These capitals accompany the Bold script minuscule. They also date back to the 1950s and are freely based on the original type designs of Roger Excoffon. For practical purposes it is more helpful to regard these characters as built up of multiple strokes rather than as single-stroke letters.

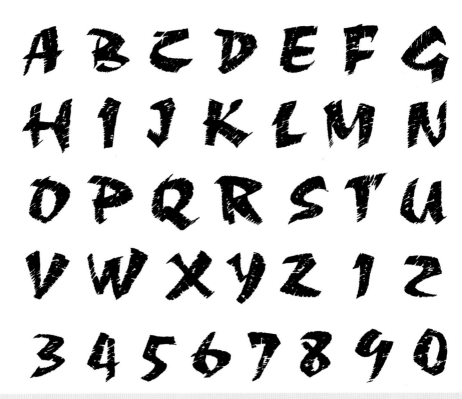

Points of interest

The capitals can be used together, but you may find them more effective when used in conjunction with the minuscule.

Although the hesitant stroke may produce a more dramatic effect, the letters can be drawn as a solid.

The pen moves downwards in successive stages in the direction of the stroke.

The interletter space is always of equal importance to the letter shape – design your words with this in mind.

Basic structure

The capitals are marginally less anarchic than the minuscule, but they also rely on a relatively consistent cap height and body weight to give cohesion. They can be drawn with either a felt-tipped pen or ink. A golden rule for free scripts: make your top stroke the largest, overhanging the centre and the lower stroke.

Structure	Strokes			Group

Each letter is carefully structured, draw your letter (and word) before you start.

Draw the outline.

The right leg of the "A" is made by pulling the pen hesitantly down the stroke in short movements.

Repeat the stroke to the right to give extra width. Hold the pen at 40° for the left leg and cross-stroke.

MNV WYZ

The lines always thicken at one end. This produces a much freer letter.

Draw the outline.

Begin the upper bowl with an arcing stroke. Draw the stem with the pen edge-on.

Make the lower bowl wider and more compressed than the upper bowl. Do not connect to stem.

DGPR

The "O" is composed of two overlapping arcs.

Draw the outline.

Begin the "O" with a wide outward sweep to the right, before returning steeply to the baseline.

Return and begin the left side of the bowl with a point, before making a crescent sweep to the baseline.

DPQR

The "S" is much bolder at the top than the bottom.

Draw the outline.

Begin with a wide upward sweep from the centre to the headline.

Return to the centre and draw a narrow spine and a slightly bolder base.

CG

Pen script, bold minuscule

This is an ideal script with which to begin calligraphy. The letterforms are bold and unambiguous. On the other hand, the simpler the letterform, the greater the options for decorative variation while still retaining legibility. The script is therefore also ideal for the advanced calligrapher.

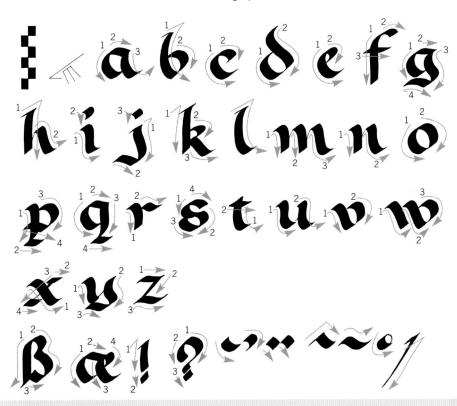

Points of interest

The letters are written with a minimum of strokes. They can be combined with words composed of lighter-weight letters.

Twisting the pen when drawing the stem lets you move into the upright instead of skating from the base.

Alternative characters: the wedge serif may be substituted, but should be used throughout the script.

These letters were written with water, and coloured inks were dropped onto them and allowed to mix.

Basic structure

The x-height of these letters is only three pen widths, producing lateral compression. Ascenders and descenders should be kept to a minimum. The letters are rounded and executed with the minimum number of strokes. Dense text is formed by writing the letters closely with minimal word separation.

Structure	Strokes			Group

This is a single-storey "a" and relates closely to the "c", "e" and "o".

To make an "a", begin with the pen at 35°, and make a semi-circular loop, finishing at a point.

Keeping the pen at the same angle, make a short rounded stroke at the head.

Leading directly from the second stroke, finish the stem with a curving stroke tapering off to a fine point.

The strike at the head of the ascenders is a characteristic. Keep the bowl as open as is practicable.

Begin the "b" with either a wedge serif or single strike leading into a bowed stem.

Make the stem with a continuous curve, ending with the flat of the pen.

Complete the bowl with a left semi-circular loop joining to the base of the stem.

Note the relationship between the "i", "m" and "n". The final stroke is the "i", but more upright.

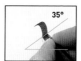

For the first stroke of "m", "n" and "r", sweep into the stem, but do not turn the foot. End it on a diagonal.

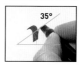

Then skate upward from the base...

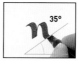

...and down to make the right stem, turning the foot.

The "s" is composed of two opposing loops.

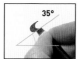

Make a small loop from the headline for the left side of the spine.

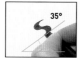

The spine of the "s" is made in two parts to accommodate the small x-height.

Head and bottom are added to the spine, giving an almost 8-shaped letter.

Pen script, bold capitals

These capitals are designed to accompany the minuscule, and because of their simplified letterform they can also be effectively used as a script in their own right. As with the minuscule, the basic letterforms make this set of capitals ideal for the beginner in calligraphy.

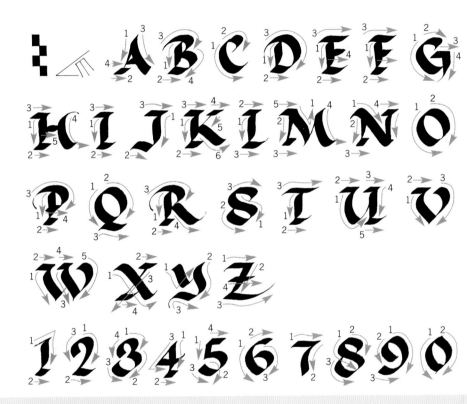

Points of interest

These letters have been drawn with a felt-tipped calligraphy pen – an ideal tool with which to practise letter shapes before moving onto inks and paint.

The curved stem is an alternative to the straight stems above. Try not to mix the two forms.

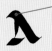

The head of the "M" can also be drawn without the serif and substituting the "N" form.

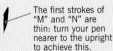

The first strokes of "M" and "N" are thin: turn your pen nearer to the upright to achieve this.

Space allowing, horizontal strokes can be flourished.

Basic structure

These letters have a cap height of only four pen widths, producing a bold letter. The stems are generally short with bold horizontal serifs and arms. The simplified basic structure allows the letters to be executed with the minimum number of strokes. The script is useful where a bold emphasis is required.

Structure **Strokes** **Group**

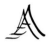 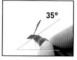 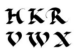

For this group of letters you can finish with a thin upward flick, drawn with the corner of the nib, or end on a heavy diagonal.

The left diagonal stroke of "A" is a thin stroke. To achieve this turn your pen to the near upright.

Turn your pen back to 35° and add a thick, confident serif.

With your pen at the same angle, draw the right diagonal with the nib corner. Draw the cross-stroke.

This hand has both head and tail strokes, which will make the stems of necessity relatively short.

Keeping your pen at 35°, make a short stroke for the stem of "B" well within the head- and baselines.

Add the base of the bowl to the end of the stem, moving slightly downwards.

Returning to the top, make a sweep for the top bowl, followed by a wider sweep for the bottom bowl.

 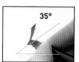

The curving of the right leg of "M" and also the second stroke of "H" act as a foil to the bold serifs, which occur on many other letters.

The first stroke of "M" is similar to "A", but more upright.

Sweep into the diagonal, down to the baseline, then skate back to the headline.

Add the final leg, again similar to "A", but more upright.

The "S" is a devourer of vertical space. Make the spine first.

Starting just below the headline, make a wide diagonal stroke close to the horizontal.

Tuck in the lower stroke beneath the diagonal. The tip may touch to give an 8 shape.

Finally, add the top stroke. This may also terminate by touching the diagonal.

Pen script, bold italic minuscule

This Italic forms part of a "family", which includes the bold and capital letters. Like the rest of the family, this script is easy to pen and unpretentious in appearance. Its boldness makes it a valuable and useful addition to the calligrapher's palette when a strong emphasis is required.

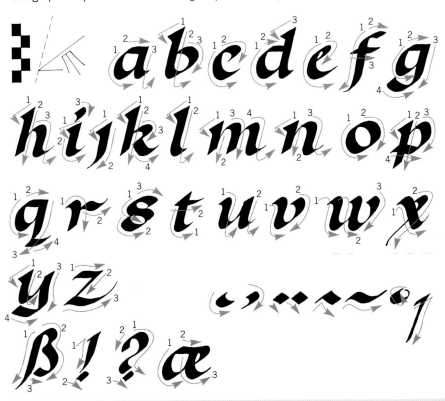

Points of interest

Although part of same family as the bold, a number of differences have been included to give the calligrapher a range of alternatives.

Here are three alternative leading-in strokes. Try not to mix the different forms.

Turning the pen towards the upright will help you to move upwards into the following stroke.

This alternative "s" has its spine "broken" into two strokes.

This alternative "p" has a serif added as on the "q".

Basic structure

The x-height of the letter only occupies three pen widths. Keep ascenders and descenders as small as practicable. The parallel stems drawn at a consistent angle produce an even colour where a quantity of text is required. If you are using this script with bold Roman, try drawing a light version of these letters.

Structure	Strokes			Group

Keep the bowl wide. This will help to increase its interior volume.

Holding your pen at 35°, start the "a" with a generous arcing stroke that touches gently on the baseline.

Keep the top stroke quite wide, extending beyond the end of the lower arc.

Add the stem keeping it sloping forward at about 15° from the vertical, generously turning the foot.

cdeg oq

The italic has been drawn with a wedge serif. This gives you an alternative to the related serifs on the upright on page 204.

Make a wedge serif with a short stroke, downwards and to the right, and return directly to cover the stem.

Keeping your pen angle, return and cover the commencing stroke. Draw the stem and a generous foot.

Complete the bowl with a mirror image of the first stroke of "a".

dfhi jklo p

The space between the two uprights should appear optically the same as the space within the enclosed bowl as on the "a".

For "n" make a wedge serif and move down into the stem.

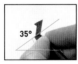

Make sure that you do not turn the foot.

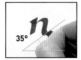

Sweep outward for the right stem and then turn the foot.

hijk mpu vwx y

On "s" the diagonal centre stroke slopes down. Because of the boldness of the letter it is horizontal.

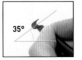

Make a small loop from the headline for the left side of the spine.

Join an opposing downward loop for the right side of the spine.

Finally, add the head and base strokes.

c

Pen script, bold italic capitals

These capitals accompany the bold italic minuscule, but are slightly more cursive in character. Their unencumbered structure makes them suitable for use as a script in their own right. They also form part of a "family" with the upright Roman and can be used in conjunction with them.

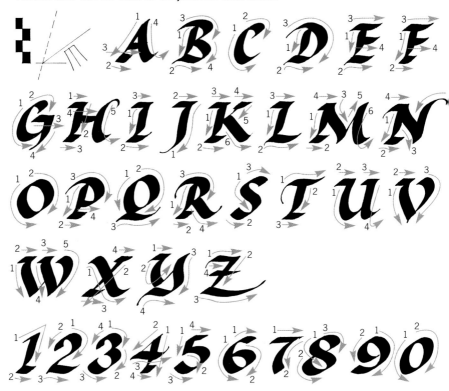

Points of interest

Notice that with the pen held at the same angle as the bold Roman, the stems of the letters become relatively thinner and the diagonals thicker.

Alternatives of "M" and "N" – a diagonal stroke with a foot added to the base of the "N".

An alternative lead-in stroke for "B". This can also be applied to the "D", "N", "P" and "R".

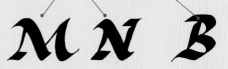

Basic structure

The simplicity of these letters offers scope for much more fun and elaboration than is possible in more decorative letters. The forward slope of the italic should carry the eye along the word without breaks. This will be helped by keeping the letters at a consistent angle. Changing the angle will act as punctuation.

Structure	Strokes			Group

FMN X

The internal space at the top of the "A", and also the "R", is a result of a bold and italicizing stroke.

 The left diagonal of the "A" is a thin stroke. To draw this turn your pen to the near upright.

 Turn your pen back to 35° and add the serif.

 Draw the right diagonal. Add the cross-stroke. Finish with a small flick on the right leg.

Compare the weight of the stem of the "B" with the right leg of "A". This difference is offset by the extra strength of the bowls.

 With your pen at 35°, make a short vertical stem. Add the horizontal base of the lower bowl.

 Return to the top and make a wide sweep for the top bowl.

 Follow this with a wide sweep to connect the lower bowl with the baseline stroke.

DOP R

The "H" can have either a short or a long headline serif.

 Sweep into the top serif and move directly into the stem, staying short of the baseline.

 Then finish the stroke with a short serif.

 The right stem is similar to "A", but more upright. Add the cross-stroke. Finish with a flick.

EFIJ KMN TUV WY

There are two choices for the "S" – it can be either narrow, as shown opposite, or wide.

For the wider "S", make a small upper loop from the headline.

The second small loop reaches near the baseline. The bottom stroke starts to the left.

To complete the letter, add the head stroke.

CGOQ

Diva minuscule

This is a free informal script – its informality is emphasized by the termination of the strokes. These basic letter shapes can be adapted in both size and weight – in fact, the more informal the design, the better this script is likely to work. The strokes have been constructed using jerky movements to give a textured effect.

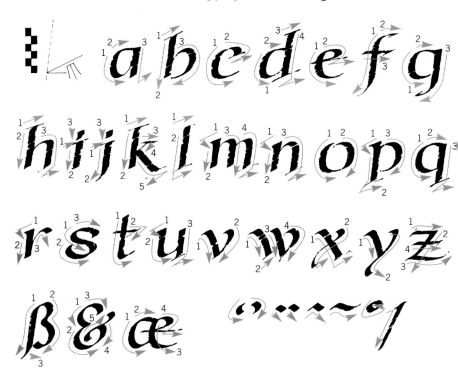

Points of interest

For free scripts, different writing speeds are used, from the relatively slow beginning for stems and bows to a quick flourish at the end.

An alternative "g". The link can be extended to dramatic effect.

The ascenders can be several times the x-height. The bows of letters can be conjoined.

The horizontal stroke of "t" can be long. It is effective at the end of a word.

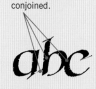

Basic structure

This script is relatively wide and written with the pen at a shallow angle of 25° and a forward slope of about 8°, giving bold stems and much lighter horizontals. The pressure of the pen and speed of writing should vary; the hand moves freely to obtain optimum value from the script.

Structure	Strokes			Group

The script has a "square" aspect, typified by the shallow curve of the bow. Retain this feature on all bowed letters.

Begin below the headline, and make a wide bow, finishing on a skated upward stroke.

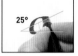

Return and complete the horizontal head stroke.

Move directly into the stem and finish the stroke in a quick left-right flick.

The serif on the top of the stem (and also on the feet of other letters) is drawn with the edge of the nib at the stroke angle of 25°.

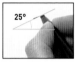

Start the stem with a diagonal cross-stroke, moving upwards to the right.

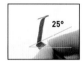

Return and draw the stem, placing it at the centre of the short diagonal.

Skate upwards from the base of the stem to arch out to the generous wide bow.

The wedge serif, which also occurs on the "n", "p", "r" and "u" may be used on "i" and "j".

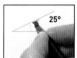

You can begin with a more formal wedge serif. Move to the left and return to the stem.

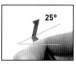

Then move downwards to complete the stem.

Make an arch as for "b", but descend vertically and terminate with a flick.

The forward slope, which is obvious on straight-stemmed letters, is more difficult to achieve on the "s".

For "s" begin with the spine, making it wide and relatively horizontal.

Add the bottom loop, extending it slightly beyond the spine. This gives a forward slope.

Return and make the top loop, also extending very slightly beyond the spine.

Diva capitals

Designed to accompany the Diva minuscule, many of these free, informal capitals also terminate in a flick. Although shown here in proportion to the minuscule, it is probably worth experimenting with the letters at differing proportions. They can also be used effectively without the minuscule.

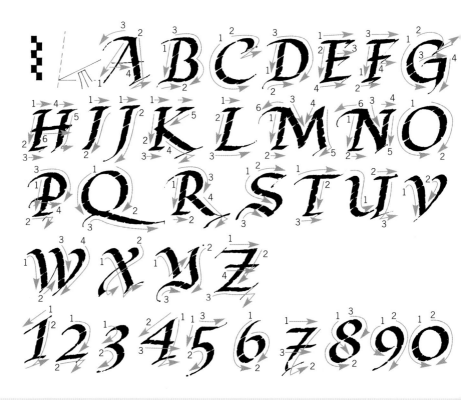

Points of interest

Depending on your design, some letters can begin with a flick, while others are more considered. The strokes are made using short, jerky movements to give a textured effect.

The high cross-stroke of "T" makes this letter ideal to enfold the minuscule.

The volume of the counter can be reduced by striking and diamonds.

Two methods of terminating the stem: formally with a serif or informally with a flick.

An alternative form of "Q".

Basic structure

This script is relatively wide and written with the pen at a shallow angle. The differing pressures on the pen and the variation of writing speed within the parts of the letter are important factors in producing a letter that appears to have been written spontaneously.

Structure	Strokes			Group

The left leg is drawn with the pen edge-on at about 60° and breaks the pattern set for the other letters.

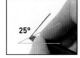

Begin the "A" with a quick diagonal stroke to the left made with the edge of the pen.

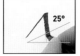

Follow with the right diagonal stroke. Finish the stroke in a quick left to right flick.

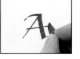

Add the cross-bar and swash, and terminate with a flick at the foot of the stem.

This is an expanded script, and in no character is it more noticeable than the "C".

Start with a very wide sweeping arc hugging the baseline and with the pen at 25°.

Return and draw a tight arc at the headline, tucked well in.

Terminate this stroke with an upward flick at 25°.

This "E" is an alternative character with the top arm extending in a swash. This can also be used on the "F."

Begin at the tip of the swash and proceed along the top arm terminating in a downward flick.

The stem forms the second stroke, lifting to the left at the baseline.

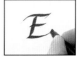

Follow with the middle and bottom arms also terminating in a downward flick.

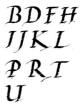

The second stroke may be either a swash or a continuation; however, whichever you choose be consistent.

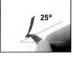

Start the first stroke of "M" with the pen relatively upright. Add the foot.

Make the second stroke as the right diagonal of "A", or sweep over the first stroke as here.

The third and fourth strokes may be completed in either one or two strokes.

Structured italic minuscule

This script is freely adapted from Vivaldi, a calligraphic typeface designed by
Friedrich Peter. Although adapted from the pen-drawn originals for dry-transfer
application, the script still retains qualities that are eminently suitable for pen
drawing. The connecting shoulder on "a", "d", "g", "q" and "u" is a distinctive
feature; it only just touches the stem.

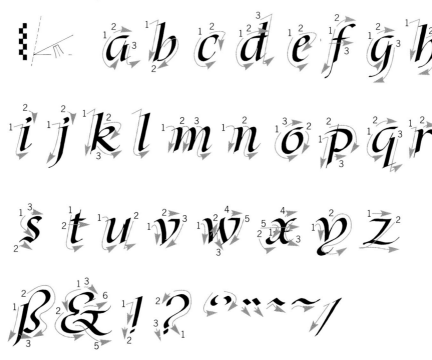

Points of interest

Every letter is precisely
honed, with each part
carefully structured. This
script can be seen as an
interface between calligraphy
and type design.

The connecting
shoulder is carefully
drawn at the same
angle, as we see on
this "a" and "n".

This alternative "d"
may be useful if you
find the rhythm of a
word too static.

This alternative "l"
has a pot-hook serif.

Basic structure

The straight top hairline serifs join the stem without fillets, while those at the bottom tend to be hooked. The stems are also straight and generally terminate with a dragged stroke on the left. The stems of "a", "g" and "q" start at about half the x-height. The ascenders and descenders are relatively short.

Structure	Strokes			Group

The stem characteristically starts short of the upper stroke. This is repeated on "g" and "q".

The left bowl of the "a" is not excessively curved: create width by pulling out the base and connecting strokes.

Add a wide top stroke keeping it horizontal and stopping as you reach the connecting stroke.

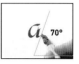

Begin the stem at about the halfway point, only just touching the connecting stroke.

Draw the hairline at the bottom of the stem with the corner of the nib.

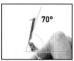

Start with an upward hairline, before moving down the stem. End with a hairline on the bottom left of the stem.

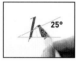

Begin the shoulder from the base of the stem, sweeping upwards and outwards.

Move downwards and return to the stem.

The sensuousness of this script is fully captured in the flowing forms of the "y". Note the reverse turn of the tail.

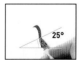

The "v", "w" and "y" all begin with a generous arc.

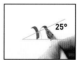

For "v" and the last stroke of "w" make a broad serif without altering the angle and connect to the stem.

The "y" is the most exotic of the minuscule characters. Complete the bowl and descender in one sweep.

The "s" is relatively narrow and lacks the angularity of many of the other letters.

Begin the "s" with the spine keeping it relatively upright.

Add a curving foot with a pronounced arc.

Follow with a downward sweeping headstroke.

Structured Italic capitals

The flamboyant character of this hand is best expressed in its capitals. As with so many exotic capitals, they are less effective on their own, and require the minuscule as a foil to prevent the strokes from overwhelming each other.

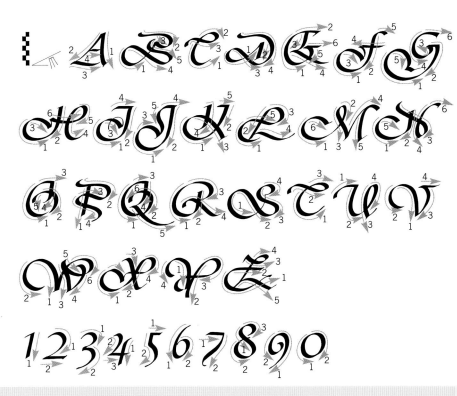

Points of interest

Don't try to draw the full alphabet at one sitting – concentrate on one or two letters to start with.

Notice the roundness of the stroke as it leaves the stem.

Try drawing the characters with a split pen.

As with many ornate characters, there may be a problem of legibility. This is usually overcome when the capital is placed in the context of other adjoining (minuscule) letters, which then give shape to the word.

Basic structure

The curves and swashes of this script are fully rounded and the letters are often expanded. The few straight stems are short and tend to fall within the swashes as opposed to touching or springing from them.

Structure	Strokes			Group

The "B" is a good letter on which to practise. Once you are comfortable with its construction, the logic of the other letters will become more apparent. Notice how the expanded loops fall at the baseline; far less emphasis is placed on the headline swash. Despite their apparent complexity, the letters are executed with few strokes.

It is advisable with this script to begin each letter at the extreme left and draw the stroke along to the right.

Draw a short stem in a downward movement. Connect this to the first stroke.

Make a long headline stroke, finishing well to the right of the stem.

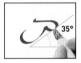 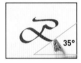 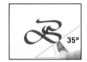

Now link the headline stroke to the stem.

Return to the start of the first stroke and sweep through the stem to make the lower bowl.

Return to about mid-stem and draw the final stroke that completes the lower bowl.

 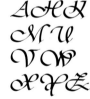

The bold diagonal crosses the left leg at an angle.

Repeat the first two strokes of the "B". Draw a diagonal stroke, starting at cap height.

Starting at cap height, draw the right stem, connecting to the diagonal at the base.

Finally, add the right flourish.

The centre stem and the right bowl end at the same height, suggesting they could lead into one another.

Make sure that the "O" is plump and rounded.

Add a downward stem that curves slightly left.

The right bowl is very small and loops through the short centre stem.

Diagonale minuscule

This is a modern, structured script, with a heavy diagonal stress relieved by slight touches of whimsy in the curve of the hairline as it joins the stem.

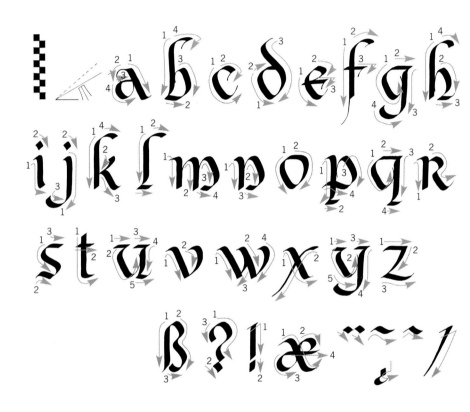

Points of interest

The ascenders are double the x-height; the descenders are shorter. If wished, a hairline may be extended from the foot of straight-stemmed letters.

The ascender can be exploited as a design feature.

This is an alternative "r".

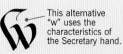

This alternative "w" uses the characteristics of the Secretary hand.

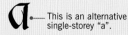

This is an alternative single-storey "a".

Basic structure

The pen angle varies from the almost flat, as at the head of the "a", but generally the pen is held at 35–40°, as considerable emphasis is placed on the diagonal downward stress, which is exploited at every possible opportunity. This produces a very formal letter.

Structure	Strokes			Group

The "a" is a defining letter giving the distinct angle to which the other letters aspire.

Keep the diagonal slope to 60°, and incline the stem at this angle. Finish on the corner of the nib.

Pull the hairline round to the mid-point and draw the horizontal for the top of the counter.

Return and complete the bowl and link with the hairline to the mid-horizontal stroke. Finish on the corner of the nib.

The forward flourish at the head of the ascender may terminate with a downwards flick.

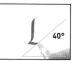

Keep the stem straight. Start the stroke to the right and finish to the left. Add a horizontal lower part to the bowl.

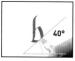

Make the side of the bowl at a 60° angle, just connecting to the stem with a curved hairline.

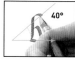

Finally, add a forward thrusting flourish.

The first stroke of "h", "k", "m", "n" and "r" is not turned and ends at the pen angle of about 40°.

The "n" (and "i", "j", "m" and "r") starts with a small serif and the pen at 30°, turning to 40° on the stem.

The right stem of "h", "m" and "n" is angled. Note the alternative foot formation as on the "h" opposite.

Finally, complete the stroke with a turned-in foot.

The triangular aspect of the "o" echoes the diagonal of the "a".

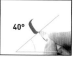

The left bow of "o" also exploits the diagonal.

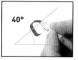

Note how the top of "o" moves horizontally along the top of the x-height.

The right bow sweeps to a point to join the first stroke.

Diagonale capitals

This modern capital script is designed to accompany the Diagonale minuscule. As its name implies, there is an elegant diagonal slope to each of the letters in this hand.

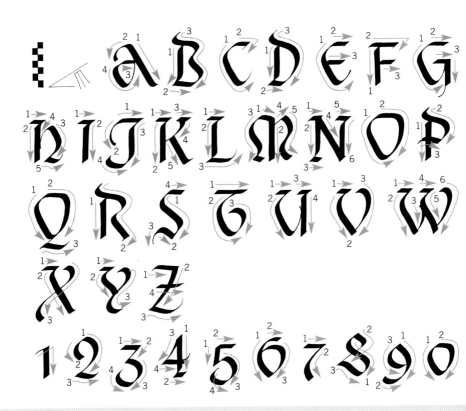

Points of interest

The diagonal stress is in rather less evidence than on the minuscule.

This is an alternative to the Lombardic form of "M" and "T".

This alternative to the Uncial form of "A" still retains the diagonal thrust.

This looped form of "B" can also be used on "D", "P" and "R".

Basic structure

The letter is seven pen widths tall, compared to five pen widths of the minuscule, and is smaller than the ascenders. There is a strong horizontal feature in the use of slab serifs, particularly at cap height. The hairline on the spur of "g" can be used on other straight-stemmed letters.

Structure	Strokes			Group

 The diagonal slope of the stem of "A" is characteristic and sets the angle for other characters.

 Keep your diagonals at a consistent slope of about 60°. Flick up at the foot.

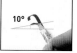 Now make a short horizontal stroke slightly above midway point.

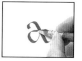 Complete with a rounded bowl. Loop upwards to join the stem, using the corner of the nib.

 The angle of the stem terminates in an upward curve in the manner of a minuscule letter.

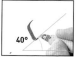 Keep the slope of the stem as close to that of "A" as possible. Commence by steeply curving into this stroke.

 Return and add a horizontal stroke along the headline, terminating in a slight downward flick.

 At midpoint, add a short horizontal cross-stroke.

 The stem ends on a diagonal instead of the more usual serif. This is repeated on "F", "H", "I", "P" and "R".

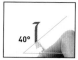 Make a short horizontal serif. Sweep back into the vertical stem, ending at the pen angle of 40°.

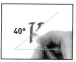 Return and make a second horizontal serif. Sweep back in a curve to the stem.

 Complete with a diagonal leg, commencing to the right of the stem.

 The upper bowl curves away from the stem instead of enclosing it. This is repeated on "B", "D" and "R".

 Holding the pen at 40°, make a straight stem starting below the headline.

 Starting above the headline, make a bold downward sweep to below the midpoint.

 Starting to the left of the stem, complete the bowl with a short arcing stroke.

Elegant script minuscule

This script is freely based on a script designed by the German calligrapher Karlgeorg Hoefer in the 1960s. It is considerably expanded and the letters link, producing a handwriting effect. This script is particularly useful when used as a sub-text complementing a bolder heading or an illustration.

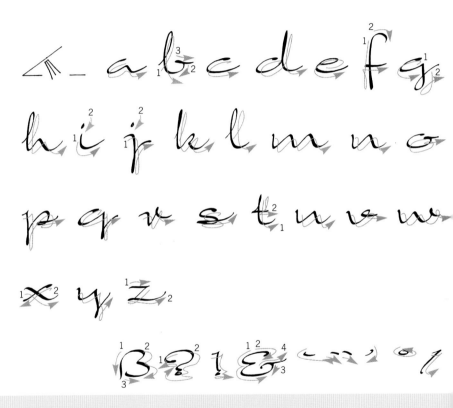

Points of interest

The letters should be written with minimum pen lifts, as in handwriting. Ascenders may be drawn with either an open or a closed loop.

The letters are linked. These three letters can be drawn in a continuous movement.

Notice the oval looping and consistent angle.

The letters can be drawn equally well with a monoline pen. Looping of ascenders is at your discretion.

Basic structure

These letters have been written with a fine, square-cut nib, producing a slight variation of stroke widths. Consider using a round-ended pen to produce a monoline letter. Also consider open-looping the descenders. Notice the proportion of height to width – the letters may be wider than they first appear.

Structure	Strokes			Group

The extreme angle of the stem enhances the effect of the letter running forward, and provides a satisfying link.

Begin the bowl of "a" with an initial small loop before making the wide loop of the bowl.

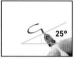

Start the stem at the midway point and move to the baseline at a steep angle.

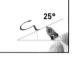

Descend to the baseline and continue along it.

The "b", "h" and "i" have been given open loops while "d" and "k" are closed. These loops may be freely adapted to suit the text.

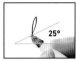

Begin the "b" with an upward stroke into the loop.

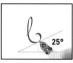

Sweep down to the baseline and along, giving a slightly backward aspect.

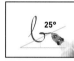

On reaching the top of the x-height, loop the stroke to join the following letter.

The "o" begins similarly to "a", but continues further along the baseline.

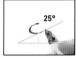

Begin the "o" with a very wide open bowl.

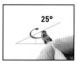

Move up to the midway point at the right, but do not enclose the bowl.

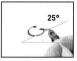

Complete with a very tight overlapping connecting stroke.

As with all the letters in this hand, the exit stroke may be freely adapted to connect to the following letter.

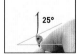

Start the "p" with a small stroke to the top left of the stem.

At the bottom loop, return through the stem, adding a stroke to the top of x-height.

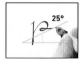

Finally, loop through the bowl and complete the exit stroke.

Elegant script capitals

These freely adapted capitals accompany the Elegant Script minuscule, and are based on an original 1960s design by Karlgeorg Hoefer. The letters link, giving a handwriting effect. The script is particularly useful when used as a sub-text complementing a bolder heading or an illustration.

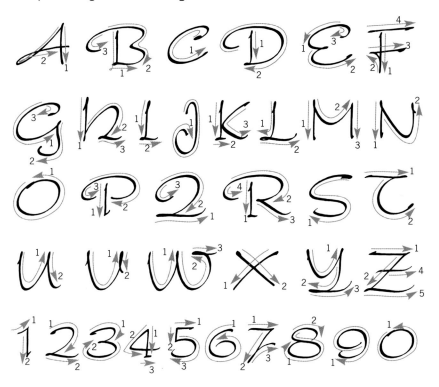

Points of interest

Generally, the capitals are less expanded than the minuscule script; however, they are also written with minimum pen lifts. The stems are upright and contrast with the tilt of the ovals.

The swash is thrown forward from the stem and has the same tilted axis as the "O".

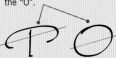

You could try these alternative forms of "H" and "T".

Basic structure

These letters have been drawn with a fine broad-edged nib. Use the narrowest edged nib you can find, giving a variation of thick/thin strokes. This is an expanded script that should be written holding the pen at a shallow angle and without lifting it too often.

Structure	Strokes			Group

The bowls of the rounded strokes lie at a considerable distance from the stem.

Move the pen upwards before descending into the straight stem and then along the baseline.

Draw the two bowls in one downward stroke, connecting to the end of the first stroke.

Return to the head of the second stroke. Sweep out to the left to make a shallow swash.

 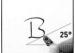 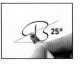

The "E" has a distinctive backward tilt, which is not repeated in any other letters.

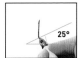

Begin the "E" with a wide sweep noting the downward axis of the ellipse.

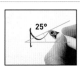

Follow this with a smaller ellipse, to the right of the top ellipse.

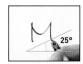

Finally, return and add a loop to complete the top ellipse.

The wide cradle does not descend below the midway point. The right leg is shorter than the left.

Begin at the headline loop. Make a straight left leg terminating in a right hook.

Return to the head and make a wide cradle stroke.

Descend into the right leg, finishing slightly above the baseline.

The "U" is wide – the left stroke leads into a delightful arc before sweeping upward into the right leg.

Make a loop at the top of the first stroke before curving downwards.

Upon reaching the headline, make another small loop.

Finish with a curve that lies slightly above the baseline.

Running brush script minuscule

This freely adapted script is based on Roger Excoffon's classic script of the 1950s. These letters fully exploit, and the letterforms are derived from, a natural ductus of the hand working in harmony with the brush, consistency of paint, and texture of paper.

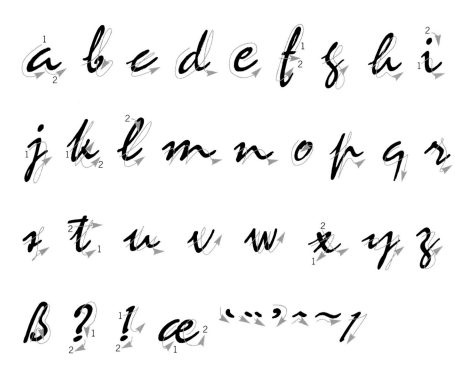

Points of interest

The letters should have a forward slope, giving a running movement that is further aided by the linking strokes.

The letters freely wander within certain set limits, but remain linked.

Letters join at the midway point. Note the movement of "n" created by different lengths.

The high cross-stroke of "t" is almost unique.

Basic structure

The texture of the paint and the quality of the brush are important for drawing this letter well. Gouache mixed to a thick consistency is ideal. Avoid using a new and pointed brush; an older brush with a worn and rounded tip is ideal. Practise by holding the brush in a near upright position.

Structure	Strokes			Group

The beginning of the commencement stroke and the angle of the stem make a backward sloping alignment.

With a loaded brush make a wide arc, stopping when you reach the midway x-height.

Then make a very short stem.

The stem does not reach the baseline and inclines to the right before sweeping steeply upwards.

ceh mn pqr u

The loop of "b" is open while that of "d" and "k" are closed. This may be varied to suit your design requirements.

Begin the loop of "b" at the midway point and move upwards.

Follow with a gentle sweep down to the baseline.

Add a much tighter loop back into the bowl.

dfh kl

The "g" is interestingly antique in form.

Begin with an upward enclosed loop.

Swing out to the right and down into the tail.

Loop back through the body of the letter.

cjp ruw yz

The "t" has an excessively long stem that rises considerably above the x-height.

Begin the "t" with a downward stroke to the left, starting at the ascender height.

Cross the stem over the first introductory stroke, finishing in a tight upward link.

Add the cross-stroke, keeping it near to the top of the ascender.

tk

Running brush script capitals

These freely adapted capitals are based on Roger Excoffon's script of the 1950s and are designed to accompany the minuscule. This is a true script in that the letterforms are dictated by the materials used, as opposed to many scripts where the materials – ink and pen – are used to realize a pre-determined form.

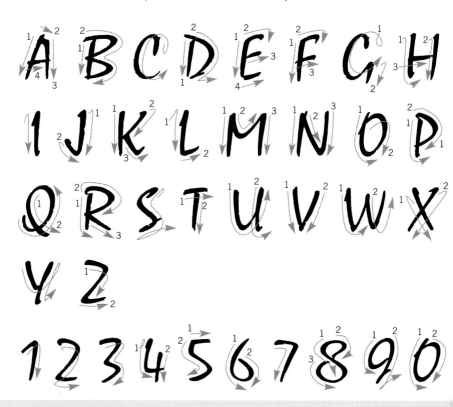

Points of interest

Although the letters are drawn in a single stroke where practicable, as in "G", other letters have clearly separate strokes, as in "D".

The stems show a slight curve determined by the ball of the hand.

The bowed strokes show a sharp return, while the loop at the bottom of the curved strokes is more rounded.

Notice the relative letter widths, a wide "R" and a narrow "W".

Basic structure

Like the minuscule, the quality of the brush you use and the consistency of the paint is all important. Your brush should have a rounded tip; use gouache mixed to a creamy texture.

Structure	Strokes			Group

The capitals of this script have a more upright aspect than their minuscule counterparts.

The left leg of "A" is only slightly inclined.

The right leg is separated at the top by a small blob and is almost vertical.

Complete the letter with a cross-stroke.

The "B" is typical of many freely drawn brush scripts in that the lower bowl is smaller than the upper bowl.

Freely draw a stem with a slight inclination to the right.

Make the top bowl with a wide upward arc.

The lower bowl is smaller, tucking under the top bowl and points downwards.

The first part of the inner "v" closely follows the angle of the stem before sweeping out to the right.

Start the "M" with a simple stem.

Make a tight downward stroke followed by another stroke flung outwards.

Complete with a slightly shorter right leg.

The "R" links to the stem at the top.

The first stroke of "R" is the same as for "M".

The bow starts with a loop to the left of the stem before returning to make a generous bowl.

Take the bowl through the stem before tucking in a short tail.

Ruling pen minuscule 1

The letterforms in this script are subsidiary to the technique. Once you have learnt to make the sensual lines that the ruling pen can produce in this expressive calligraphy, you will be able to adapt this to your own requirements.

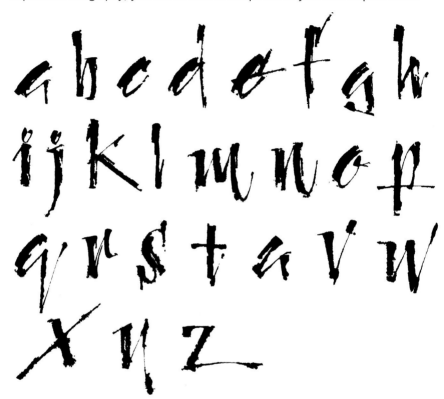

Points of interest

A strong diagonal links most of the letters above and, although freely drawn, provides a unifying theme.

This "abc" is essentially the same as the letters above, but written in a circular movement with the hand not resting on the paper.

The diagonals are further emphasized on this "abc". Note the different effect when written on a smooth paper.

You could try writing with water and then drop different-coloured inks onto it.

Basic structure

The ruling pen, although not designed for calligraphy, will produce a range of stroke widths. These will depend on the angle at which it is held, ranging from a fine line when held upright to a bold line when held on its side, and all the gradations in between.

Structure	Strokes			Group

Hold your pen in your writing hand and load from the side from a loaded brush. Do not dip your pen.

Holding your pen on its side make a bold downward diagonal.

Turn the pen onto its tip and make a quick upward stroke.

Follow with a medium width downward stem.

Despite the freedom of the letterforms this script is very angular, particularly noticeable on the "h".

Keeping the pen still at nearly upright, move upwards and outwards.

Moving the pen onto its side, make a bold right leg. At the base turn the pen back onto its tip and complete.

Follow with a downward stroke and a flick at the end.

The horizontal strike at the base should be executed quickly. This also applies to "e", "f", "v", "w", "x" and "y".

Begin this letter also with a blob, but make a bolder stem.

Then quickly move upwards...

...and turning the pen onto its side, complete the bowl with a bold strike. Lift and strike along the base.

The two serifs give added weight to the "s." This is important because of the upright aspect of the letter.

Start the "s" on the tip of the pen, quickly turning into the blade for the spine.

Return and with the edge of the pen make a bold serif at the head...

...and complete with another bold serif at the base.

Ruling pen minuscule 2

This script is primarily concerned with technique, the letterforms themselves springing from the tool and the material used. The use of such an improbable tool as a ruling pen for expressive calligraphy was first pioneered by the late German calligrapher Friedrich Poppl and dates from the 1960s.

a b c d e f g h
i j k l m n o p
q r s t u v w
x y z

Points of interest

The texture of the paper and the manner in which the ink floods onto the paper and is dragged across to form the letter are intrinsic to this script.

The letters above have been produced from an angled ductus. Now try holding your pen without resting your hand on the paper and moving your wrist in a circular movement. This will produce more rounded forms.

Basic structure

The ruling pen, a technical drawing instrument, is used, utilizing all parts of the blade – from the very fine tip producing hairlines to the edge of the blade, producing very bold strokes. The ink is further puddled, with the tip of the pen dragged through the wet ink to produce additional strokes.

Structure	Strokes			Group

Hold the pen in your writing hand and load from the side with a loaded brush. Do not dip your pen.

Begin with your pen at a slight angle, gradually increasing the angle to allow more ink as you move downwards.

Follow by a quick flick upwards with the point of the pen.

Hesitate at the top. Make a backward loop, followed by a quick down stroke on the tip of the nib.

This script is a mixture of hesitant but bold strokes followed by quickly executed fine strokes.

Turn the pen onto its edge to make a positive blob, then finish the stem on the point.

Begin at mid-stem on the point. Move upwards on the side.

Turn the pen onto its side and enclose the bowl in a tight rounded stroke, dragging out a tail to the left.

Use the ball of your hand as a fulcrum to make the long curving stem.

Make a generously bowed stroke from the ascender to the descender, ending in an upward flick.

Return to the head and make a forward bow.

Complete with a quick horizontal cross-stroke crossing the following letter.

The upper part of the "s" is noticeably larger than the bottom.

Throw the top of "s" out to the right.

Tuck in a short centre stroke with the tip of the pen.

Add the bottom stroke with the edge of the nib.

Ruling pen 3

Although relatively formal letterforms in themselves, these letters have an urgency derived from their broken, bold and unfinished form. This contrasts with the very fine, whispering hairlines which help delineate their shape.

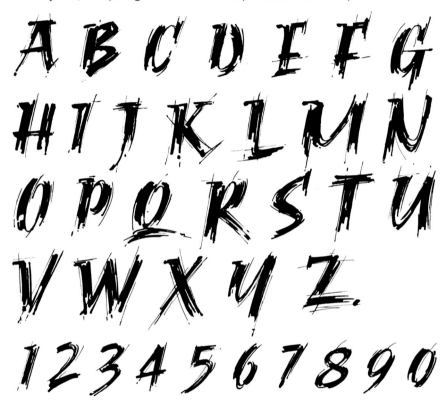

Points of interest

The characteristic of the letter is the emphasis placed on the weight and contrast of the thickness of the pen strokes within the letter.

These are the relative contrasting line thicknesses that you should aim for.

The inner stroke of "M" and "N" begins steeply before suddenly pulling away to the right.

Begin with the inner part of the bold stroke and build up the letter progressively. Add the hairlines as a final touch.

Basic structure

The letterforms derive directly from the various parts of the ruling pen: the bold strokes are created by using the side of a fully loaded pen, while the hairline strokes are drawn with a quick movement, the tip of the pen only gently touching the paper.

Structure	**Strokes**			**Group**

Note the imbalance of the legs on the "A".

Begin with a bold stroke for the left leg.

Make the right leg about twice the weight of the first.

Add the cross-stroke and build up the weight of the letter. Finally, add hairlines.

The cross-stroke on the "G" connects with the bowl.

Ensure that you make a clean, round loop at the bottom of the letter.

Add a smaller loop at the top, followed by the stem.

Finally, add the serifs and the hairlines.

The urgency of this letterform is best expressed in the "M".

Begin with a relatively bold outer leg.

Bring the inner stroke down sharply before thrusting away to the right.

Add a bold right leg and complete with hairlines.

Let your pen almost skid over the surface when adding hairlines.

The first stroke of "S" is relatively upright.

The centre stroke is short and almost horizontal.

Tuck the final stroke under the letter and finally add a serif and hairlines.

Art nouveau minuscule

This alphabet is based on one created by the architect Peter Behrens in about 1900. Although designed as a typeface, the letters were directly derived from a pen-drawn letter in which the pen was held at a consistent angle of about 40°, producing an almost monoline letter.

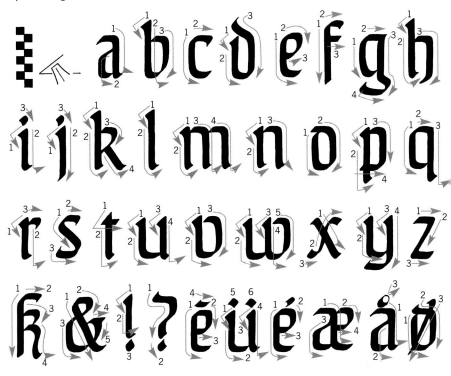

Points of interest

The main character of this Art Nouveau alphabet is carried in the capital letters. The function of the lower case is basically to complement them.

The strong vertical and horizontal character is particularly noticeable in the stem and the cross-strokes, which are almost the same thickness.

The serif consists of a short 45°-movement outwards from the stem, returning at the same angle.

Begin the downstroke near the headline, thus avoiding thinning at the angle.

Basic structure

This alphabet has a strong horizontal/vertical emphasis, with curved strokes kept to a minimum. It has a consistent pen angle, except where diagonals occur, when pen angle is altered to give the letter an even weight.

Structure	**Strokes**			**Group**

The pen is turned to the horizontal to make the diagonal strokes of "a" and "z".

Move the pen horizontally at 40°.

Turn into the stem, move straight vertically downwards, and turn for the foot.

Turn the pen to horizontal to make the diagonal stroke of "a".

i l m n t u

This stroke forms the basis for many strokes in this hand, particularly in the wedge serif formation.

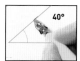

Move the pen downwards with a short stroke at 45° and return directly to the stem.

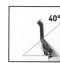

Complete the vertical downwards stroke.

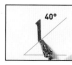

Return, complete the serif and make a small turn at the base to create a foot.

b f j k r v w y

This is an alternative "o" without the horizontal emphasis. The formal structure of straights and curves will apply to all letters.

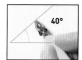

Hold the pen on the page at an angle of 40°.

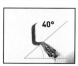

Make a short stroke to the left and move vertically downwards; avoid making curves.

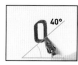

Repeat for the right side, but ensure the angles do not thin.

a c d e g h k p q

The pen moves down the diagonal at 40°. This occurs also on the "x" and occupies the full pen width.

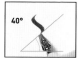

Start with a tight sweep into the diagonal. Draw the diagonal noting that the stroke is straight.

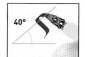

Make a short headline stroke turning at the end. It does not extend beyond the diagonal.

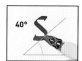

Repeat the headline stroke at the foot, but starting with the turn at the left.

c x y

Art nouveau capitals

Based on the capitals designed by Peter Behrens in c.1900 to accompany the related minuscule, these letters were originally created for a typeface. Although formal in appearance, they are pen-drawn. As with many Art Nouveau letters, in reactionary design, every effort is made to break away from previous letterforms.

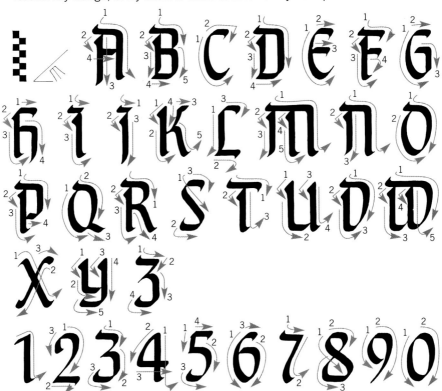

Points of interest

These capitals have a strong horizontal emphasis, which is created by the bar along the tops of the letters, with the stem starting below the line.

 The horizontal bar commences with a sweep above the line.

The serif and stem can be drawn in a single stroke, with the pen returning to create an infill.

Art Nouveau letters are typically high-waisted. This centre stroke can be raised.

This alternative "E" has a horizontal top stroke.

Basic structure

The formal angular structure of a letter designed as a typeface is a cardinal feature of this script; the horizontal headline bar provides an exotic innovation. The capitals can be used with or without the lower-case or minuscule letters.

Structure	**Strokes**			**Group**
The "A" contains characteristics of many of the letters, such as the horizontal crossing over the stem.	Make a turn before moving into the headline bar.	With as tight a turn as you can manage, move at right angles to make the stem.	Start the left leg below the horizontal with a loop. Return and draw the vertical stem. Add a central cross-stroke.	
The gentle curve to the right of "E", "G", "O" and "Q" provides a foil to the rigid formality of other letters.	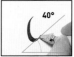 Although this is a curved stroke, do not allow the pen to sweep outwards too far.	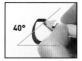 Keep the headline stroke straight with a downward turn at the end.	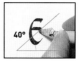 Repeat this stroke in the middle, observing that it is above the centre.	
This hand is relatively compressed. Do not let the counters of the rounded letters become too wide.	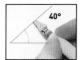 Hold the pen at 40°. Here an obliquely cut nib has been used.	Make a tight turn and a steep-sided bow. This may be almost straight-sided.	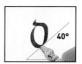 Complete the bowl, making sure to keep the counter small.	
One characteristic of Art Nouveau letters is the placing of horizontal strokes either high or low on the body.	Start with a loop then, at a point two-thirds from the baseline, make a rounded right angle.	Repeat the first stroke, but continue to the baseline.	Under the first stroke and above the baseline add a hook, move along the line, and connect.	

Illumination and ornamentation

When referring to manuscript or art, illumination is to decorate with gold or other precious metals and luminous colours. Illuminated and decorated manuscripts have a long tradition linked with religious texts. There are thousands of examples from Europe and the Middle East that span 1,500 years, some so lavish in application that it is stunning. The next few pages will show you how you also can illuminate your work.

Decorating with gold

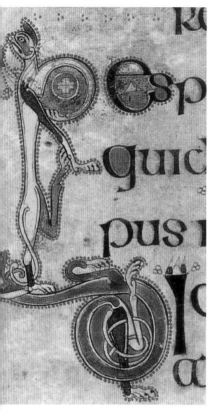

Decorated Letters "R" and "D" composed of two elongated lions in yellow and green. Illustration from the Book of Kells.

Illumination is the decoration of books or manuscripts with precious metals, particularly gold and silver. Early manuscripts were decorated to make the text more interesting and understandable in the way that we do today with photographs and illustrations. The illumination helped the reader, a priest or missionary, find his way around the text. For the artist it was an honour to allow his imagination to serve the word of God.

Early manuscripts were written in continuous lines of writing with little or no punctuation to divide the text. Simple line breaks or dots were used to make the reading easier. Eventually the use of verses or paragraphs beginning with a slightly larger letter, often in red, was adopted to help the reader.

With the development of minuscules larger capitals based on the Roman inscriptional letters were used to denote the beginnings of verses and paragraphs. Before long artists became more extravagant with the colour and formation of the larger letters. These letters are called versals and are the beginning of the decorated and illuminated letters and border designs that we see today in historical manuscripts. The large range of colours found in the decorative pages would have been applied using egg white or gum.

Gold combined well with the painting and calligraphy, creating a rich opulence. Gold does not tarnish, keeping its brilliance for hundreds of years. Although it was expensive it could be beaten into very fine leaves to be used sparingly but with great impact. Early English manuscripts such as the Lindisfarne Gospels had only very small amounts on the title pages.

Applying gold

Gold can be applied in different ways but needs a gum to stick it to paper or vellum (calf skin). Traditionally, illuminators would have used a sticky resin such as gum ammoniac, gesso or glair (clarified egg white).

Real gold ground into a fine powder and mixed with gum arabic forms paint. This is called "shell gold" because it used to be stored in mussel shells. It can be wetted with distilled water and painted on in the same way that paint is applied. Once dry it can be burnished carefully with an agate burnisher. Today shell gold is sold in a small pan like watercolour, but real gold powder can still be bought by the gram and mixed with liquid gum arabic in the same traditional way.

Initial "B" from The Bestiary of Guillaume le Clerc, early thirteenth century. Adapted by Tim Noad using PVA and patent gold.

You can also buy metallic powders, which look like gold but are much cheaper. These can be applied to paper and vellum in the same way. You will need to mix the powder with liquid gum arabic unless a dry gum (dextrin, a starch derivative) has already been added. Many tenth-century manuscripts (for example, the Benedictional of St. Aethelwold) contain beautiful versal letters painted in shell gold.

Shell gold (and metallic powder mixed with gum arabic) can be used in the pen. Shell gold can also be used as a painted background, making the whole area rich in colour.

Initial "D" from a twelfth-century psalter. Adapted by Tim Noad using PVA and patent gold.

Gold leaf

Gold leaf is available in two forms: transfer leaf and loose-leaf gold. These are supplied between tissue pages in small books of 25 leaves attached to a backing sheet (patent gold) or unattached (transfer gold). In the U.K. attached patent gold is called transfer gold and the unattached transfer gold is called loose-leaf gold. The gold should be at least 23½ carat and is supplied in two thicknesses: Single and double (or extra thick gold).

Beginners can start with single transfer gold, followed by double transfer gold: as gold sticks to itself, it is easier to apply a thin layer first followed by a thick layer, preferably transfer gold (double). Transfer gold gives a brighter finish than patent but is more difficult to apply. Other precious metals such as silver can be used, but silver eventually tarnishes when exposed to the atmosphere. Palladium or platinum can be used as alternatives but are expensive.

Gum ammoniac

A gum is needed to enable the gold to adhere to the paper or vellum surface. Traditionally illuminators used a sticky resin called gum ammoniac, which produces a flat, bright surface when the gold had been applied to it, or gesso, which will create a raised "cushion." The gum can be easily applied with a brush to a large surface that requires a gold background, or used easily with a pen for writing, or with a small brush for filigree designs or patterns. Once the gum is dry it can be breathed upon to make it sticky again and the gold pressed on to it. When it is covered in gold and completely dry (at least 30 minutes), polish the gilded design with a piece of silk.

Initial "P" at the beginning of St. Jerome's Preface to the Four Gospels from the Lindisfarne Gospels, written between 698 A.D. and 721 A.D.

Gum ammoniac size

Gum ammoniac size can be bought ready-made but is simple and fun to make from its natural state. The dried gum has the appearance of muesli but contains many impurities such as bits of twig and stones.

1. Remove the impurities and crumble some of the lumps into a small jar.
2. Add distilled water to just cover the lumps and leave for about 12 hours or overnight. The jar now contains a milky fluid like single cream.
3. Stir the contents and pour through a fine mesh into another similar-sized jar, taking care not to push any of the bits through the mesh. The liquid in the second jar is the size or glue. Add a drop of red watercolour paint or food colouring to the mixture so that you can see when you paint or write with it. The liquid can be kept in a covered jar in the refrigerator for about 6–9 months.
4. When the size is ready use an old paintbrush to apply it thinly to the background areas you wish to gild. When you have finished rinse the brush in warm water immediately.

Using gum ammoniac size

Once the gum is dry, which may take up to an hour, you can begin. When planning your work, make sure that any writing is done first. This is where you will make your mistakes. Then apply the gold and, lastly, add the colour. The reason for doing the painting last is that the paint contains gum and gold sticks to gum.

1. Place your design on the vellum or paper onto a cold surface – glass is ideal. This helps the gilding process. Have your single patent gold ready and some glassine paper (crystal parchment paper).
2. Take a breathing tube and breathe twice onto the gum. (See Applying gold leaf onto gesso, page 250.)
3. Lay your patent gold onto the gum pressing firmly with your fingers. Repeat until all the gold has been deposited where you want it.
4. When it is dry (about 30 minutes) burnish by polishing with a piece of silk.

This design draws on ideas from medieval illumination and from the decorative arts of William Morris. The juxtaposition of gold and silver produces a stunning contrast.

Gesso

Gesso can be used on both paper and vellum and forms a slightly raised cushion on which to lay the gold. The gesso is painted on with a brush or quill. When breathed upon, gesso provides a sticky surface to which gold leaf adheres well.

To make gesso you need:
- 8 parts of powdered slaked plaster of Paris (which adds bulk)
- 3 parts of lead carbonate (please note that this substance is poisonous – handle with care)
- 1 part sugar
- 1 part seccotine (fish glue)
- a pinch of Armenian bole (or a touch of red watercolour)
- distilled water to mix

You can buy slaked plaster of Paris, but it is easy to make. A batch will last you for years stored in an airtight container in manageable lumps and grated or ground when required. You need a large bucket, a plastic or wooden spoon, 500g dental plaster (fine plaster of Paris). Fill the bucket with water and sprinkle the plaster into the water, stirring continuously. Continue to stir for about an hour to prevent the plaster from setting. Leave overnight. Drain off the water taking care not to lose the plaster, fill to the top again and stir continuously for 10 minutes. Leave to settle for 24 hours. Pour off the water, add fresh water and stir for 10 minutes. Repeat this procedure daily for one week, then every other day for two weeks. Finally drain the plaster through a fine muslin cloth and spread the slaked plaster into a shallow plastic container (not metal). Leave to dry. When almost dry, it can be scored into manageable smaller squares. Store these in an airtight container ready for use.

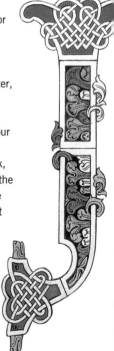

This letter is rich in gilding and colour. The highlights on the two central panels contrast well with the richer colours around the knotwork at each end.

Making gesso

Put the dry ingredients into a mortar and grind well with a pestle, for at least 15 minutes. Add the seccotine and distilled water and grind until smooth like thick cream, another 15 minutes. Using a small spoon, scoop half to 25mm blobs onto polytheme film and leave the "cakes" to dry. These will keep for many years in an airtight plastic container.

Lead carbonate is poisonous. Thoroughly wash your hands and the utensils you have used. Do not use the pestle and mortar for foodstuffs.

Reconstituting gesso

1 Crumble the piece of gesso into a small glass jar. Wash your hands after handling as it contains lead carbonate. Keep the jar for gilding materials only. Tilt the jar by standing one half on a pencil and add two drops of distilled water from the dropper to cover the gesso.

2 Keep the jars tilted so that the water covers the gesso and leave for 1–2 hours to let the water permeate the gesso (it should be like thick cream). If it appears too thick, gently push the gesso with a glass rod to mix evenly. Add more water, one drop at a time. Once the gesso is reconstituted you can use it.

Applying gold leaf onto gesso
You will need:

- gesso (one half of a small cake of gesso)
- a small glass jar
- distilled water and dropper
- glass rod
- paper tube
- patent gold (single) and transfer gold (extra thick or double)
- paper or vellum
- fine pen
- fine paintbrushes no. 1, 0, and 00
- scalpel or craft knife, round blade
- scissors
- glassine or silicone paper
- burnisher
- large, soft brush
- gouache and watercolour paints

1. Burnisher
2. Large, soft brush
3. Burnishers
4. Scalpel or craft knife
5. Paper tube
6. Patent gold
7. Transfer gold
8. Glassine or silicone paper

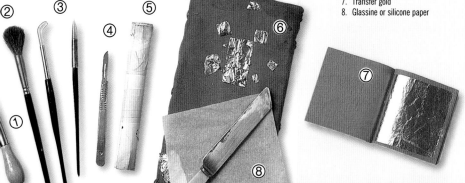

Applying gold leaf onto gesso

1 If you are using vellum, prepare the surface by lightly sanding with pounce or fine glass paper.

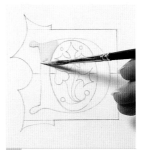

2 Fix your paper/vellum to a firm flat surface – glass is best. Trace your design onto the paper or vellum. Using a fine paintbrush, apply the gesso by loading the brush and pull the blob. (Before dipping into the gesso, dip into distilled water and squeeze the excess from the hairs. This prevents air penetrating the gesso and creating bubbles. If bubbles appear, remove by adding a drop of oil of cloves.)

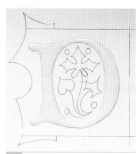

3 Load the brush and pull the gesso over the surface rather than painting it on, which will create grooves. Work quickly and methodically.

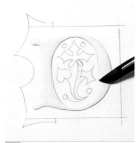

4 Leave the gesso to dry overnight. Inspect for rough or uneven areas and carefully scrape smooth with a sharp curved blade such as a scalpel. (Do this task over a loose piece of waste paper so that the scrapings can be wrapped up and thrown away.) The smoother the finish on the gesso the better the gilding will be. Burnish the gesso with an agate burnisher for a really smooth finish.

5 Mask any areas of your work that are not to be gilded. Do not touch the gesso with your fingers: this prevents the gold sticking to it. Have your patent gold and glassine at hand. Breathe onto the gesso through your paper tube twice. This will create moisture and make the gesso sticky.

6 Apply the patent gold (gold face down) and press firmly with your fingers. Repeat this process two or three times, covering the gesso with gold.

7 Place the glassine paper over the gold and press firmly to make sure that all the gold has stuck to the gesso.

Burnish the gold through glassine (crystal parchment) paper with a burnisher. Then carefully burnish directly onto the gold to create a good shine. Brush away any unwanted particles of gold with a large soft brush.

8 For an even brighter finish apply the transfer (double) gold on top. Cut a piece of gold larger than the gilded area, leaving the backing sheet in place. Place the gold onto the work with the backing sheet in place. Press down. Repeat until the letter is covered. Leave for 24 hours, then burnish to make it shine.

Use a large brush to dust away excess gold. Leave for at least an hour, then burnish onto the gold for a brilliant finish.

9 To complete the illuminated letter, fill the ungilded areas with gouache paint.

10 Using a no. 1 or 2 brush, establish the colours with a light wash, then paint using gouache applied with small strokes of a fine brush to build up colour over the whole design. Finally, use permanent white gouache paint to highlight the design with pattern.

A detailed gilded, painted, and finished decorated letter "D".

252
Glossary

Arm Horizontal stroke, free at one or both ends.

Ascender Part of a **minuscule** letter that rises above the **x-height**.

Bar A horizontal bar as on "e" or "A".

Baseline An imaginary line on which a letter sits.

Black Letter or **Gothic Letter** A medieval letter, such as the Gothic Textura Quadrata.

Body height (see x-height).

Bowl A curved stroke enclosing a **counter**.

Capital (see also Majuscule.) A large letter originally derived from the letters of ancient Rome.

Capline see Headline.

Counter The fully or partially enclosed part of a letter such as "b" or "D".

Cursive A script inclining towards handwriting or continuous writing.

Descender A part of a **minuscule** letter descending below the **x-height**.

Display capital A set of highly decorated capitals used as an introductory word or sentence.

Ductus The way a script is written and the way in which the writing tool is held and manipulated.

Ear Small stroke to the right of "g".

Fraktur A late German Gothic letter defined by its "broken" stem.

Gothic (see Black Letter).

Headline An imaginary line defining the top of a letter.

Italic A forward-sloping Humanist letter partially defined by the single-storey "a".

Link A stroke connecting the upper bowl to the lower loop of "g".

Loop The lower part of the letter "g".

Lower case (see Minuscule).

Majuscule (capitals, upper case) A large letter originally derived from the letters of ancient Rome.

Minuscule (lower case) A small letter. A letter with both ascenders and descenders; often, in calligraphic terms, a small letter written with a "slanted" pen, (e.g., the Caroline minuscule).

Sans serif A letter without **serifs**, usually with square **terminals**.

Serif A small stroke that terminates the main stroke of a letter, usually at right angles to the main stroke. This stroke may take many forms.

Slanted pen A pen with the nib cut at right angles to the shaft and used for writing letters with the pen at an angle to the stem, producing letters with slanting heads and feet.

Straight pen A pen with the nib cut at an oblique angle to the shaft, producing letters with straight heads and feet.

Stem The main part of a letter, usually the vertical or diagonal stroke.

Stress The direction of the thickening of a curved stroke.

Stroke A straight or a curved line.

Swash letters Letters with flourishes added to sloping and Italic letters, usually as an initial introductory stroke or as an extension of an **ascender** or **descender**.

Tail The diagonal stroke of "R" and "Q".

Terminal The end of a stroke that does not finish in a **serif**.

Uncial An early Christian and Roman book hand.

Upper case (see Majuscule).

Versal A single letter used at the beginning of a chapter, verse, or paragraph, usually highly decorated in abstract, animal (zoomorphic), or human (inhabited) form.

x-height or **Body height** Height of the body of a **minuscule** letter without **ascender** or **descender**.

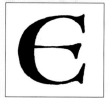

Index

Credits

My thanks to Mary Noble for her help in providing the chapter on Preparation based on her considerable experience in the teaching of calligraphy. My thanks also to Janet Mehigan for her contribution and help in the preparation of the chapter on Illumination and Decoration.